GOPRO®:
HOW TO USE®

GOPRO
MAX

GOPRO

MAX

KP
KAISANTI PRESS

"If you change the way you look at things,

the things you look at change."

~Dr. Wayne Dyer

INTRODUCTION

That little GoPro camera you hold in your hand is the result of years of testing, revising, and perfecting. What started as a simple desire to carry a camera for surfing pics of some friends grew, grew, and grew some more.

The same convenience that GoPro founder Nick Woodman was searching for when he strapped a camera onto his wrist is what has attracted millions of people to these powerful storytelling devices. Everyone has moments in his or her life to be remembered, and there is no easier way to record them than with a GoPro camera. These cameras are waterproof, shockproof, tough little cameras that are fully capable of recording life's moments in such crisp, clear high quality that we can replay them over and over to feel like we are there again.

When the first GoPro was released, I had already been using big, bulky water housings to take photos of surfers, bodyboarders and windsurfers around the world for years. The resulting images were worth the hard work, but when I got my first GoPro camera, the struggle of the big camera was gone and just the fun remained. That's when it all clicked. Everyone was going to want one of these, and people were going to need help. So I set out on a mission to figure out the clearest, most logical way for people to learn how to use their GoPro cameras from start to finish.

Nine years, thirteen books, and millions of readers/viewers later, you are reading the evolution of my intent to help you, written specifically for the GoPro Max.

This how-to-use guide will teach you how to use your GoPro Max camera with confidence from the initial setup all the way through to sharing your edited photos and videos. The technology has jumped leaps and bounds and it's all available right now... for you! Let me teach you everything you need to know. I'm so happy to have you on board!

Jordan Hetrick
Bestselling Author on GoPro Cameras

CONTENTS

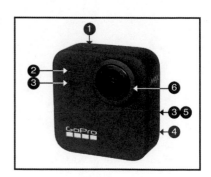

CONTENTS

STEP THREE - MOUNTING (cont.)

STEP FOUR - CAPTURE THE ACTION 62

CONTENTS

ABOUT GOPRO MAX

Welcome to the world of 360! GoPro Max is the next level of GoPro cameras offering the ability to film life's magic moments in full spherical 360. Through creative engineering, GoPro has created a camera that gives you so many possibilities for videos and photos like you've never seen before.

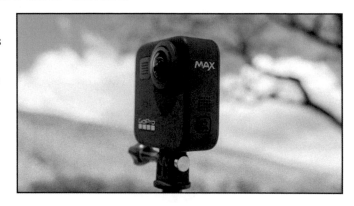

GoPro Max uses two ultra wide-angle lenses to record everything into a full 5.6k spherical image. This creates high quality 360 videos and photos. But, even if you don't like the look of spherical 360 photos or videos, the benefits of what you can create are mind-blowing. GoPro Max is a full-on one-person filming, editing and creating powerhouse. Whether you are using Max for real estate, action sports, vlogging, or just to record life's simple moments, GoPro Max is THE tool that will create memorable content.

Let's talk about some of the magic you can create using GoPro Max. GoPro Max gives you the technological power to: Create an invisible mount which makes the camera appear to be floating around you. Edit your photos and videos to a super wide-angle perspective for immersive action. Record full spherical 360 audio recording using 6 microphones. Film videos with unshakeable stabilization and horizon-leveling for footage you won't believe. Maximize in-camera stitching for an easier workflow. And create amazing transitions using your new knowledge.

You will learn about these techniques and way, way more in this book written for GoPro Max. This edition offers a fully comprehensive editing section, which will teach you how to use all of the tools you need to edit everything from a quick clip to a professional-looking video like a pro.

Being so unique, there is a lot to learn and understand before you begin to love your GoPro Max. But with the possibilities of what you can create with GoPro Max, it's worth taking the time to get to know this camera.

There's never been a better time to record life's adventures, whether it's in your backyard, under the sea or on top of a mountain.

So grab your GoPro Max and let's learn everything you need to know about your new camera so you can create the best videos and photos ever! Once you get to know it, you are going to love it!

HOW TO USE THIS GUIDE

Now that you've decided to really learn how to use your GoPro® Max camera, the information in this guide will teach you everything you need to know to get the shots you've always wanted.

This guide is organized into 7 Steps, which were written to logically guide you through the learning process. By the end of this book, you will have a clear and thorough knowledge of how to do everything possible with your GoPro Max camera.

In Step One- Get To Know Your GoPro Max, you will learn how to unlock the full potential of your new camera. This section includes essential information to familiarize you with your camera and to get you started, as well as get you connected to the GoPro App. You can also download the GoPro Max User Manual from GoPro's Support page on their website to be used in conjunction with the information in this guide. Your camera's User Manual tells you all of the little details about every setting option, while this guide provides you with the vital knowledge to understand what you really need to know to use your GoPro Max.

The Go Deeper sections provide more advanced tips for using your GoPro Max camera. You may want to revisit these sections after learning the basics.

If you just bought your camera, before you buy the wrong mounts for your lifestyle, check out the Mounting Section in Step 3 to see which mounts are right for you and your passions!

Take your time, go step by step and by the time you finish this book, you will know how to use your GoPro Max camera to record, edit and share life's most memorable moments!

STEP ONE
GET TO KNOW GOPRO MAX

Learn To Navigate Your New Camera

Welcome to GoPro Max! This first section gives you hands on practice to easily navigate your new camera and access its features so you can focus on filming. Once you know your way around, you will be able to unlock the full potential of GoPro Max to capture your exciting moments in the best way possible.

So let's get to know your new camera!

SETTING UP YOUR CAMERA FOR THE FIRST TIME (It's Easy!)

1-4 5 6

1. As soon as you open the box, put the lens covers on to protect the two lenses.

2. **Open the side door** that covers the battery, microSD card slot and USB-C port.

3. **Insert the microSD Card in the small slot** with the text facing the back (side with the Touch Screen) of the camera. A 64GB microSD card is included in some Max kits as a bonus. Max requires a Class 10 or UHS-1 microSD card up to 256GB (such as the SanDisk Extreme Pro and the Samsung EVO Select).

4. **Insert the battery** with the GoPro logo facing the front of the camera. Use the included GoPro Max battery. Make sure to push the battery all the way in.

5. **Charge your camera.** Plug one end of the USB cable into the USB port on your camera and the other end to a computer or 5V/1-2A USB power supply. Your camera battery comes partially charged and using it with a partial charge will not affect the battery life. Charging typically takes about 2 hours using a wall charger or power pack and up to 4 hours using a computer.

6. Once your camera has charged, the red light will turn off indicating that charging in complete. Remove the USB cable and **close the side door**, making sure the door closes completely. Slide the tab up so the red is not visible.

Your camera is ready to use. It's that easy! Now let's go through elements of your camera.

NOTE: Make sure you are running the most current firmware (v01.50 or higher) to take advantage of the modes and settings as shown in this book. To see which version is installed on your camera, turn on your camera and swipe down from the top of the screen to expose the Dashboard and Preferences menu. The firmware version is located under *Preferences>About>Camera Info*. If your camera's firmware needs to be updated, **the easiest way to update is to connect to the GoPro App, which you will learn how to do here in Step One.**

WHAT ARE THESE BUTTONS AND PORTS FOR?

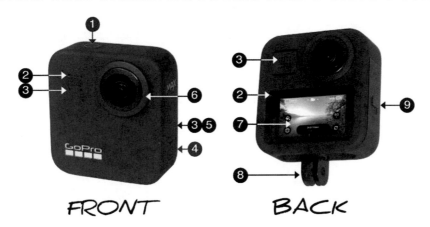

FRONT BACK

1. SHUTTER Button

Press this button to start and stop recording or to take photos. The camera beeps once when it starts recording. After recording a video, the camera beeps again three times after the file has been processed.

2. Camera Status Lights

These red lights turn on when the camera is recording video and when taking photos. You can turn off just the front light or both of the lights (one is also on the back) in the Preferences Menu.

3. Microphones

Six waterproof microphones record stereo and 360 sound.

4. POWER/MODE Button

Press this button to turn your camera ON.

Once your camera is powered on, press this button to scroll through shooting modes. Press this button to escape out of Settings or Media screens for a quick return to shooting modes.

Hold down this button for 4 seconds to turn your camera OFF.

5. Speaker

This speaker plays audio when watching videos on the Touch Screen.

6. Lenses

Max has wide angle two lenses, one on each side of the camera, which are used for recording the full 360 degree view. These glass lenses are not replaceable, so it is extra important to keep these lenses free from scratches and dirt.

7. Touch Screen

The Touch Screen is a built-in LCD Screen that can be used as a viewfinder for composing shots, to change settings and to play back your footage. The Touch Screen section in this step gives you an explanation of everything you can do using this screen.

8. Mounting Fingers

The Mounting Fingers are used to attach your camera to mounts and can also be folded up to use your camera unmounted. You will learn more about using these for creative mounting setups in Step 3.

9. Battery, MicroSD Card and USB Port

Open this door to install or replace the rechargeable battery and to insert or remove your microSD card. The USB port is for charging and transferring files. Step-by-step instructions for transferring your files are provided in Step 5- Creation. This door is removable. The rubber gasket on the door keeps water out of your camera, so make sure it is always closed securely.

Note: GoPro Max does not have a built-in HDMI port, so you will have to use an adapter or USB drive if you want to view your unedited Max files on a TV or monitor.

NAVIGATING GOPRO MAX

Let's turn your camera on and learn to navigate your new camera so you can tap into all of the fun features of this powerful 360 camera.

The simplest way to get around GoPro Max is to use the camera's integrated Touch Screen on the back of the camera. All of the modes, settings and setup options are available through the Touch Screen.

There are lots of setting options on GoPro Max (which we will get into in the next step), but after a little practice, you will be able to navigate your camera with ease. First, let's take a closer look at navigating using the Touch Screen.

If you want to take a moment to practice getting around, follow the steps to take a short tour.

1. **Press the Power/Mode Button on the side of the camera to turn your camera on.** It may take a few seconds for your camera to power on.

2. The first time you turn the camera on GoPro Max will power on in HERO Mode, which means that it will film using just one of the lenses to record a traditional rectangular video. Obviously, Max also records in 360 and can easily be switched back and forth. Just **Tap the camera icon in the bottom left corner of the Touch Screen.** A sphere icon in the bottom left corner tells you that you are now in 360 Mode. **Tap the sphere icon again** to go back to HERO Mode for now.

3. In both HERO and 360 Modes, GoPro Max has **three main recording modes**, which are indicated by the **icons at the top middle of the screen**. The three modes from left to right are: Time Lapse, Video, and Photo. **Swipe Right** for Time Lapse Mode. **Swipe Left** for Photo Mode. Then **Swipe back to Video Mode**. The icon at the top of the screen indicates your current mode.

4. Next, **Tap the curved arrow icon** at the bottom right of the touch screen. This switches lenses in HERO mode. In 360, this just switches the preview lens since the camera records using both lenses.

5. Now, at the **bottom middle of the Touch Screen, Tap the settings box to select or edit a Setting Preset**. Most of the modes have just one **Setting Preset to choose from**. A Preset defines how your camera will function within that mode and which settings to use, which will make more sense as we get into the next step. You can Scroll up or down to see the available Presets for that Mode. If you swipe over to HERO Photo Mode, for example, you will see two default Presets: 1) Photo and 2) PowerPano. **The next step will help you understand how to customize and use these presets to get the most out of your camera.**

6. **Tap the Photo preset** to exit the Preset dialog screen and return to the recording screen.

7. **Next, Tap on the middle of the screen** and all of the icons will be hidden for composing your shots more clearly. **Tap the middle of the screen again** and they reappear.

8. To begin recording after selecting a Preset, you would **press the top Shutter Button**.

> **TIP:** Using Buttons to Change Modes. When the Touch Screen is inaccessible, you can easily change modes by pressing the Mode Button on the right side of your camera to scroll through Video, Photo, and Time Lapse modes, in that order. The most recently selected Preset within each of the modes is available by default. You cannot switch between 360 and HERO modes using the Mode Button.

> **TIP:** Each preset's settings can be changed independently of the other presets. Any changes made only affects that current preset.

QUIKCAPTURE (ONE BUTTON CONTROL)

QuikCapture enables you to power on your camera straight into recording without any standby time. When recording is finished, the camera automatically turns back off.

To use QuikCapture, you need to first enable the feature when your camera is turned on. Swipe down from the top of the screen and tap the "Jumping Rabbit" icon. Now QuikCapture is enabled.

When your camera is turned off and you want to get straight into recording, utilize QuikCapture for quick access to video recording and time lapse photos with the push of a button. **To begin recording video, Press the top Shutter Button** and your camera will power on and begin recording. **Or Hold Down the top Shutter Button for at least 3 seconds** and your camera will begin recording a time lapse. Once you **press the Shutter Button again, your camera stops recording and turns off.**

QuikCapture is a great tool for specific filming situations once you understand GoPro Max and your favorite presets. QuikCapture also conserves battery life that would be used during standby time. Note that there is a 4-5 second startup time when using QuikCapture.

You can set QuikCapture to start recording in 360 or HERO mode using the Dashboard, under Preferences>General>QuikCapture Default.

THE TOUCH SCREEN

The Touch Screen is a very convenient feature of GoPro Max and one that was missing from GoPro's first 360 camera- the Fusion. The Touch Screen gives you the ability to preview and compose your shots, as well as see a Live View of how setting changes affect your videos and photos. If you like to get muddy or sandy, consider using a screen protector (available from third-party sellers online) to keep your Touch Screen scratch-free.

You've already learned how to navigate the Touch Screen to change modes and basic settings, but the following section provides more information about other useful ways to tap into the convenience of the Touch Screen.

The Touch Screen serves three primary functions: to **change settings**, as a **viewfinder**, and to **view your recorded photos and videos**:

TO SELECT AND CHANGE SETTINGS

As you learned previously, all modes and settings can be changed using the Touch Screen.

The Touch Screen tells you the following information about your camera settings, modes and status:

1. Camera Mode
This icon indicates which recording mode you are currently using (Video, Photo, or Time Lapse).

2. Time/Storage/Files
In Video Mode, this displays the remaining number of minutes you can record on your memory card at the current video resolution. (This time will change when you change settings because different file sizes require different amounts of memory.)

In Photo Modes, this tells you how many photos you have remaining at the current setting.

3. On-Screen Shortcuts
On-Screen Shortcuts let you select which icons you want available on the Touch Screen for easy access. Since On-Screen shortcuts can be customized for each of the presets, these icons will vary based on your selected Preset. There are two possible locations for the On-Screen Shortcuts. Recommended On-Screen shortcuts for each Setting Preset will be given in the next step.

4. 360 or HERO Mode
Use this icon to switch between 360 and HERO recording.

5. Settings Preset Dialog
Tap this box to switch Setting Presets. All settings for the current Preset can be changed using this dialog box. To edit a Preset's settings, you can either tap the box and then select the edit icon next to the preset OR press and hold the setting preset to go directly to the settings options for that preset.

6. Switch Lenses

Tap this icon to switch between the front and back lens. In HERO Mode, the selected lens will be the only one recording. In 360 Mode, this only affects the preview since both lenses will used to capture the image.

7. Battery Life

This displays the exact percentage of remaining battery life.

• To show settings info (including current mode, the counter, capture settings and battery status) on the preview screen, Tap the Screen. To hide this info, Tap the Screen again. Hiding the info while you record allows you to see your shots more clearly for better composition.

• To escape out of a Setting Menu, either 1) select a Setting, 2) press the Back Arrow, or 3) press the Power/Mode Button.

• Swipe Down from the top of the screen to access the Dashboard and Preferences Menu for more general camera settings. (You will learn about these at the end of Step 2.)

AS A VIEWFINDER

The Touch Screen provides an easy way to **set up and compose your shots**. Use the Touch Screen to preview how your shots will look with the selected settings. After selecting your settings, Tap the Touch Screen to hide the icons for a clear screen.

When looking at the Touch Screen as you film, keep the Touch Screen on to compose your shots. If the Touch Screen goes to sleep while you are filming, tap the screen or press the side Power/Mode Button to wake it back up. You may want to set the Screen Saver for a longer period (such as 3 minutes or Never) when recording long clips. You can set the Touch Screen to turn off after 1, 2, or 3 minutes (the time can be set in the Preferences Menu>Touch Screen>Screen Saver).

If you rotate your camera vertically, the icons also rotate, and any photos or videos will be recorded in a vertical format. This is irrelevant for 360 mode, but it does affect HERO mode footage. The orientation can be locked if you don't want the Touch Screen to rotate vertically by tapping the Orientation Lock in the camera Dashboard.

When composing shots through the back lens, the preview image appears reversed, but the actual photo or video will not be reversed.

When using the Touch Screen **to set up mounted shots**, preview the composition on the Touch Screen. Once the shot is set up and your mounting position is secured, **let the Touch Screen go to sleep** to conserve battery life.

TO VIEW AND TRIM YOUR RECORDED PHOTOS AND VIDEOS

After a session, use the Touch Screen to view your videos and photos. One of the great things about GoPro Max is the instant gratification of seeing your photos and videos right away on the Touch Screen. The built-in screen lets you view your footage immediately, but unfortunately you can't see the full 360 videos on the Touch Screen.

• Swipe Up from the bottom of the screen to open your media. The diagram shows Touch Screen items for playback (icons will vary slightly depending on the type of media you are viewing).

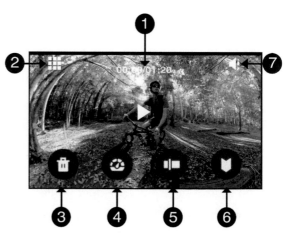

1. The **Time Counter** shows a running count of your play back time.

2. Select the **Grid Icon** to view thumbnails of your media.

3. Tap to **Delete** the current file.

4. **In HERO Mode,** Tap for **Slow Motion** playback. (Only displayed for videos recorded in 60 fps or higher.) **In 360 Mode,** a curved arrow icon is displayed which is used to switch the view to the other lens.

5. **Scroll** through the timeline of a video clip.

6. Add a **Hilight** to your videos which will be used by the GoPro App for edits.

7. Raise or lower the **Audio playback volume** on your camera.

• **Swipe Left** from the right side of the screen to view older videos or photos.

• **After tapping the Grid**, use the Gallery view to select files. **To Delete** multiple files, Tap the Check box in the top right corner, then the Trash Can icon to delete the selected files.

• **Scroll up** to view any photos or videos you have already recorded. The most recent files are shown first.

• **Push play/pause in the middle of the screen** to watch the video, view a single shot photo or view a sequence of photos.

• When viewing photos, **double Tap to zoom in slightly**. Double Tap again to zoom back out. Photos do not display in 360 on the Touch Screen so don't be surprised if they don't look like the scene you recorded.

🗣 VOICE CONTROL

At first, Voice Control seems a bit like a gimmick, but as you start to use it, you will realize that it's actually **very, very useful when using a 360 camera**. Voice Control gives you easy hands-free access to start and stop recording with your GoPro Max. Since your camera records a full 360 sphere in 360 Mode, Voice Control gives you the freedom to move away from the lens before recording. Voice Control is also useful to control your camera when you are too far away to reach the Shutter Button, such as on the end of a long extension pole. You will learn more about the importance of this in later chapters.

With a simple command, you can start recording or taking photos in a variety of modes. It's also much easier to change modes using Voice Control. Instead of scrolling through the modes, you can go straight to the mode you want to record with.

To activate Voice Control, Pull Down the top tray on the Touch Screen. Tap the Voice Control Icon at the middle left to remove the "x", turning the icon blue.

The preferred Voice Control language can be changed in the Preferences Menu (Preferences>Voice Control>Language).

You can't do everything with Voice Control, such as switching between 360 and HERO Modes, but there is a lot you can control. **Here is a list of the commands you can use with your GoPro Max:**

To Start and Stop Recording or Taking Photos in the Current Mode

"GoPro Capture" (captures photos or video in the current mode)
"GoPro Stop Capture" (for Video and Time Lapse modes)

To Change Modes and Power Off

"GoPro Video Mode"
"GoPro Photo Mode"
"GoPro Time Lapse Mode"
"GoPro Turn Off"

To Start and Stop Recording or Taking Photos

"GoPro Start Recording" (starts recording video)
"GoPro Stop Recording" (stops recording video)
"GoPro HiLight" (set a HiLight Tag to mark memorable video moments)
"GoPro Take a Photo" (if your camera is not recording a video)
"GoPro Start Time Lapse"
"GoPro Stop Time Lapse"

Of course, as with anything, there are optimal times to use Voice Control. For best results, use Voice Control when there is **minimal ambient noise**. When recording video or a time lapse, you need to **stop recording** before issuing a new command.

Also, keep your GoPro **within a few feet** to make sure it can hear you, especially if there is ambient noise, such as the ocean or wind. Speak clearly and say the exact command.

Also, Voice Control will not work when your camera is underwater, or even sometimes after you have been in the water (if there is sand or water covering the mic opening). Make sure to shake your camera or blow any water out of the mic openings after going in the water.

TAKING CARE OF GOPRO MAX

Before we get too deep into using your new Max camera, there are a few things to remember to keep your camera in top condition.

These simple steps will keep your camera working like new for years:

• Keep the side door closed with the tab up **before getting your camera wet**. Max is waterproof to 16' (5m), but only when that door is closed completely.

• **Rinse off your camera and mounts with fresh water** after using them in the ocean or getting them dirty. Gently dry your camera with a soft cloth and **blow off the residual water around the door before opening it**.

• **Avoid touching the lenses with your fingers.** You don't want grease, sunblock, or scratches on the lenses. Make sure the lenses are always clean! This is your camera's window to the world. GoPro Max **works great for clear, in-focus shots** as long as the lenses are clean. The lenses on GoPro Max are not replaceable, making it extra important to prevent cracks or scratches.

• **Keep the solid lens covers on** when not recording to protect the lenses. When using one lens to record in Hero Modes, keep a lens cover on the lens not being used.

• Try to **keep sand and dirt out of the microphone openings**. You don't want to interfere with audio quality by blocking these openings.

• GoPro Max can't handle too many hard hits so **if you want the extra protection for the lenses, use the Protective Lenses** that came with your camera for extreme sports. For full camera body protection, you can use a third party waterproof housing (Vgsion is one available option).

WIFI / BLUETOOTH

GoPro Max uses a combination of 2.4 and 5GHz WiFi and Bluetooth to connect to external devices, such as a remote or a phone/tablet. Your camera emits its own signal, so you don't need to be within range of any WiFi signals to use your camera's WiFi features. There is no indicator light or icon to tell you if your WiFi signal is on.

To access the Connections dialog, pull the top tray down on the Touch Screen. In Preferences, Tap Connections to access the Wireless Connections. You can manually turn on or off the WiFi and connect to the GoPro App or the Smart WiFi Remote.

GoPro Max automatically manages your camera's WiFi, switching from WiFi to Bluetooth to reduce battery drain. If you will not be using your camera for an extended period, you may want to turn off the WiFi Signal. The drain on your battery is minimal, about 3-5% over 12 hours, but over time it could drain your battery if it hasn't turned off automatically.

GOPRO PLUS

GoPro Plus is something all GoPro camera owners should at least be aware of since the benefits can easily outweigh the cost. GoPro Plus is GoPro's subscription plan (about $5 US per month) with three useful features- cloud storage, camera replacement, and discounts on mounts. First of all, GoPro Subscribers can store unlimited photos and videos at their full, original resolution. This is helpful so you can access your files anywhere, although it can take a long time for large files to upload to the cloud. Depending on your data plan, you may want to only upload using WiFi.

Second, if you break your camera, which is a possibility if you are out adventuring, you can replace your camera up to 2x per year for a small fee which is way less than the original camera.

The third benefit is the discount on mounts- most mounts from GoPro's website are available at half price, which can save you some good cash straight out of the gates.

GoPro Plus is totally optional, but at least you are informed of the benefits.

USING THE GOPRO APP

The GoPro App works on your tablet or smartphone and is available for free from the App Store (iOS) or Google Play (Android). The App is optional, but the benefits are many.

In addition to giving you remote access to your camera's Shutter Button, modes and settings, the GoPro App allows you to **view the action as you record** videos and photos when you can't see your camera's Touch Screen. This is extremely useful for composing your mounted shots. You will see the benefit of this technology when you learn to set up your shots in Step 3- Mounting.

> **TIP:** Live View (viewing what you are filming while your camera is recording) compatibility depends on your device, but if you see a "Preview Not Available" message once you start recording, you are filming in a resolution that is not compatible with your device. All devices should be able to handle the highest resolution in HERO mode (1080 @60 frames per second). Live View is not available when recording 360 videos. Of course, your camera will still record, but you won't be able to preview it using the App.

The GoPro App is also the **easiest way to transfer photos and videos from Max to your phone or tablet** for sharing with friends, family or on social media. The GoPro App also gives you the best tools for editing 360 photos and videos, which we will learn more about in Step 5- Creation.

You can also **update your camera's firmware wirelessly** through the App. Updating your camera ensures that your camera is equipped with the most up-to-date features and settings. The App will notify you when an update is available.

TO CONNECT GOPRO MAX TO THE GOPRO APP:

Download the GoPro App from your app store. The GoPro App is free so make sure you don't accidentally download an app that looks similar but charges a fee. There are no additional upgrade options for the GoPro App.

After you install and open the App, tap the camera icon in the bottom left corner. Then tap "Add a Camera" or the "+" symbol. The App will walk you through the setup.

When reconnecting to the App, you should just be able to open the App and tap on the camera icon. Under your camera name, the App should say "Camera Found".

If the App says "Not Found" below the image of your camera, turn your camera on to make your camera discoverable. If the camera is still not found, make sure your camera's WiFi is turned on in Preferences>Connections.

UNDERSTANDING THE APP

Once your camera is connected wirelessly to the App, the GoPro App gives you 3 options: 1) Control Your GoPro, which we will explore more here. 2) View Media, where you can view, transfer, and edit the media on your camera's microSD card. We will dive deeper into that in Step 5, when you learn to edit your media. And 3) Manage Auto Upload settings, which is for GoPro Plus subscribers (learn more about GoPro Plus next) to adjust your preferences for auto uploading footage to GoPro's cloud service.

CONTROL YOUR GOPRO

When you select "Control Camera," the following icons give you remote access to the full range of settings and modes on GoPro Max:

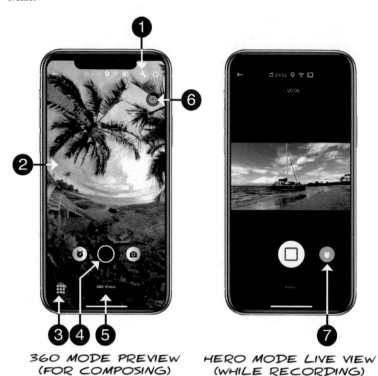

360 MODE PREVIEW
(FOR COMPOSING)

HERO MODE LIVE VIEW
(WHILE RECORDING)

1. Camera Preferences

Tap this icon to change general settings for your camera. (General settings include items such as turning on and off Voice Control/ QuikCapture/ Beeps, etc. and more which are covered at the end of Step 2-Settings).

2. Preview Screen

This screen shows a preview of your camera's view. In 360 Mode, the screen shows a full frame view on the App. As you rotate and move your phone or tablet, you can look around at the camera's full 360 view. You can also zoom in or out by pinching with two fingers or dragging up and down to adjust the composition. All of these adjustments are only to preview your shots. This full 360 view is useful for composing the angle and distance from your subject, but the camera will still record the full 360 sphere, which can be edited later.

In HERO Mode, the preview shows the actual frame that will be recorded.

3. GoPro Media

Tap this icon to view the videos and photos that are currently on your camera's memory card. You can view, trim, download, delete and share these files.

4. Mode/Shutter Button

Swipe left or right to change between modes or to Live Stream. Press the Circle Button on your selected mode to begin recording video or taking photos. Learn more about using Live Stream in Step 7.

5. Settings Presets

This area displays your current Preset and basic settings. Tap this area to switch Presets or edit a preset. In Step 2- Settings, you will learn which settings to use.

6. 360 or HERO Mode & Switch Lenses (HERO Mode Only)

Tap this icon to switch between 360 and HERO recording. In HERO Mode, use the curved arrow icon below to select between the front and back lenses.

7. HiLight Tag (displayed only when recording video)

Press this button while recording video to add a HiLight Tag, which tells the GoPro App which moments to highlight in the editing tab of the App.

TIP: On-Screen Shortcuts are not available when using the GoPro App.

After filming, you can view, trim, grab a still photo, delete, and download the content from your camera's memory card. When looking at your media, you will see a low resolution preview which will appear to be poor quality. This is not the actual quality of the footage. If you plan on editing your photos and videos further using the GoPro App, you will need to save the photos and videos you want to use to your phone. We will cover saving your files and mobile editing using the App in Step 5.

QuiKSTORIES The GoPro App can also automatically transfer the most recent HERO files from your camera to your device to create an auto edit for you. 360 files cannot be used for an auto edit. This feature, called QuikStories, makes it easier than ever to share your most recent adventures. Learn more about editing Stories in Step 5- Editing.

When you finish using the App, turn off your camera by pressing the power icon in the top right corner of the App. You can also turn your camera back on using the App if the camera's WiFi is still enabled.

TIP: **Offloading Footage To A Computer.** If you want to skip ahead and offload your footage to a computer, there are a few ways to transfer your recorded files from your camera's microSD card (where they are stored) to a computer. Step-by-step instructions for transferring and organizing your files are provided at the beginning of Step 5.

Now that you've got your camera up and running, let's go to Step 2 to learn about the modes and settings.

STEP TWO
THE SETTINGS
Choose Your Settings to Get the Shot

When it comes to capturing unforgettable moments with GoPro® Max, the options are endless. GoPro Max is a powerful little 360 camera, packed with options for creating mend-bending videos and photos. Because Max is such a powerful recording tool, there are lots of setting options to choose from! The **biggest factor to recording those unforgettable moments is setting up your shots correctly**. To a new 360 camera user who may not yet realize the full potential of the footage you are about to capture, the setting options may be a bit hard to filter through. In this step, we will break it down to give you the simplified guide to GoPro Max's settings and modes so you can learn which recording options to use and when.

As you begin to unlock the power of your new 360 camera, it's important to realize that everyone has different tastes and interests. Some of you may love editing high quality videos on a computer, while others may prefer mobile editing for social media. Some of you may love the spherical 360 look and some of you may prefer a more traditional look for your photos and videos. Whatever your pleasure, **we will give you the knowledge you need to customize your GoPro Max to your tastes** so you can take your footage to the next level of amazing!

In both 360 and HERO mode, there are **three main modes; Video, Photo and Time Lapse**. Each one functions slightly differently so we will approach each one as its own group. The fourth section in this step highlights some of the general camera settings available in the Preferences menu to customize your filming experience.

Because there are a lot of setting options available on Max, explaining the settings is the most technical step. Once you get through this first step, the rest will be a breeze. Just try to get a basic understanding of the main settings and the rest will fall into place. **So, let's get into the art of capturing those magic moments.**

NOTE: Make sure your camera is running firmware version 01.50 or higher so that the following information matches your camera's settings.

360 VS HERO MODE

As we touched on briefly in Step 1, GoPro Max offers two styles of recording photos, videos or time lapses- 360 or HERO mode. The first, called **360 Mode, records a full 360 degree sphere**. The second mode, called **HERO Mode, records a more traditional rectangular frame**. Let's learn a bit more about each one.

When 360 is selected, the camera **records with both lenses capturing a full 360 degree video or photo**. Because the camera records the full 360 view, this gives you lots of freedom to edit your footage later, either keeping it in 360 or editing the footage into a more traditional rectangular format.

In 360 mode, the camera actually records two separate videos. Each one is more than a full hemisphere (194 degrees). These two videos are then "stitched" together in-camera, creating a full 360 sphere photo or video. The overlapping areas disappear without losing any of the scene which opens up some amazing perspectives and mounting opportunities.

In HERO mode, Max **only uses one of the lenses to capture a traditional rectangular image**. Even though it doesn't record the full 360 view, HERO mode uses the super wide angle lens to produce amazingly smooth videos, immersive photos, and some other unbelievable features.

You will learn more about how to take advantage of 360 and HERO modes as we move through this book.

SETTING PRESETS AND ON-SCREEN SHORTCUTS

As we make our way through this section, we will give you the best recommended Setting Presets for each mode. These Presets can be changed and saved to your camera, so you are ready to film when life calls. The Presets can always be changed later as your personal preferences develop, but these recommended presets are a great starting point for high quality photos and videos. For each Preset, two On-Screen Shortcuts can be selected. Selecting an On-Screen shortcut adds an icon for your most commonly changed settings onto the Touch Screen. By the end of this chapter, you will understand how to use each one of the recommended shortcuts.

RECORDING VIDEOS

This section helps you understand the different **modes and settings when using GoPro Max to record videos.** Let's go through the following three steps to help you get the videos you dreamed of when you bought your Max!

1. First off, let's **learn about the two video modes.**

2. Next, we will walk you through the settings to help you **understand how each setting affects your videos.**

3. Then, we will **show you how to use the presets** to get the most out of your GoPro Max.

Just as a reminder, there are two ways to edit a Setting: *If you are on the main recording screen, you can* **hold down on the setting preset box** *to go straight into the settings for the current preset.*

Or, after selecting the Preset, **Tap the Pencil icon to the right of the preset**. *This opens up the Settings Dialog box. Any changes you make will automatically be saved to that Preset.*

1. VIDEO MODES (PRESETS)

First of all, let's talk about **the two ways your GoPro Max can function while recording video.**

When recording video with Max, there are two Capture Modes to choose from:

 360 VIDEO- **The Highest Quality Full 360 Videos with tons of potential for creative editing!**

When the Sphere Icon is showing in the bottom left corner of the Touch Screen, you are in 360 Mode.

Use this mode to record **stabilized high quality 360 videos**. In 360 Video Mode, your camera uses both the front and back lenses to **record a full 360 degree sphere**. 360 video has so many creative possibilities when you go to edit your videos.

Besides the fact that this mode records full 360 video, the camera operates like any other video camera. Press the Shutter Button to start recording video. Press the Shutter Button again to stop recording.

360 video doesn't offer a lot of extra frilly features because the magic mostly happens when you go to edit your videos. There

are some advanced settings and filming tips that you will learn to improve the initial raw video out of the camera. We will cover these advanced settings as we move through this step, as well as mounting and filming tips in the next two steps.

Even though the editing potential for 360 video is almost limitless, starting out with high quality video is key.

360 Video records a full 360 spherical video, offering the most editing flexibility.
Video recorded in 360 Video Mode with Max mounted on the Max Grip.

• 360 video files from Max end in the filename ".360". When you record a 360 video, Max will also create two other files with the same name ending in .THM and .LRV. THM files are used for creating the video thumbnail. The LRV is a low resolution version, which is used for previewing videos using the GoPro App.

For now, copy these presets to make changing key settings as easy as possible on the go.

Match your 360 Preset to the following settings:

This preset is used to record the highest quality 360 video.

360 VIDEO MODE PRESETS
<u>Main Video Settings to Change:</u>
Mode: 360
RES / FPS: 5.6k and 30 FPS
<u>Protune Settings to Change:</u>
ISO Max: 400
Sharpness: Medium
360 Audio: 360+Stereo
Wind Reduction: Auto
<u>On-Screen Shortcut Settings:</u>
Upper Left: Color
Upper Right: ISO Max

• To record 360 video for slow motion, switch over the RES | FPS setting to 3k at 60 FPS. Or you can use the super slow motion editing trick we will show you in Step 5 if you recorded in 5k at 30 FPS.

• If the light gets dim, use the ISO On-Screen Shortcut to raise the ISO to 800 for better low light filming.

• Videos recorded in 360 Video Mode are automatically stabilized and there is no option to turn this off (not that you would want to).

⬛🎥 HERO VIDEO- Traditional Rectangular Format Video with the widest range of settings and the most compatibility with devices.

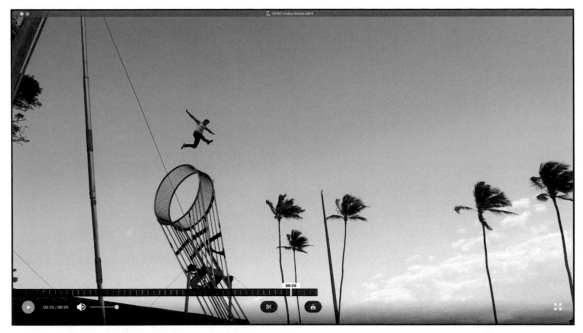

HERO Video Mode records a traditional rectangular video, offering the extra recording features.
Video recorded in HERO Video Mode with Max handheld on the Shorty.

The second video option is to **record a more traditional rectangular frame using HERO Video Mode**. In HERO Video Mode, Max records are relatively small frame (1080p) using just one of the lenses.

When the icon in the bottom left corner of the Touch Screen shows a GoPro Camera Icon, you are in HERO Mode. Simply use the "Switch Lens" icon ⟳ *to select your lens and start recording.*

In HERO Mode, the camera only records what is shown on the Touch Screen. Even though you can't expand out of that recorded frame when you edit, this mode offers tons of powerful recording features that are not available in 360 video. Let's go over some of these extra features now since they do not apply to 360 video.

First copy this setting preset for a good starting point in HERO Mode:

HERO VIDEO MODE PRESETS
Main Video Settings to Change:
RES / FPS: 1080p and 60 FPS
Lens: Max SuperView
Max HyperSmooth: On
Clips: Off
Horizon Leveling: (Turn On using On-Screen Shortcut)

Protune Settings to Change:
Bit Rate: High
ISO Max: 400
Sharpness: Medium

On-Screen Shortcut Settings:
Leave As-Is

• For 1080p output, this preset has everything you need. This Preset will capture super smooth videos with a level horizon.

• Use the On-Screen Lens Shortcut to switch lenses for different style shots.

TIP: You can always reset the presets to factory settings if they get mixed up in Preferences>Reset>Reset Presets.

HERO VIDEO MODE FEATURES

FOV DIGITAL LENSES- previously known as Field of View (FOV)

Digital lenses are GoPro's term for field of view, which is more common throughout the industry. Changing digital lenses **affects the zoom, cropping and fisheye effect**. It's important to remember that they are merely "digital", obviously GoPro Max does not have multiple physical lenses.

Digital lenses are definitely one of the most useful On-Screen Shortcuts to have available because you can easily swap lenses for a different look. When you tap Digital Lenses using the On-Screen Shortcut on the Touch Screen, you can scroll through the digital lens options for a live view of how the different lenses affect your shots. Once you understand the digital lens options, you can select the lens that best captures the perspective you want.

In HERO Mode, GoPro Max offers four digital lenses to choose from- Max SuperView, Wide, Linear, and Narrow. The four lenses are available in all of the HERO Mode video setting options.

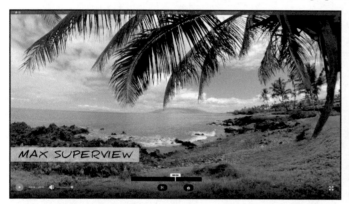
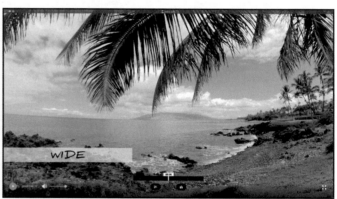
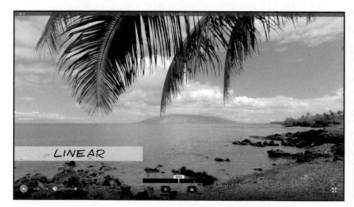
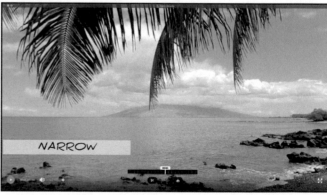

As you can see, changing lenses creates a different look, even when filmed from the exact same location. Max SuperView is the most pulled back with extra curvature around the edges of the frame. Wide is your standard wide angle GoPro lens. Linear creates a slightly more pulled back shot with straighter lines than Wide, while Narrow produces the most zoomed in shot with a reduced fisheye effect. All videos were filmed at 1080p @ 60 FPS.

Let's look at a quick comparison of the four digital lens options from widest to the most zoomed in:

MAX SUPERVIEW (13mm equivalent)

For close up body-mounted shots, in tight spaces

Max SuperView is a super immersive wide angle perspective that captures as much of the surrounding scenery as possible.

This is **great for up close or body-mounted shots** where you cannot get the entire subject in the frame. Max SuperView is also useful for dramatic landscape shots. Be aware that there is **distortion around the edges of the frame** when shooting in SuperView because it's such a wide angle shot. SuperView is **best for shots with the subject centered in the frame**, like paddling, biking or snowboarding.

• An "M" next to the video resolution on the camera status screen indicates that the Max SuperView lens is being used.

WIDE (16mm equivalent)

Point of view shots, equipment-mounted shots, expansive skies

Wide is the traditional GoPro perspective of the **actual optics** through the GoPro Max lens without any adjustments.

The Wide lens allows for some amazing perspectives, even when objects are extremely close to the camera. The Wide lens also creates some curvature around the edges of the frame (known as fisheye), which you will learn to work with in Step 4.

The Wide lens is a great lens to start with because captures a very wide perspective. Use the Wide lens as your standard lens and change lenses to Linear, Narrow or SuperView when needed to capture the perspective you want.

LINEAR (19mm equivalent) and NARROW (27mm equivalent) Lenses

Straighter horizon lines, good for real estate photography, architecture, portraits and recording family memories

The Linear lens was developed to reduce the curvature caused by the GoPro's wide angle fisheye lens. Linear uses framing adjustments within the camera to flatten the "bubble" in the middle of the wide angle shots. This results in **straighter horizon lines through the middle and less curvature around the edges of the frame**. Since your camera is still filming through a wide angle lens, you may notice some stretching effects at the edge of the frame.

Linear does not capture as wide of an angle as the Wide lens and can be used to film more traditional-looking video shots. Linear is especially useful for real estate videos, where viewers want a more realistic preview of a building.

The **Narrow lens is the same as the Linear lens zoomed in about 1/3**. Since you may notice a decrease in image quality when using the Narrow lens, the best recommendation is to film using the Linear lens and zoom in slightly when you edit if the video quality allows.

The drawbacks of the Linear and Narrow lenses are that you lose a bit of that GoPro-style immersion we are used to seeing.

 HORIZON LEVELING

This is one of those features that will blow your mind at first. Once you start recording, **Horizon Leveling uses the full hemisphere from the lens your are recording with to keep the horizon level.** Even when your camera is rocking side to side or even rotating in a full circle, the horizon will stay level. Try it out yourself by turning it on and rotating your camera while recording, but keep the lens pointed in the direction of your subject. It's amazing and offers so much potential for shots like you've never seen before!

If you want to see the actual camera's movement, turn off Horizon Leveling. Use the Onscreen Shortcut to turn this on and off as needed.

 CLIP

When creating videos for sharing on mobile devices, the Clip feature gives you the power to **automatically create 15 or 30 second clips**. When you select one of these designated times, the video automatically stops recording after the set time. The progression of the video is indicated by a red line that goes around the screen. This red timeline can be used to plan out short clips to get the content you want at just the right time. Unless you want to record only a 15 or 30 second clip, make sure this feature is turned off.

"Clip" is turned off by default, but you can add it as an On-Screen Shortcut. Once it's activated, to record a "Clip", tap the icon on the Touch Screen and select 15 or 30 seconds. Press the Shutter Button to record your clip and the clip will automatically stop recording after the selected time. You can stop recording a Clip early by pressing the Shutter Button again.

MAX HYPERSMOOTH VIDEO STABILIZATION

While the digital lenses affect the view, Max HyperSmooth affects the motion. GoPro cameras can easily be carried with you for an easy way to record life's great (and simple) moments. That handheld-style of filmmaking usually results in bumpy footage that's hard to watch. But not with Max HyperSmooth's gimbal-like stabilization! When used with Horizon-Leveling, GoPro Max quite possibly produces better results than a gimbal- pretty amazing!

How does it work? **Max HyperSmooth uses the area outside of the frame to keep the video steady,** so as the camera rocks and rolls, the frame rotates like a gyroscope to stay steady. Since Max uses an extremely wide-angle lens, the camera has a lot of area outside of the frame to work with, resulting in super smooth videos.

An easy way to see the effects of stabilization is to hold your camera in a fixed direction and then move it side to side. The video movement will be much less noticeable than your actual movement. Once you get out there and start filming, Max HyperSmooth is going to make this your favorite handheld camera ever.

HyperSmooth setting options are available in the Setting Presets menu. An On-Screen shortcut can also be added for HyperSmooth Boost. This makes it easy to toggle between Boost and regular HyperSmooth stabilization.

Tips For Getting the Most out of Stabilization:

GoPro Max gives you gimbal-like stabilization without actually using a gimbal. Because your camera films stabilized shots but also needs the freedom to move-to pan, tilt, etc.- you can **give your camera's stabilization a helping hand by following these tips:**

• Stabilization needs an adequate amount of light to work properly. In daylight and in most outdoor scenes, stabilization works perfectly. However, **in low light situations**, such as in the evening or dark indoor environments, the level of stabilization applied will automatically be reduced. In low light, use the ISO Max On-Screen Shortcut to raise your maximum ISO to 800 depending on the lighting conditions (see more about ISO in Protune Video Settings which is coming up). Stabilization can create strange effects and ruin your low light shots, so if it's an important shot in minimal light, test it out first or turn it off.

• No gimbal or stabilization can totally compensate for erratic movements, so even though the stabilization will smooth out shaky shots, **try to hold your camera steady** and **use smooth movements** when possible.

VERTICAL VIDEO

GoPro Max offers the option to **record video in a Vertical Orientation**. Although traditional video has always been recorded in a landscape format, vertical video formats have risen in popularity out of the simple fact that we typically hold our phones in a vertical position.

To give users the option of recording vertical videos in-camera, GoPro Max can be set to rotate to a vertical format depending on the camera's orientation. Touch Screen items also rotate when the camera is rotated vertically.

If you like to record vertical videos, keep this feature enabled. However, if you prefer **to record videos in the traditional Landscape orientation**, *set your camera to Landscape in the Touch Screen settings menu under Preferences>Touch Screen>Orientation. You can also use the Orientation Lock on the Dashboard to lock the Orientation.*

If you accidentally record vertical videos, you can easily rotate them in post-production, but it's easier to turn this function off if you don't need it.

The vertical orientation also offers a unique opportunity to compose your videos far different than in the past. Some video shots can really benefit from the taller video frame for viewing on phones and tablets. Of course, 360 videos can be edited into any format, both horizontal and vertical.

2. VIDEO SETTINGS

THE BIG 2 VIDEO SETTINGS

Now that we have covered the video modes, we will cover the big two video settings. These first two setting options are the most important when it comes to selecting the right settings for your videos. They determine the quality, playback speed and framing of your video. These are basically **the physical attributes of the video you are recording**.

Selecting the best video settings for your moment will help you achieve the shot you want and give you the freedom to edit your video how your mind envisions. Whether your camera is mounted near or far, you are filming fast action or scenery, full sun or low light, the settings you choose here will produce high-quality footage to work with when you edit your videos. Understanding how these settings affect your videos will help you take full advantage of the best Max settings for a specific scene or activity.

These two settings are adjusted using the RES/FPS setting option in the Settings menu.

1) RESOLUTION

RES stands for resolution and this determines the actual size of your video image. Depending on how you plan to share your video, this can be one of the most important settings.

When choosing settings, you will see the file size displayed like this: 5.6k-30, which is also sometimes written like this: 5.6k @ 30FPS. The first number before the dash ("5.6k" in 5.6k-30) tells you **the size of the video image**. So, why does resolution matter?

In simple terms, a video "image" is made up of a bunch of small dots, called pixels. A video comprised of many pixels creates a larger, more detailed image.

The resolution name (5.6k, 3k, 1440p or 1080p) defines how many lines of pixels exist within the video frame. **The higher the number, the better the quality**. As you can see in the chart below, a 5.6k video is much larger than a 3k video and produces more detailed video.

In 5.6k and 3k, which are the 360 video resolution options, the names refer to the width of the image in pixels. For example, a 5.6k video is about 5600 pixels wide (after stitching).

In the available HERO Mode resolutions (1440p and 1080p), the number refers to the vertical height of the image being recorded. For example, in 1080p, the image is 1,080 pixels high. (The "p" after the number stands for "progressive scan," which, without getting too technical, creates smoother, more detailed video).

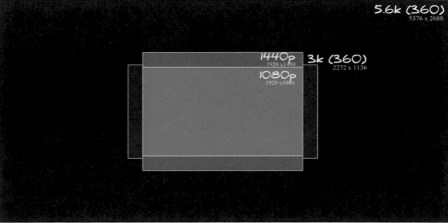

This chart shows the relative pixel dimensions (width x height) of the video resolutions available on GoPro Max.

The Lowdown

360 Video Resolutions

• 5.6k 360 video is used for regular speed playback. This is the highest resolution video available on Max. Reframing 5.6k video typically results in a 1080p video.

• 3k 360 video is a much lower resolution (2272x1136), but it offers higher frame rates (coming up next) so you can play back the video in slow motion. Reframed 3k 360 video typically results in 720p rectangular videos.

HERO Mode Video Resolutions

• HERO Mode only offers two video resolutions- 1440p or 1080p. *When you tap RES/FPS in the settings, both Aspect Ratios are available on one screen. The numbers 4:3 next to 1440p resolution denotes the Standard 4:3 resolution.*

The main difference between the two is the shape of the video frame, known as Aspect Ratio. 1080p (1920x1080) is a Widescreen 16:9. 1440p is a Standard 4:3 resolution, which is the same width as 1080p but taller. You can see a comparison of the two below. **1440p can be used for point of view (POV) shots** when your camera is mounted close to you or **any time you want more of the scene in your frame**. 1440p is typically cropped to 1080p when you edit.

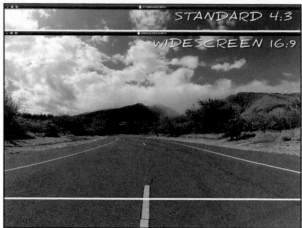

*The image above shows how the **Widescreen 16:9** shot in the middle crops out the top and bottom of what's captured in a **Standard 4:3 frame**.*

TIP: For TV's, computers and online video (YouTube, Vimeo, etc.), you will most likely want to display your footage in a 16:9 Widescreen Aspect Ratio. For Widescreen videos, footage filmed in a 4:3 Aspect Ratio will need to be edited to fit a widescreen frame. If you need to film in a 4:3 Aspect Ratio for a particular scene, you can crop or scale it when editing to make it match.

2) **FOV** FRAMES PER SECOND (FPS)

If you want to play your videos back in slow motion, selecting the right frame rate is how you make it possible. The number after the dash in 5.6k-30 (30 in this example) tells you how many frames are being recorded each second. Frames Per Second (FPS) refers to **the number of individual frames (similar to photos) the camera records each second**.

A video typically needs to play a minimum of 24 frames per second for the video to flow smoothly. Anything less than 24 frames per second and the eye can begin to distinguish individual frames (almost like a quick slideshow). When you record video at 24 frames per second and play it back at normal speed, this looks great. But when you record at a higher frame rate, say 60 frames per second on Max, you can slow that video clip down to play 24 frames per second, which effectively makes that clip take 2.5x longer to play, giving it a slow motion effect.

Capturing footage at a higher frame rate (higher number FPS, such as 60FPS) is better if you may want to play back your footage in slow-motion, which a lot of action clips need to slow down the fast action. All of the video frame rates play back at regular speed by default, but with a higher frame rate, you have the option to edit it to play back in slow motion.

The important thing to remember is that as the frame rates increase, the available resolution is lower and advanced settings typically decrease, which is why 360 slow motion video is only available in 3k @ 60FPS. All frame rates are available in 1440p/1080p since it's a relatively low resolution and not overly demanding on the camera. **Finding the right balance of resolution and frame rate for your scene is the secret to getting the footage you want.**

NOTE: Many film and video makers display their footage at 24FPS because the on-screen "look" most closely matches film. Other professional video producers use 30FPS as a standard frame rate, arguing that 24FPS is only useful if you are transferring digital footage to film, which never really happens. 30 frames per second is better suited for viewing on televisions and computers. If you want to maximize the slow motion, use 24 frames per second, but **we will use 30 frames per second for the video editing tutorials in this book.**

The LowDown

• **360 VIDEO: Only select 3k @ 60FPS when you want slow motion.** The reduced resolution gives you less editing freedom but can be worth it when you want slow motion.

• **HERO VIDEO:** In HERO mode, **record everything at 1080p/1440p @ 60FPS** since it still has all features available and is compatible with all devices. You can reduce the frame rate later if desired.

> **TIP:** **ANTI-FLICKER- PAL (50Hz) vs. NTSC (60Hz):** Most countries outside of North America use a format for televisions called PAL instead of NTSC. If you are in a country that uses PAL and your camera is set to shoot at PAL, the available frames per second rate will be different while using certain settings. Settings with 24 or 30FPS will be available at 25FPS in PAL. 60FPS in NTSC will be 50FPS in PAL.
>
> If you are recording videos to upload to YouTube, you can use either NTSC or PAL. NTSC is a better choice because it offers a higher frame rate (60FPS vs. 50FPS) for slow motion. However, when filming under artificial lights (e.g., streetlights), the lights may flicker when using NTSC in a PAL country. *PAL (50Hz) or NTSC (60Hz) can be selected using the Preferences>General>Anti-Flicker setting.*

TIPS FOR CHOOSING RESOLUTION AND FPS

You can select the right settings for your shot (slow motion, regular speed, etc.) by choosing Resolution, and FPS.

When choosing the best combination of Resolution and Frames per Second, consider the following tips:

TIP #1: Use the highest resolution that suits your needs. It's always better to reduce a file size when you edit rather than increase it. In 360, 5.6k gives you the highest quality video files to work with.

TIP #2: When you edit your videos for slow motion during editing, **the audio speed will also be affected**. Just because you record at a faster frame rate doesn't mean you must use the clip for slow motion. You can play a clip recorded at any frame rate in regular motion video. If you play a video recorded at any frame rate to play back in regular speed at 24FPS, any extra frames will be removed without affecting the audio.

TIP #3: HEVC VS. H264. GoPro Max 360 video resolutions use a compression method (codec) called HEVC (High Efficiency Video Coding or H.265). This is just the method of compressing the large video files into a smaller file for storage. As video resolution increases, HEVC is a better compression standard for the larger files, which is why it's used for GoPro Max's 360 video settings.

HEVC is a relatively new codec still being implemented into our computers and phones. HEVC files are compatible with many of the more recent devices. If you are using a newer model computer (some 2015-2017 Apple or 2017 Windows computers), make sure you are running the latest operating system. Depending on your computer model, on a Mac, High Sierra OS (and newer) can view these files, and on a PC, Windows 10 is compatible. Newer iPhones (7 and newer) and some Android 5.0+ devices (such as the Galaxy S7 and newer) are compatible with the HEVC codec.

Older computers, cell phones and tablets will most likely not be able to view these files. Since not all devices are compatible with HEVC, GoPro kept the option to record in the older H.264 codec for HERO Mode video settings. If you are using an older phone, tablet or computer that is not compatible with the relatively new compression, *the option to use H.264 for HERO Mode settings can be selected in Preferences>General>Video Compression.*

If you are not able to view HEVC files on your computer or phone yet, the best option is to import the videos to your computer and then convert the videos using GoPro Player (MAC) or GoPro Exporter (PC), like we show you in Step 5. You can then choose an output other than HEVC. This allows you to use the highest performance settings available on GoPro Max.

ADVANCED VIDEO SETTINGS (PROTUNE)

These advanced video settings are available in 360 Video and HERO Video modes. The following Advanced Settings provide more ways to improve the quality of your videos, and most of these settings are available as On-Screen Shortcuts.

PT PROTUNE

• Protune is an advanced group of settings that gives you **fine-tuned control over your video quality**. It is mostly aimed towards experienced image-makers (which you will be soon) who want to affect the look and quality of their videos by adjusting manual settings. Now that you are learning how to maximize your camera, you should definitely use these settings. You already changed the most important ones in the Settings Presets.

• Protune settings in photo and video modes are slightly different. Protune settings must be set individually for each Setting Preset, but these are important settings to instantly improve your video quality.

Go Deeper

Advanced Protune Settings

You can select and change the following Protune setting options within each Preset. These recommendations are for the Video Presets. As you gain experience, you can customize these settings to your particular tastes and adjust them for changing lighting and action.

Start with the **following recommended settings:**

BIT RATE: High (Only available in HERO Video Mode)

By default, the bit rate is set to Low, but changing this setting to High instantly improves the quality of your video. Bit Rate refers to the amount of data being processed per second and the High setting allows more information to be recording, resulting in better quality video.

SHUTTER: Auto

The Shutter setting defines how long the camera's shutter stays open for each video frame. Auto is typically your go-to for Shutter settings. But, if you want to lock exposure to keep the Shutter open for a specific amount of time per frame, you can select a Shutter setting. A manual Shutter setting creates constant exposure throughout a video that will not adjust as lighting changes. Using Manual Shutter is not a good option in inconsistent lighting. In bright light, you will need to use a fast shutter with a low ISO to avoid overexposure. A faster shutter (1/240, 1/480, 1/960) gives you sharper images with less blur. A slow shutter (1/30 or 1/60) can be used to create motion blur (a more cinematic look) but needs a stable mounting position to keep foreground objects in focus. You can see a live view of how the Shutter speed affects exposure by previewing the Live View on the Touch Screen.

Available shutter speeds, which vary based on the frame rate, are 1/30 sec, 1/60 sec, 1/120 sec, 1/240 sec, 1/480 sec, and 1/960 (60FPS only). If you record at 60 FPS, the minimum shutter time available will be 1/60 sec. At 30 FPS, 1/30 will be available. These are the slowest shutter times possible to capture enough frames to match the selected frame rate. Not all Shutter speeds are available for every frame rate.

Because the available shutter speeds are typically slower than the Auto shutter speed, your shots may be overexposed in bright daylight.

EXPOSURE VALUE COMPENSATION (EV COMP): 0

EV Comp tells your camera to make the footage brighter or darker than the exposure reading from the camera. You only need to

adjust this manually if you are going for an overexposed or underexposed look, or if your camera is taking an inaccurate reading of a scene and you want to manually override the exposure reading. For example, if you are filming a scene with bright and dark areas, you can adjust the EV to +1 to brighten the scene one stop. Exposure Control (which you will learn about in this step) is an easier way to do this, but it's useful to be aware of how to use EV Comp.

WHITE BALANCE: Auto

White balance refers to the color temperature- a lower number creates a colder (bluish) look and a higher number creates a warmer (more yellowish) tone. Unless you have experience setting white balance, or have a very specific need, Auto White Balance is your best option.

ISO ISO MIN + MAX: 100 MIN / 400 MAX

To set a specific ISO (100 for example), set the MIN and MAX to the same number.

ISO is a very important setting that affects the quality of your videos. The ISO determines the sensor's sensitivity to light. If you want to record the cleanest, noise-free video possible, tap into the lowest ISO available on your camera, which is 100 ISO. Because a low ISO is less sensitive to light, it absorbs light more slowly resulting in high quality video without any noise.

As a general rule, keep your MIN ISO at 100 so the camera can record at 100 ISO when the light is bright enough. Set the MAX to 400 and raise it to 800 for cloudy or shady conditions. Try to stay below 1600 ISO max, even for low light conditions. A high ISO (3200-6400) absorbs light more quickly and will allow you to record twilight or night video, but the video will be full of noise and appear to be low quality. Noise is all those little specks that make your footage look grainy like you may have noticed in videos you've recorded at night. Noise can be corrected to a certain extent when you edit, but it's best to start off with high quality, noise-free video.

SHARPNESS: Medium

Sharpness refers to the amount of digital sharpness that is added to your footage in the camera after it is shot. A Medium amount of sharpness will make your footage look crisp, but not overly sharpened. Choose Low if you would prefer to sharpen the video in post-production.

COLOR: GoPro Color

GoPro Color adjusts colors to add vibrance and give your footage pop. GoPro really fine-tuned the color profiles in GoPro Max, making the raw videos ready to share without much color correction. To take advantage of these adjustments, choose GoPro Color. Flat produces videos with a more even tone if you prefer to adjust colors from scratch when you edit in post-production or if certain shots look over-saturated. If some of your shots filmed in GoPro Color are oversaturated (too much color), you can also reduce the saturation when you edit your clips.

Both videos shot in 360 Video on GoPro Max at 5.6k @ 30 FPS. Notice how the colors are more vibrant when GoPro Color is used.

360 AUDIO: 360+Stereo (360 Video Mode Only)

Take advantage of the six microphones on Max to record audio in full 360 spherical audio. This will also record a stereo track. You can also choose to record just a stereo audio track.

MICS: Match Lens (HERO Video Only)

When you select Match Lens, the audio will be recorded from the microphones on the same side as the lens you are using. We will talk more about the audio options in the Audio section in Step 4.

RAW AUDIO: Off (HERO Video Only)

When you turn on RAW Audio, your camera records a separate audio file recorded as a .wav, in addition to the audio on your video file. The audio track is saved with the same name as the video so you can locate the file on your microSD card and sync it to your video when you edit. Select Low if you want to make your own adjustments to the audio or High for a track that is already pre-processed.

WIND NOISE REDUCTION: Auto

This setting is used to override your GoPro Max's audio intelligence, which automatically switches between trying to reduce wind noise and Stereo recording. If you are going to be in a setting **where wind is not a factor** and you want to make sure your camera constantly records audio in Stereo mode, **turn this Off**. Also, if you want to record ocean sounds, set this to Off to prevent the camera from trying to correct the natural sounds. But in general, leave this on Auto and let the camera's audio intelligence decide when to reduce wind noise while keeping the audio clear.

3. HOW TO USE THE VIDEO PRESETS

• Use **360 Video Mode when you want the most creative editing freedom.** Stick to 5.6k @ 24 or 30 frames per second for the highest quality footage. In Step 5, you will learn how to reframe your videos to a more traditional look or create unique 360 shots. You can also pull impressive still photos from the high resolution 360 video. For mobile edits when you want easy slow motion, step it down to 3k @ 60 frames per second.

• Even though HERO Mode does not record in 360, with the extra settings available, this mode is not to be overlooked.

Choose **HERO Video Mode when you want to take advantage of in-camera Horizon-Leveling and Max Hypersmooth stabilization**. Keep it at 1080p @ 60 frames per second so you can slow it down 2x when you want to. HERO Video Mode's variety of lens options allow you to choose your settings for videos that are ready to share with less editing than spherical 360 videos.

TAKING PHOTOS

GoPro Max offers a variety of photo modes to help you achieve amazing photos. There are a few of ways you can set up your camera to take photos, from taking a single 360 photo to taking an automatic panoramic photo. The 360 photo-taking capability of this camera is top-notch, and that is great motivation to understand the various shooting modes.

This section will help you understand when and how to use the three photo capture modes when using your GoPro Max to take photos. Since each photo mode is used for a different purpose, we will cover each one in depth and provide the recommended Setting Presets for that mode.

We will then look a little deeper into the more general photo setting options and explain how they can improve your photos.

Time Lapse Modes also offer a few settings that allow you to take photos as well, which we will cover in the next section.

PHOTO MODE

The Capture Modes within Photo Mode are designed for you to operate your GoPro Max like a standard point and shoot camera, where pushing the Shutter Button tells your camera to take a photo.

THE THREE CAPTURE MODES

Recommended Setting Presets will be given with each capture mode so you can set your camera presets to these settings. You can use these Presets as a starting point and modify them as your knowledge grows and your needs change. The following three Capture Modes are available within Photo Mode:

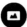 1) **360 PHOTO-** High Resolution 360 Spherical Photos

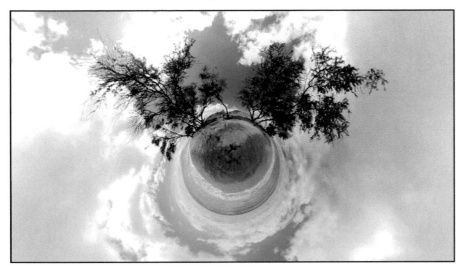

Photo taken with GoPro Max camera at WIDE FOV using the 360 Photo Preset. The camera was placed on the ground on the Max Grip by GoPro. The example shown is reframed into a "Tiny Planet" photo, but there is so much more you can do with your spherical 360 photos like you will see in Step 5.

360 Photo is the 360 photo mode **for creating spherical 360 photos using both of Max's lenses**. When you press the Shutter Button (or when you say, "GoPro Take A Photo"), your camera takes one photo. Spherical 360 photos are 16.6MP (5760px x 2880px).

360 Photo Mode is such a fun, creative photo mode with tons of possibilities ranging from artistic to entrepreneurial. First of all, when mounted correctly (we will show you how of course), the mount disappears creating a magic floating camera effect. Secondly, the photos can be reframed for a wide array of look from a single photo. You can extract a traditional looking photo or zoom all the way out for tiny planet photos. This is also the mode to use when creating panoramic photos for virtual tours.

When looking at the thumbnails of these photos in your files, the full photo looks odd, like shown below. Once you open it with the GoPro App or GoPro Player, you can reframe the photo as desired. We will cover more reframing styles in Step 5.

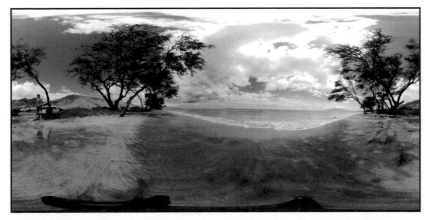

The photo file as you will see in the thumbnail, or if you decide to edit using Photoshop or another editing program besides GoPro's Apps.

• When mounted on a pole, use the self-timer (set to 3 or 10 seconds) or voice control to reposition yourself further from the lens or

to disappear out of the shot completely. We will teach you more tricks for composing your 360 photos in Step 4- Capture the Action.

• When taking photos in Single Photo Mode, hold your camera steady and keep your subject around the middle of the frame for the least distortion. You can also rotate your camera 90 degrees to take vertical photos.

Start with the following Presets for the highest quality photos in 360 Photo Mode:

360 PHOTO MODE PRESETS
Protune Settings to Change:
ISO Max: 200
Sharpness: Medium
On-Screen Shortcut Settings:
Upper Left: Timer
Upper Right: ISO Max

How To Use The 360 Photo Preset

• Because the camera captures the entire scene in the photo, use the Timer to press the shutter and then move away from the camera.

• The Max ISO Shortcut is available for better control of image quality. Keep the ISO as low as possible for the highest quality photos but raise it if the lighting is dim.

> **TIP: 360 Photos from video.** Pulling still photos (called frame grabs) from your 360 videos is easy to do using the GoPro App on your device. Pulling still images out of video taken in 360 Video mode results in high quality still frames which compare to the quality of the photos taken in 360 photo mode. Plus, in 360 Video Mode, you can record 30 frames per second for long periods and pull still photos from the video. Keep that in mind the next time you want photos and videos simultaneously.

2) HERO PHOTO- Easy-to-share traditional photos using one lens.

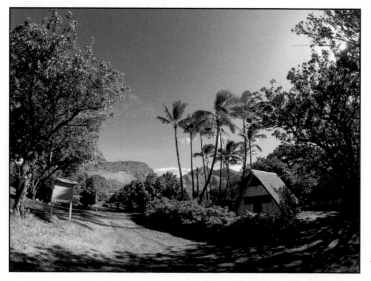

Photo taken with GoPro Max camera with the WIDE lens in HERO Photo Mode.

HERO Photo mode **takes a standard 4:3 Aspect Ratio photo through just one of the lenses** with the press of the Shutter Button or by using voice control ("GoPro Take A Photo"). The photo is 5.5 MP (2704px x 2028px), which is relatively small compared to many cameras and even smartphones. You will probably rarely use this mode as it's better to take a 360 photo and pull a traditional photo from that. HERO Photo mode is **best used when you want to frame your photo for quick sharing.**

As an added feature, if you hold down the Shutter Button, your camera will continuously take a sequence of up to 30 photos. This feature is useful when you want to capture spur of the moment bursts of action. Holding down the shutter button gives you the freedom to snap a sequence anytime. You cannot use voice control to continuously take photos in this mode.

HERO Photo mode also has several beneficial features, such as:

Horizon Leveling (HERO Photo Mode Only)- Set Horizon Leveling to On in the Settings dialog when you want a level horizon, no matter how you are holding the camera.

FOV Digital Lenses

HERO Photo mode offers two digital lenses to choose from- Wide or Max SuperView. In HERO Photo Mode, the two digital lenses affect zoom and cropping. Photos taken in photo modes are always captured at a 4:3 ratio and photos taken in Wide or Max SuperView result in a 5.5 MP photo. The Wide and Max SuperView Lenses in Photo Mode are similar to video lenses.

When selecting a lens, you can see a live preview of your composition on the Touch Screen as you change lenses. This can be helpful for many shots where you are framing your composition.

• You can also get a similar look to a zoomed in photo by cropping a Wide field of view photo and upsizing it if you need to. (We will get to that in Step 5-Creation).

Start with the following Presets for the highest quality photos in HERO Photo Mode:

HERO PHOTO MODE PRESETS
Protune Settings to Change:
ISO Max: 200

Sharpness: Medium

On-Screen Shortcut Settings:
Upper Left: Lens
Upper Right: ISO Max or Horizon Leveling

How To Use The HERO Photo Preset

• The Digital Lens On-Screen Shortcut is very useful for photo modes to quickly change your composition between the Wide and Max SuperView lenses. Max SuperView is an excellent lens for photographing mounted action shots.

• For the Upper Right Shortcut, choose between ISO Max or Horizon Leveling. If you think you will keep Horizon Leveling turned on, place the ISO Max Shortcut here for a quick and easy way to adjust the ISO based on lighting conditions.

3) POWERPANO- Automatic 270 Degree Panoramic Photos

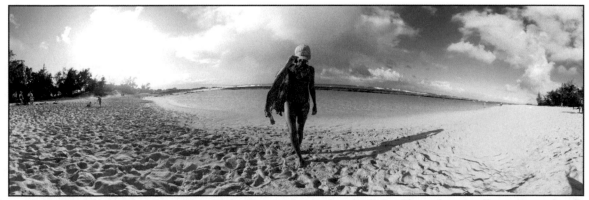

Photo taken with GoPro Max camera in PowerPano Mode. Max was mounted on the GoPro Shorty for a small, easy to use handle that easily fits in your pocket. Max ISO was set to 200 for a noise-free photo since the photo was taken in full daylight.

PowerPano makes it **easy to capture high quality, 270 degree panoramic photos** without even moving your camera. Pano photos are a creative way to add a twist to your photography.

When you press the Shutter Button, Max creates a photo which wraps beyond the edges of whichever lens you choose, creating a 4320px x 1440px pano photo. A pano photo is not to be confused with a 360 panorama. A PowerPano is not a 360 photo and cannot be orbited around. Since a PowerPano is just a section pulled out of the sphere, what appears in the photo is all that is recorded.

Also, **Horizon Leveling is automatically turned on in PowerPano Mode** so Max will automatically adjust the framing to capture a level horizon.

If you choose the front lens, you can take the full pano and won't show up in the photo. Be aware of your shadows. With such a wide pano view, your shadows are likely to appear on one side of the photo or the other.

For selfie panos, of course, select the back lens which is facing you.

Start with the following Presets for the highest quality photos in PowerPano Mode:

POWERPANO MODE PRESETS
Protune Settings to Change:
ISO Max: 200
Sharpness: Medium
On-Screen Shortcut Settings:
Upper Left: Self-Timer
Upper Right: ISO Max

How To Use The PowerPano Preset

• Use the ISO Max On-Screen Shortcut to adjust the Max ISO based on lighting conditions. For low light scenes, bump it up to 800, but try to keep the ISO at 400 or lower. 100-200 ISO will produce the cleanest shots.

OTHER PHOTO SETTINGS

Now that you understand the three unique ways to use GoPro Max to capture photos, these setting options can improve your photos even further. These settings, as well as others can be customized as On-Screen shortcuts.

The following Settings options can be changed using the On-Screen Shortcuts (when available) or in the settings dialog for each Preset.

SELF-TIMER

In photo modes, self-timer can be **set to 3 or 10 seconds** which makes it easy to **capture the perfect selfie, scenic shot or 360 Pano without any shake**. Self-timer is also useful to give yourself a few seconds between pressing the Shutter Button and checking your composition before the camera actually takes the photo.

When taking 360 photos, the self-timer is really useful for moving your hand away from the camera or exiting out of the frame completely. The delay also allows you to stabilize the camera before taking the photo, preventing camera shake.

Use the countdown timer to time your photos perfectly or to disappear from view.

To use Self Timer, set the Self-Timer in the Settings dialog or add it as an On-Screen Shortcut for the camera preset you are using. (The Timer On-Screen Shortcut is on by default in 360 Photo and PowerPano, but it can also be added to HERO Photo if desired.)

Once the On-Screen Shortcut is available on the Touch Screen, press the Self-Timer Icon and select your desired timer time. When you take a photo by pressing the Shutter Button, the self-timer begins counting down with the countdown time indicated on the Touch Screen.

 PROTUNE PHOTO SETTINGS (available in all Photo modes)

Some of the Protune settings for photos are the same as video settings, but there are a few differences.

The **following recommended settings** will help you understand how to use Protune to improve your photos:

Shutter: Auto

The Auto Shutter setting lets the camera select the right setting for your scene. However, by selecting a set ISO and Shutter speed, you can **manually set your exposure**. This is very useful for certain situations where you want a fixed exposure throughout a range of shots.

The Touch Screen shows a live view of how the manual Shutter setting will affect the photos, but it's still a good idea to take a few test shots to determine the correct exposure for your scene. A faster shutter setting (1/1000 sec. or 1/2000 sec.) lets in less light and will be most common for bright scenes.

The available Shutter settings are AUTO, 1/125, 1/250, 1/500, 1/1000, or 1/2000.

 Exposure Value Compensation: 0

If you notice that your images are consistently turning out over or underexposed, use this to fine tune the exposure to your tastes. Most photographers typically like to avoid overexposing photos too much because the details in the highlights are easily lost.

ISO Minimum: 100

You can always keep the minimum ISO at 100 to get the highest quality images when there is enough light.

ISO Maximum: 100 in daylight/400 in cloudy conditions

As mentioned in the section on video ISO, when there is enough light to keep the ISO down, you will capture less noise in your photos, resulting in cleaner, clearer images. When you really want the highest quality photos and are photographing in bright light, set the max ISO to 100. In low light situations, setting a max ISO of 400 gives your camera a range so photos will also come out sharp. For Photos taken in really low light scenes, you may need to use 800 ISO, but at 1600 or 3200 ISO, the photos will have a lot of noise.

 White Balance: Auto

As with video, Auto White Balance is your best option. White balance affects the color tone of your photos which can be fine-tuned using this setting option, but in general, the camera will produce an accurate reading of the correct white balance.

 Sharpness: Medium

Sharpness refers to the amount of digital sharpness that is added to your photos in the camera after it is shot. A medium amount of sharpness will make your photos look crisp, but not overly sharpened. You can easily sharpen your photos when you edit them if they need further sharpening.

 Color: GoPro Color

GoPro Color adjusts colors to add vibrance and give your photos pop. Flat will produce photos without as much color, but it does pick up more details in the shadows and highlights. If you use Flat, you will need to adjust the colors in post-production, which is easy using the mobile editing tips in Step 5.

TIME LAPSE MODES

Time lapse modes give you the option to **set an interval between photos or frames**, spacing out your sequence over a longer period of time. The main purpose of time lapse modes is to create a gap between moments, which when played as a video, makes time speed up. With the ability to reframe your videos after you've recorded them, GoPro Max is an **excellent tool for creating time lapses**, and there are several modes available to achieve the shot you want. And, as you will see, there are many ways you can use time lapse modes to create truly unique time lapse videos!

Time lapses make an artsy addition to a video. Learning the art of creating a visually-appealing time lapse takes some experimentation to get right, so don't be discouraged if you don't get a great one on your first try. Since time lapses are a new style of filming for many people, we will first cover some general time lapse tips and then move into the two different time lapse modes (along with recommended Setting Presets) for recording your time lapse.

The following general time lapse tips will help you with some of the more technical aspects of recording a memorable time lapse:

• For a still time lapse, use a tripod or **set your camera in a stationary position so the scene creates the movement instead of your camera**. Any movement of your camera will be intensified.

• TimeWarp Video mode (as you will learn about next) makes it **easy to film a stabilized hyperlapse, where your camera changes position throughout the clip**. There are lots of creative ways to film captivating hyperlapses as you will learn about in the TimeWarp Video section.

GoPro Max offers **two time lapse capture presets to choose from** depending on what you are filming and how you want to capture it. Both of the following options are available in 360 and HERO Time Lapse modes.

 TIMEWARP VIDEO- Stabilized Time Lapses for Action Shots and Hyperlapses

Video shot on GoPro Max in TimeWarp Video 360 Mode at 5x Speed. The camera was mounted on the Max Grip as a monopod and set on the ground. Reframing was used to rotate the view as the TimeWarp played. You will learn how to reframe in Step 5-Creation.

TimeWarp Video combines **time lapse video with stabilization** to produce smooth time lapse videos in-camera. Once you learn to use this mode and see the amazing time lapse videos you've created, this mode will be your favorite time lapse mode for quick and easy time lapses.

You can choose to record in 360 Mode for full spherical TimeWarp videos with infinite possibilities for creative edits. Or use HERO Mode to create TimeWarp vides that are ready to share in a traditional video format.

TimeWarp Mode offers shorter intervals between each frame than the standard time lapse mode, making this **the go-to mode for action time lapses and hyperlapses**. With the shorter intervals, **TimeWarp Videos require less recording time** to create stunning videos and the stabilization smooths out movements so it's almost fool proof. Of course, there are some techniques you can use to make these Time Warp videos even more eye-catching!

<div align="center">

TIMEWARP VIDEO MODE PRESETS
Main Video Settings to Change:
Horizon Leveling: On (HERO Only)

Protune Settings to Change:
ISO Max: 400
Sharpness: Medium

On-Screen Shortcut Settings:
Upper Left: Lens (HERO)
Upper Right: Speed (360 and HERO)

</div>

How To Use the TimeWarp Preset

• Use the Speed On-Screen Shortcut (which was added to the Presets above) to easily change speeds depending on your action. Learn more about the speeds in the following tips.

• In HERO Mode, use the Digital Lens On-Screen Shortcut to select the best lens for your time lapse. All four video lenses are available in HERO Mode.

Max SuperView and Wide are typically better for mounted shots, while Linear is a better option for landscape shots.

• Max ISO is set to 400 for sharp shots in a variety of lighting conditions.

• The WB is also set to Auto, but if you are filming primarily during daylight you might want to set it to 5500K to keep it consistent throughout the TimeWarp.

These tips will help you create the best TimeWarp Videos possible with Max:

• In TimeWarp Video, the Speed setting is used to set the interval between each frame of the video.

• Unlike standard video mode, the time counter **displays the playback duration of the video**, not the recording time.

• Speed settings in TimeWarp are displayed in their speed relative to real time. Available speeds are 2x, 5x, 10x, 15x, and 30x. Auto Speed is available only in HERO Mode. For example, at 10x Speed, recording for 10 minutes will result in a 1 minute time lapse video.

• In HERO TimeWarp Mode, the Auto Speed setting automatically slows down or speeds up your TimeWarp based on the action. This is a convenient option when you aren't sure what speed would best accentuate your journey. Because the speed will vary, you won't know exactly how long your resulting TimeWarp will be.

• TimeWarp speed settings are shorter than the intervals used in Time Lapse Mode.

• So how long will your TimeWarp Videos be? When you choose your speed setting on the Touch Screen, the camera gives you a similar reference as the chart below to use when selecting a speed. If you record for 5 minutes, here is how long your videos will be at each speed.

SPEED	VIDEO LENGTH (Per 5 minutes of Recording Time)
2x	2.5 minutes
5x	1 minute
10x	30 seconds
15x	20 seconds
30x	10 seconds

• In HERO TimeWarp, an exciting new TimeWarp feature on GoPro Max is the ability to **shift your time lapse over to regular speed video** by pressing the Tap To Real Speed Button on the Touch Screen. Press the button at any time to switch over to real speed. Use this to slow down a section of your video to real speed for a dramatic effect, then press the button again to return to TimeWarp. Or just stop recording, and TimeWarp will reset.

• When recording in consistent lighting conditions, **lock the Exposure** by pressing on the Touch Screen before recording. Make sure to press it twice until you see the "Lock" icon. This will give your TimeWarp videos a uniform exposure throughout the video. Don't use Exposure Lock though if you will be going in and out of shade and sun.

• Use TimeWarp Mode to **create easy, smooth hyperlapses**. A time lapse is typically filmed from one stationary position or with very slow, steady movement. A hyperlapse, on the other hand, is filmed by moving the camera's location between every frame. To film a hyperlapse, keep your camera fixed at a certain point or object as you move. The short intervals between frames in TimeWarp Video Mode allow you to move relatively quickly and record a lot of shots in a short period of time. If you are filming in 360 TimeWarp, it's easy to edit a video to bring out the focal point or subject.

• The shorter intervals combined with stabilization make TimeWarp Video **the best choice for action time lapses**. TimeWarp Video is especially useful for activities that may be a little slow to watch the full duration, such as a long hike, a scenic bike ride, a road trip, or a long distance paddle. When you know you want to play your video back faster than real time, use TimeWarp video to record your journey.

• TimeWarp videos **can also be filmed at night** but you will need to use a higher ISO of 400 or 800. Max doesn't have a Night Lapse option for time lapses in full darkness. For super dark scenes, a high ISO of 3200 or 6400 is required, but the videos will have a lot of noise.

• Bring TimeWarp videos to life by using **the filming techniques** you will learn in Step 4- Capture Your Action, such as tilting and panning. Just remember to draw out your movements much, much longer than normal since your movements will be played back faster than real time. In HERO Mode, use these techniques as you film. In 360, some of these movements, such as panning and tilting, can be added when you edit.

• **Battery runtime** in TimeWarp Video Mode is similar to recording normal video in the same resolution even though you are capturing far fewer frames.

• In 360, TimeWarp Video Mode is **available in 5.6k resolution**. In HERO Mode, **choose between 1080p (16:9 Widescreen) or 1440p (4:3 Standard)** based on how you want to frame the scene.

A Few TimeWarp Video Ideas

• Stand out in a crowd. Film a crowded area with the subject standing still in the middle. When you speed it up, the subject will look like an island of calm in a sea of movement.

• For travel clips, film a hyperlapse as you circle around your favorite landmark or scene focusing on a central object to give your viewers a quick, stabilized 360 degree view for the full experience.

• Follow behind or look back at a subject while you walk through a crowded scene. Your subject will be the only thing that seems to stay steady.

• Film your journey down a path or trail for a quick lead up to your action clips.

 TIME LAPSE MODE- Automatic Time Lapse Videos for Longer Duration Activities

Time Lapse Mode offers two different format options- video and photo. Let's learn about how to get the most out of each output.

The Format setting can be selected in the Setting Preset dialog under Format. Select Video for automatic time lapse videos. Select Photo if you want the camera to produce a batch of time lapse photos.

TIME LAPSE VIDEO OUTPUT

In Time Lapse Video Mode, your camera records one frame (similar to one photo) at the selected interval (.5 sec, 1 sec, etc.). The individual frames are then **automatically combined in the camera and played back as a video** at 30 frames per second.

Because the frames are spaced apart and then played back quickly, there are gaps in between moments and time appears to speed up, creating the time lapse effect.

With the addition of TimeWarp Video for short interval time lapses, Time Lapse Video Mode is **best reserved for stationary time lapses when you want an interval of 2 seconds or longer.**

Shot on GoPro Max using the Time Lapse 360 Video Preset with a 2 second interval. The camera was mounted on the Max Grip as a tripod for a stationary scene. A low ISO of 100 was used in the low light scene to add motion blur as the waves lapped on the sand.

TIMELAPSE VIDEO MODE PRESETS

Main Video Settings to Change:

Interval: 2 seconds

Protune Settings to Change:

ISO Max: 200

Sharpness: Medium

On-Screen Shortcut Settings:

Upper Left: Lens (HERO)/ ISO Max (360)

Upper Right: Interval (360 and HERO)

How To Use the Time Lapse Video Preset

• You will probably only use this for longer, stationary time lapses. The interval is set to 2 seconds for the shortest recording time required to create a video. You can adjust the interval to longer intervals using the On-Screen Shortcut.

• The ISO is low since there will be no (or little) camera movement and this preset is for use in daylight time lapses, but you can adjust it using the Max ISO Shortcut.

• In HERO Mode, the On-Screen Digital Lens shortcut allows you to switch lenses easily, primarily between Wide and Linear.

Go Deeper

This section will help you with some of the more technical aspects of Time Lapse Video Mode.

• In Time Lapse Mode, the interval setting defines the amount of time between each frame of video (or photograph depending on your settings).

• Like in TimeWarp Video Mode, the time counter will **display the playback duration of the video,** not the recording time. To **capture one second of video, you need to record 30 frames**. The time counter will remain at 00:01 (1 second) until you have recorded 30 frames. The chart to the right tells you how long you need to record at each interval for 1 second of video.

INTERVAL (in seconds)	RECORDING TIME REQUIRED FOR A 1 SEC. CLIP
2	1 minute
5	2.5 minutes
10	5 minutes
30	15 minutes
60	30 minutes

• Choose a **short interval** (2, or 5 seconds) for a scene with **continuously moving action** like waves lapping on the beach or traffic in a city for example. A short interval is also useful for **an event that happens over a relatively short period of time,** like a sunrise or preparing your gear to go ride.

• Choose a **long interval** (10, 30 or 60 seconds) for a scene where there is **not a lot of movement**, like slow-moving clouds, or **for longer duration events**, like road trips, construction or long art projects.

• When recording a Time Lapse video, **mount your camera in a stable position and add slow movement when you edit** for a professional look, which is easy to do with spherical 360 footage.

• Since the battery will run out after a couple hours max, you will need extra batteries or an **external power supply for longer interval time lapses**. When recording extended time lapses, you can use a 5V/1-2A external USB power bank to power your camera through a USB cable while you record. If using an external power supply with your camera mounted, open or remove the side door for access to the USB port on your camera.

• 360 Time Lapse Video Mode can be filmed in **5.6k resolution**. HERO Mode offers **1440p or 1080p**.

A Few Time Lapse Ideas

• Record an artist making a drawing or a painting. Choose a relatively short interval depending on the predicted time of the project. Use TimeWarp Video at 15x or 30x Speed for a 45 min to 1 hour-long art project.

• Mount your camera to the back of a standup paddleboard for a downwind paddle or a bike for a trail ride. Try to set up your shot with a stationary object in the foreground, like the board or a bike seat so you don't make your viewers dizzy. The moving action in the background makes for an exciting action time lapse. For shorter rides, TimeWarp Video at 15x or 30x works well since the stabilization will make a huge impact on the result. Switch over to Time Lapse Video mode at 2 sec. or 5 sec. intervals for long duration rides.

• Film the sunset at the beach or lake. Try to choose a day with scattered clouds, and it's even better if the clouds are moving quickly through the sky. The movement of the clouds, the reflections on the water and the dwindling light will create dramatic time lapse clips. Try to frame your shot so there is some movement close to the foreground, like breaking waves or trees blowing in the wind. Because of the wide-angle lens on GoPro Max, movement that is far off in the distance won't make much of an impact.

TIME LAPSE PHOTO OUTPUT

Time Lapse Mode can also be used to record a photo time lapse by changing the Format setting to Photo. Instead of a time lapse video, the end result will be a batch of individual photos. **You can take time lapse photos in 360 Mode or HERO Mode.**

There are a few major benefits when you output your time lapse to photos:

• **Shoot photos of yourself in action** by setting the interval and pushing the Shutter button before you want to start taking pictures. You don't have to worry about pressing the Shutter Button at the right time and you can continuously take photos of yourself or a group. The individual photos will be available for you to choose from. This technique results in a lot of photos, but you can select the best of the bunch and delete the extras. This is **a great option for 360 photos** since you have more time to move further from the camera while continuously taking photos.

• When using time lapse mode to take photos, **use the shortest interval possible (2 seconds)** so you don't miss the best moments. The jpeg photos taken in this mode don't require much space on your camera's memory card, so it's best to capture as many moments as possible.

• If your end goal is to create a video, use the Video format. Merging 360 photos into a timelapse with the ability to reframe the timelapse is more complicated than reframing a timelapse created using the video format.

Photo taken with GoPro Max camera using the 360 Time Lapse Preset set to Photo Format with one photo every 2 seconds. The camera was mounted on the 270Pole.

ADVANCED VIDEO & PHOTO SETTING OPTIONS

After you familiarize yourself with your new camera and become comfortable with the basic operations, you may want to utilize the following setting options for specific shooting needs. These setting options can be utilized when recording videos or photos.

EXPOSURE CONTROL / SPOT METER

Exposure Control allows you to **specify a particular area of the frame to determine exposure**. This is especially useful for high contrast scenes, for example if part of the scene is in complete shade and the other area is in bright sunlight. Your camera naturally tries to set an exposure that balances the two extremes. With Exposure Control, you can tell it to expose for the shady area, or just the bright area.

Exposure Control offers three options:

The first option, called Auto Exposure (or Spot Meter for the center of the frame), is to continually set exposure based on a particular area of the image. When you move your camera, the exposure will change as the lighting changes in that region.

The second option, called Locked Exposure, allows you to set the exposure based on a certain area of the image, then lock that exposure until you deactivate it, or switch modes.

The third option is Hemisphere Exposure, which is available only in 360 modes. Hemisphere Exposure allows you to set the exposure based on the lighting in one of the lenses. If you plan to primarily use the footage from a specific perspective (lens), use Hemisphere Exposure for the best results. For example, in a point of view shot where the camera mounted close to you and facing forward, the front lens might be the view you want while the other lens is pointing at your jacket. This lighting imbalance could throw off the exposure. You would get much better results if you set hemisphere exposure on the front lens.

Exposure Control can be set before or during recording. It's important to note that if you lock an exposure using Exposure Control, it will override manual Shutter and ISO settings that were selected using Protune.

<u>**To activate Auto Exposure, Locked Exposure or Hemisphere Exposure:**</u>

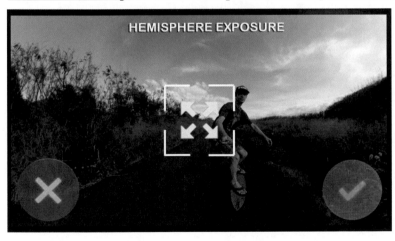

1. Press the Touch Screen until a box appears and then shrinks to the area where you are pressing.
2. Drag the box to the area where you would like to determine exposure. Or tap another area of the frame. For Hemisphere Exposure in 360 Modes, keep the box in the middle of the screen.
3. If you are using Locked Exposure, tap inside the Auto Exposure box to change it to Locked Exposure.
4. Click the check box to enable Exposure Control.

Exposure Control can be disabled by changing modes, turning off your camera, or pressing the screen and tapping the "x".

DASHBOARD and PREFERENCES

The Dashboard and Preferences Menu allows you to change various settings on your camera.

After powering on your camera, Swipe Down on the Touch Screen to bring up the Dashboard with the Preferences Options. Some of these options, such as Voice Control, QuikCapture, Connections, and checking your camera's firmware version were discussed in Step 1.

You can come back to revisit most of these settings once you are comfortable using your camera. Two of the settings, Date and PAL/NTSC (Anti-Flicker), should be checked now, but the rest can wait until you begin using your camera. If you have not done so yet, **start by setting the date** so you can keep your files organized. Also, if you are outside of North America, check to see if your camera is set to PAL or NTSC using the Anti-Flicker dialog.

DASHBOARD FEATURES

The Voice Control On/Off, Beeps, QuikCapture and Screen Lock Buttons are all accessible on the Dashboard for quick setting changes.

Orientation Lock

Tap the Orientation Lock to the right of the Preferences Icon to lock the current orientation.

Grid

Use the Grid Icon to turn on the Grid for composing shots and keeping a level horizon. This is not necessary for shots recorded in 360 or using Horizon Leveling.

Connection Status

A White GPS icon indicates that GPS is On. When a line is shown through the grayed out icon, GPS is off. When the icon just Gray, it's unavailable. The Phone icon represents the connection to the GoPro App.The Cloud Icon shows your AutoUpload Status, for GoPro Plus members.

The Dashboard

Screen Lock

With the Dashboard open, the Screen Lock option is the fourth button at the right of the Touch Screen. When Screen Lock is enabled, the Touch Screen locks automatically to **prevent settings from accidentally changing or to prevent Exposure Control from being set** (which happens sometimes when water gets on the Touch Screen). This is especially useful when you are going in the water or when carrying your camera in your pocket. To unlock Screen Lock, tap on the screen, Swipe Down and then tap on the lock. This will allow you to make changes before the screen automatically locks again.

The following options are found in the Preferences Menu.

GENERAL SETTINGS

 Beep Volume

This allows you to **adjust the volume of the beeps to High, Medium, Low or completely silent (Mute).** The beeps are helpful to let you know if your camera stops recording when your camera is mounted out of sight, on your helmet for example.

If you are recording nature or music, the beeps tend to be loud and distracting so you may want to lower the volume or turn them off completely. To quickly mute the beeps, press the Beeps Icon at the top of the Dashboard.

 Default Mode

This defines which preset you want to be available when you turn your camera on. The **default is HERO Video,** but if you want your camera to start up in a 360 preset every time, set your preference here. 360 video will most likely be the most commonly used video mode.

 Auto Power OFF

If you find that you keep forgetting to turn off your camera and the battery dies before you get a chance to use your camera, you can **set your camera to shut off automatically** after 5, 15 or 30 minutes of inactivity, or Never. 30 minutes is a good option to prevent an accidental dead battery.

 LED Lights

You can **control the amount of LED lights that light up** on your camera. The options are All On, All Off, or Front Off Only. The LED lights flash while videoing or taking photos. The lights are pretty small, but sometimes if you are filming close to your subject, the red glow from the LED lights can show up on your subject. Also, if you are recording video at night, turn off the LED lights if they are affecting your scene.

 Anti-Flicker

If you are in North America, film in NTSC, which is 60Hz. If you are outside of North America and plan to watch your GoPro footage on a TV, most televisions outside of North America use PAL (50Hz), so set your camera to 50Hz. Setting your camera to 50Hz will affect the frame rates as shown in the video settings section.

 Video Compression

HEVC is the standard format for all video files on GoPro Max. Choose HEVC+H.264 if you want HERO Mode video settings to use H.264 for compatibility with older devices.

 Date /Time

Set the date on your camera. If you have any hope of staying organized with the huge number of files produced by a GoPro camera, you need to be able to search through your files by date. When you connect your camera to the GoPro App or Quik for Desktop, the date will set automatically.

If you did not connect to the GoPro App, go into the Preferences Menu and make sure the date is correct. Also, if you don't use your camera for an extended period of time, check to make sure that the date did not reset automatically.

TOUCH SCREEN

 Orientation

When the Orientation is set to All, your camera will automatically adjust to the correct orientation including a vertical orientation. After rotating your camera, make sure the camera has changed to the correct orientation by looking at the Touch Screen icons to make sure they are in the correct orientation. In HERO Modes, the orientation is based on the beginning of your video clip and once you start recording, the orientation is locked. To prevent your camera from recording vertical videos, select Landscape. In 360, it really doesn't matter which orientation you use.

 Screensaver

This option allows you to change the settings for the Touch Screen on the back of your camera.

Under the Screensaver option, you can set the Touch Screen to sleep after 1, 2, or 3 minutes or never. Setting the display to sleep after a short period will help to maximize the battery life but may cause the screen to sleep while you are filming longer clips. If you are using the Touch Screen to compose your shots as you film, set the Touch Screen to shut off after 3 minutes or never, depending on the length of your shots.

 Brightness

You can also adjust the Brightness of the Touch Screen to suit your tastes. Plus, a lower brightness uses less battery.

REGIONAL MENU

📍 **GPS**

When GPS is enabled, your camera will record key GPS stats, which can be used to show speed in the GoPro App for HERO Mode videos, or for geotagging your photos. The GPS data can also be used from 360 videos but not directly through the GoPro App.

Language
Select the language for the Touch Screen dialog.

ABOUT

Camera Info- This displays your camera name, serial number and firmware version.

Battery Info- Check to make sure that the battery is still in good condition and that it's a compatible battery for Max.

RESET

Format SD Card- After you transfer footage to your computer, select Format SD Card to erase all of the files. You can also Reset Presets or use Factory Reset to start the camera from scratch.

Congratulations, you've made it through the technical settings step. You are now ready to move on to Step 3 where you will learn how to mount your camera!

STEP THREE

MOUNTING

Set Up Your Camera To Work The Angles

The quality that really makes GoPro cameras stand out is their ability to be mounted in unique locations to capture angles that used to be unwieldy or nearly impossible. GoPro Max adds even more magic to the mounting mystery by making the mount disappear when mounted properly. We will show you everything you need to know about mounting GoPro Max.

When it comes to mounting your GoPro Max, think outside the box. Look for angles you've never seen before. Or use others as inspiration to record your life in a way you never thought to do before. **Getting creative with mounts is what will make your footage truly unique.**

There are hundreds of ways to mount your GoPro Max and the possibilities keep expanding as creative users come up with new mounts and new mounting techniques. If there is an angle you can imagine, there is a way to capture it with your GoPro Max. And the best part is that this camera is so small and lightweight that it's hardly even noticeable as you carry it along with you on your big (and small) adventures.

So, study up and learn the best ways to mount GoPro Max so you can decide how to best capture your point of view. The mounting examples also provide more insight into choosing your modes and settings for particular shots.

This chapter begins with **the basic elements- the camera, the mounting fingers and buckles-** and then gets **deeper into the wide variety of mounting techniques you can use with GoPro Max** to get the angles you want to capture.

We will primarily focus on mounting for 360 videos and photos since 360 video offers truly unique mounting options. For HERO Modes, Max can also be mounted to any other mount just like you would a traditional GoPro camera.

Other companies besides GoPro make versions of many of these mounts, however this book only points out other available options when they offer something unique from the original GoPro mounts.

GETTING STARTED

GoPro Max is **part of a unique mounting system** that made GoPro cameras stand apart from other cameras in the first place. Your camera has **foldable mounting fingers** on the bottom which can be attached to a variety of **mounts** using a **thumbscrew**. This basic combination is the starting point for a whole world of fun, creative mounting techniques. GoPro Max takes it to the next level of imagination with the ability to make the mount disappear!

Let's get started with one of the most exciting and creative aspects of using your GoPro Max- mounting!

MOUNTING BASICS

First, let's cover a few of the basics you should know before mounting your GoPro Max.

USING GOPRO MAX IN THE WATER

Yes, the camera is waterproof! But underwater videos are not clear.

• GoPro Max is **waterproof to 16' (5m) without an additional case as long as the side door is closed.**

• However, to create the 360 spherical image, GoPro had to use two curved lenses. Unfortunately, **the curved lenses** required to create spherical photos and videos **don't produce clear imagery underwater**. In both 360 Mode and HERO mode, photos and videos recorded underwater will turn out blurry. Until GoPro makes a separate underwater housing for Max, **Max is more of a "splash" camera.** You can use it all you want in the water and go down to 16' deep, but it's not designed for filming

The Protective Lenses

underwater. The **360Bubble** is the only underwater option as of publication that actually produces clear underwater images, or if you are really crafty, you could make your own similar mounting setup for underwater use using a clear acrylic lamp globe. This "bubble" pushes the water far enough away from the camera for crisp, clear images. The **Protective Lenses**, which came with your camera, improve the clarity slightly and can be used in shallow water, but they are not specifically designed for underwater use and easily fill up with water when submerged. If you do use them, make sure they are pressed down flush to the camera for the best watertight seal and stitch lines.

• Third party companies, such as Vgsion, make **an underwater case for GoPro Max.** This case, which is similar to the SuperSuit for the Hero 8 Black, provides the ability to go deeper underwater (up to 40mts/131ft), but without solving the problem of blurry underwater shots, this is really only a useful option if you want the **extra layer of protection for extreme sports.** If you want to protect just the lenses, the Protective Lenses that came with your camera are a great option.

• **If you are in the water**, water drops on the lenses quickly ruin a shot. Water drops on the lens are visible in your shots and any water around the edges of the lens will affect the stitch line in 360 spherical photos and videos.

The first step is to make sure the lenses are clean and buffed out. **To prevent water drops from collecting on the front of the lenses when your camera gets wet, buff the lenses with a clean, soft cloth before going in the water. Any oil or grease on the lenses will cause water to collect.**

The second step is the try to get the water drops off. You want to **try to keep the lenses out of the water as much as possible to reduce water drops**. If the lenses get wet, **shake your camera or blow on it lightly to try to remove the water.** With Max, you want the water drops to fall off or repel off the lenses as quickly as possible.

Unfortunately, licking the lens like you can do with other GoPro cameras doesn't work well for Max. The layer of water remaining on the lens, especially around the edges messes up the stitch lines.

• GoPro Max, like all GoPro cameras, **does NOT float. Whenever you go in the water, use a floating handle** to float your camera. The SP Gadgets floating handle has a ¼"-20 top screw attachment to add an extension pole or a tripod mount. You don't want to watch your camera sink out of your hands and into the depths! Also, be sure to lock the Touch Screen to prevent water from changing the settings.

THE SIDE DOOR

• The **side door is removable.** When the side door is open or removed, you can **access the USB port** to charge the battery, transfer files or connect to external USB power while your camera is mounted. However, your camera is NOT waterproof with the door removed. Also, be careful removing the side door because it breaks easily.

• **As long as the side door is securely closed,** GoPro Max camera itself is always ready for the water. You don't need to worry about it. This means there are no cases to worry about and no prep to get your camera ready to film in the water.

• Whenever you finish accessing the side door and are ready to start using your camera again, **make sure the door is closed completely with the Latch Release tab pushed up so you don't see any red**. You'll notice a small rubber gasket around the opening. That gasket seals water out of your camera. Keeping the door securely closed is essential to keeping your camera waterproof.

• When your camera is new, the door should close easily and securely latch. But after time, some dust or dirt may accumulate making it a little rougher to close. Make sure to keep any sand or dirt off the gasket by cleaning it periodically.

FOGGING ISSUES

• Since GoPro Max doesn't require a separate waterproof housing, fogging (moisture on the inside of the lens) is not a major problem, but **some condensation can occur under the lenses in humid environments.** If you notice fogging on the inside of the lens, stop recording when it is convenient to let the camera cool down. As the camera cools off, you will notice that the moisture inside of the lens will start to dry out. The fogging is **caused by the difference in temperature** inside of the glass and outside, just like a car window fogs up. You can minimize this by letting your camera adjust to the climate. For example, if you come out of an air-conditioned room into 100-degree heat, wait a bit for the air inside the camera to adjust. If you are going into the ocean or lake, put the camera underwater for a minute to let the temperature adjust.

• If you are experiencing fogging problems during a filming session, try to record only when you need to. The camera heats up when actively recording. **Use QuikCapture** to reduce standby time, which will allow your camera to cool off and give the moisture time to dissipate in between shots.

A FEW MORE MOUNTING TIPS

• **Keep it simple.** You could get overambitious and buy every mount (because yes, there is a fun, creative use for almost every mount), but simplicity is going to be your best friend. When you are out having fun, whether it's biking, snowboarding, or just cruising around, the key is to be in the moment. Prepare beforehand. Select two or three mounts to take with you to avoid spending your time fumbling around setting up the camera. The magic is in the moment, so have your camera ready and film the best you can with what you have…which leads to the next filming tip….

• **Put effort into your shots.** Even though they might just look like shoot-from-the hip style shots, most of the impactful GoPro videos or photos you see took effort. Select a few mounts for each activity and keep it simple, but once you start filming, put your energy into getting "the shot", not just a bunch of average shots. This may mean you need to walk closer to your subject, or pause a moment longer, but the images you create will reflect your energy. There is a huge difference between "I could have taken that shot" and "I took that shot." With the latter, the proof is in the image.

MOUNTING ELEMENTS

Next, let's cover the basic mounting elements used for mounting the GoPro Max camera.

FOLDABLE MOUNTING FINGERS

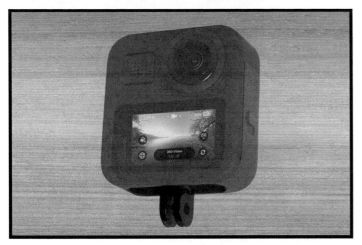

GoPro Max comes with foldable mounting fingers on the bottom of the camera allowing you to mount it to a variety of mounts using a thumbscrew. The foldable mounting fingers can easily be folded up when using your camera without a mount to set your camera on a flat surface, and if they are damaged, the fingers are replaceable.

Tips for Mounting the Camera with the Mounting Fingers

• The mounting fingers can be **attached directly to some mounts** or **used with any of the buckles**. Use the **long Thumbscrew to connect the mounting fingers to a mount**. Tighten the thumbscrew extra tight to prevent the camera from being wobbly at the mounting fingers.

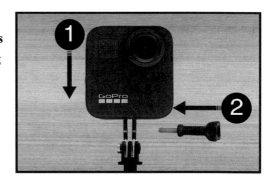

• When possible, mount your camera with the Thumbscrew facing the opposite side of the door so you can open the side door while the camera is mounted.

• A short Thumbscrew is only used for connecting additional mounting pieces together.

HOW TO MOUNT MAX FOR THE INVISIBLE POLE EFFECT

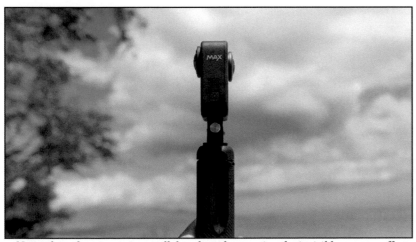

Notice how the camera is parallel to the pole, creating the invisible camera effect. The Max Grip is about the largest diameter pole that works well with GoPro Max.

One of the best creative features of GoPro Max is the ability to **make the mount disappear**, creating a floating camera affect. Whether you're a filming action, lifestyle/vlog , real estate, or scenery, the floating camera effect is definitely the greatest asset to using a 360 camera.

As long as your camera is mounted to a **"direct to GoPro" mount and lined up with the pole**, you can work the invisible pole for your 360 shots.

The way to do this is to mount Max on a straight pole using a direct to GoPro mount, like shown. For the best stitch lines, use a pole that places the camera at least 10 inches off a surface or away from your hand (if you are holding the pole). You want to use a pole that is about the same depth as the camera lenses or thinner (about 1-1/4" maximum pole diameter). Since each of the two lenses records more than 180 degrees, the overlapping areas in the stich line results in a disappearing pole.

• A **direct to GoPro mount**, like the one pictured below is the best option for mounting a 360 camera like Max. For 360 filming, use an extension or handheld pole and mount the camera straight in line with the pole.

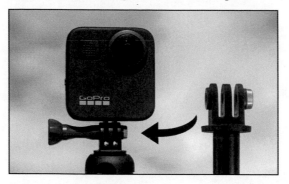

A direct to GoPro mount allows the camera to be mounted directly in line with the pole.

• For the best results when filming in 360, the **top mounting attachment needs to be centered** so the camera will line up directly with the pole. If you add on a tripod mount using a ¼"-20 screw, make sure to select a mount like the one shown below. The Kupo or Forevercam metal tripod mounts are two good options for a centered mounting location.

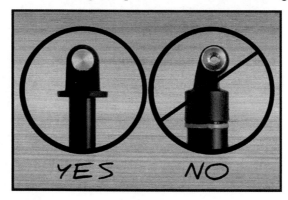

For the best alignment with the pole, try to avoid offset attachments like the one shown on the right.

• When recording HERO Mode videos, it's better to tilt the camera at the end of the pole to angle at yourself or your subject.

EXTENSION POLE

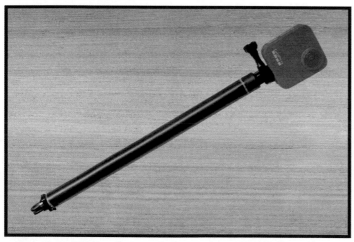

You can use **an extension arm or section** with many of the traditional GoPro mounts to capture unique perspectives and create the invisible mount effect. An extension arm is used to lift your camera out and away from a mount or your equipment.

A premade extension (preferably out of carbon fiber or metal) is the safest option for mounting GoPro max. The SP Gadgets 12" section is shown to the left.

• Look for a **direct to GoPro mount extension pole** with a top connection similar to the one shown in the previous section. Alternatively, you can use the GoPro Tripod mount on any premade extension pole with a ¼"-20 screw attachment at the top, such as the Insta360 pole.

• Use a **straight pole** without bends or curves. Bends or curves will cause the mount to appear in the image because the pole

won't be directly in line with the camera.

• If you want to buy **a premade extension**, SP Gadgets makes all of the pieces to assemble your own floating extensions, including a 12" section and a 24" section. Insta360 also makes several extension poles that mount using a ¼"-20 screw, which can be adapted to hold GoPro Max using a tripod mount.

• Due to lack of options, some people have been making their own extension poles for Max. It's a bit risky because if it breaks, you might lose or damage your camera. But you can easily **make your own extension** using two mounting pieces from GoPro's Grab Bag of mounts, a ¾" diameter PVC pipe and some epoxy or Flex Glue. Cut the pole to your desired length using a PVC cutter, glue the mount with two prongs exposed on the bottom and the camera mounting end on top of the pole. You can paint the pole matte black if you want a less homemade look, but it doesn't really matter because the pole will disappear out of your 360 shots anyways. Test your DIY pole before mounting it somewhere that could potentially damage your camera. A variety of lengths is convenient to have available for different mounting setups.

The pieces for a DIY extension pole.

• **Secure your angle,** especially when using an extension pole! Once you have figured out exactly how you want the camera pointing, **use a Philips screwdriver to tighten any thumbscrews** that hold the camera in place. If you don't tighten the screws properly, the mount can accidentally rotate, and you won't know if you are still capturing the right angle. Even small bumps and shakes can move your camera around very easily, so use a screwdriver to tighten the thumbscrews as tight as you can. Alternatively, GoPro makes the Tool, which is used to tighten thumbscrews and fits into your pocket better than a screwdriver. Depending on the length of the extension, you may even need to add some thin rubber washers to prevent the pole from accidentally moving in the buckle.

• We will learn about some of the best ways to mount an extension pole later in this step.

BUCKLES

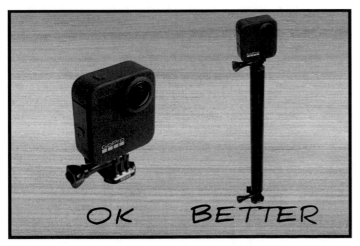

Some GoPro mounts, such as the adhesive mounts, only work with buckles. As we showed you, your camera can attach to a buckle using a long thumbscrew. When using a buckle, the **buckle then slides into a mount**, locking your camera in place.

For shots recorded in HERO Mode, mounting the camera directly to a buckle is not a problem and can produce some amazing footage.

Unfortunately, when mounting Max directly to buckle mounts for 360 shots, the buckle does not disappear, resulting in a very obvious stitch line and some strange distortion. Mounting Max directly to a buckle is not the ideal way to mount the 360 camera, but when used as the mounting base for an extension, this allows you to use the wide variety of GoPro mounts available and make the mount disappear. You will find that using **an extension pole on a buckle is one of the most creative ways to mount your 360 camera.**

There are **three buckle options to choose from** when mounting your camera on a mount base. The Mounting Buckle comes with GoPro Max. The other two buckles are included with other mounts as you expand your mounting options.

MOUNTING BUCKLE

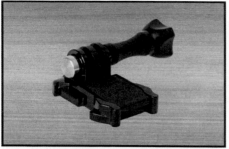

The Mounting Buckle is the **best buckle to use with an extension pole** because of its strong, compact design which can handle the extra weight of the pole. The Mounting Buckle is typically used for **low-profile mounting positions** where you don't need a lot of front to back rotation to get the angle you are looking for. With its low-profile, this buckle provides a securely mounted position that **can handle a lot of impact** for extreme moments.

VERTICAL MOUNTING BUCKLE

The Vertical Mounting Buckle allows for a **greater range of motion than the Mounting Buckle**. When using this buckle, you can rotate your camera 180 degrees from front to back. This can be really useful for mounting an extension pole to a surface, such as the roof of a car or a helmet, allowing for a wide range of angles. The key is tightening the thumbscrew securely enough that it doesn't move while you are filming.

SWIVEL BUCKLE

The Swivel Buckle/Mount **can be tilted 30 degrees in any direction**, which allows you to fine tune your angles when your camera is already mounted. Unless you are mounting Max directly to the Swivel Buckle, this buckle moves easily with the extra weight of an extension so it's the least useful of the three buckles for mounting Max.

Tips for Using the Buckles

• The buckles can be inserted into the mount bases **facing either direction**.

• Except for the Swivel Buckle, your camera can't rotate in the buckle. You can **add extensions to the other buckles** if you need to change the orientation of your camera. A 3-Way Pivot Arm can be used to rotate the camera 90 degrees, so if you are just looking for more height but want your camera to point the same direction, you will need to use two extension pieces. Make sure to tighten each joint so there is no weak point in your setup. For 360 shots, the fewer the mounting pieces, the better since anything not in line with your camera will show up in the shots.

• After inserting the buckle into a mount, push down the **attached black locking plug** to secure your mount in place. This prevents the buckle from accidentally releasing from the mount. The locking plug also helps to reduce vibrations.

BEST MOUNTS FOR 360

Now that you know about the individual mounting pieces and how to put them together, we will focus on the best mounting tools to use with Max in general and also the best mounts for capturing the "magic floating" camera shots in 360 photos and videos.

Let's take a look at the best mounts to use with GoPro Max!

ADHESIVE MOUNTS

When properly applied, Adhesive Mounts are **the most secure base for mounting your camera or an extension pole to most surfaces.** The Adhesive Mounts stick to smooth surfaces using a super strong adhesive tape. They are single use and can be removed, but they are **typically left on for more permanent use.**

There are two basic adhesive mounts to choose from:

CURVED ADHESIVE MOUNT

The Curved Adhesive Mount has a slightly curved base for **mounting to rounded objects**, most commonly a helmet or a curved surface of a vehicle. The Curved Adhesive Mount can be easily distinguished from the Flat Adhesive Mount by its square corners.

Mounting Tips:

• When using this mount on a helmet, **find the best position and curve to match the base of the mount**. Inspect all the edges of the mount to make sure you have a good fit. If the edges of the mount lift slightly because the curve of the mount doesn't match the curve of your helmet, you can secure it using a small amount of epoxy or sun-curing surfboard resin (like Solarez). Make sure to only apply the resin around the base of the mount, not on the part of the mount where the camera slides in.

• This is the **best mounting base to use for mounting your GoPro on a helmet.** See the Action POV Mounts for more ideas on where to use this mount for Helmet Cam angles.

Mounting Example:

THE "GNARWHAL" MOUNT ON A HELMET

• RECOMMENDED SETTINGS: When using this mounting setup, record in 360 Video Mode at 5.6k-30 for high quality video with the invisible floating camera effect. If you are making lower resolution videos for mobile sharing, use 3k-60 since slow motion can help highlight the action with this type of shot.

• GoPro Max is mounted on the end of a custom extension pole made using a PVC pipe. The extension is mounted to the Mounting Buckle on a Curved Adhesive Mount. All thumbscrews were tightened using a screwdriver to prevent them from moving.

• Although the weight of the mount is noticeable, the distance from the helmet creates an amazing floating camera effect in front of the subject.

FLAT ADHESIVE MOUNT

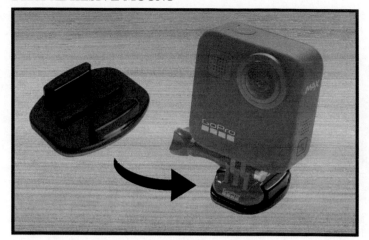

The Flat Adhesive Mount is a simple, low-profile mount for **flat, non-flexible surfaces**. The Flat Mount has a flat base and rounded corners. When mounted properly to a flat surface, this mount provides a secure, semi-permanent base to hold your camera. The best application for the Flat Adhesive Mount is to a location where you can use the mount repeatedly- e.g. your own car, plane, boat, or sporting equipment.

Mounting Tips:

• Follow the Adhesive Mount Mounting Instructions at the end of the Adhesive Mount Section to set up a secure mount. The mount is very unlikely to fall off if mounted as instructed on a non-flexible surface.

• **Drilled Mount.** For a secure mount in applications where a typical adhesive mount might come off, you can **modify the mount so that it can be drilled into a surface**. To do this: 1) Drill a hole in the middle of the mount, 2) Countersink a hole for the head of the screw (so it doesn't interfere with your camera sliding on) and 3) Screw or bolt your mount onto your board, surface, etc.

• The **Surfboard Mount** is a flat adhesive mount with **more surface area than the standard Flat Adhesive Mount**. It comes with a separate tether mount that fits together snugly with the cutout on the Surfboard Mount. The extra surface area creates a stronger bond and can be used for other mounting setups besides just on a surfboard.

• Do not use an Adhesive Mount on a **SoftTop surfboard or bodyboard**. If you are riding a SoftTop surfboard or a bodyboard, **use the GoPro Bodyboard Mount instead**.

• The **Fusion Mounts** are another adhesive mount with more surface area than the traditional adhesive mounts and work well with Max.

More Tips For Using Adhesive Mounts:

It is especially important to follow the mounting instructions if you are using the mount in cold weather. The following tips will help you use the Adhesive Mounts to their full potential.

• **Do not apply the mounts to a flexible surface**, like the nose of a snowboard. The mount can come off when the surface flexes.

• To **remove a mount** from a tough surface, you can usually pry it off with a butter knife. If you are worried about damaging the surface, use a hairdryer to soften the adhesive and slowly peel it off.

• When setting up a new angle, the best option is to **always use a new mount**. If you must reuse a mount, make sure to use a new piece of adhesive tape. **3M VHB 4991** is the super strong adhesive bonding tape that comes on GoPro® mounts. You can pick up a roll online and it's always good to have on hand if you plan to reuse any mounts.

• When possible, use a camera tether for backup.

• Adhesive mounts can withstand temperatures up to 250°F (121°C).

• When mounting your camera, **make sure the buckle "clicks" into place to lock it into the mount.**

• **ADHESIVE MOUNT MOUNTING INSTRUCTIONS:** Follow these steps to securely mount your camera using an adhesive mount:

1. First check to **make sure you are using the right adhesive mount** for the surface you are mounting to. If you are mounting to a flat surface, use the Flat Adhesive Mount, Flat Fusion Mount, or Surfboard Mount. When mounting to a curved surface, use the Curved Adhesive Mount. Before removing the backing from the adhesive, test the mounting position to make sure the edges of the mount sit flush on the surface.

2. Use isopropyl alcohol to **clean the surface** where you are going to place the mount. Make sure there is no wax or sand on the surface. Let the alcohol dry or wipe clean before moving to the next step.

3. Decide which direction you want the camera to face when mounted and **make sure the groove for the camera to slide into faces that direction**. You can insert the camera forwards or backwards, but you can't easily rotate the camera once it is mounted.

4. The mount works best if **applied at room temperature**. Peel the plastic backing from the mount and stick the mount to the surface. NOTE: The adhesive does not feel extremely sticky to the touch and needs to be pressed hard onto the mounting surface. For tricky surfaces, use a hair dryer to heat up the red plastic liner that covers the adhesive before removing it. This will make the adhesive tackier and improve the adhesion. Some people use a lighter to soften the adhesive, but be careful not to burn it.

5. For the strongest bond, **wait 24 hours before placing your camera into the mount** to let the adhesive form a strong bond. After 72 hours, the mount will be fully set to the surface.

Mounting Example:

ADHESIVE MOUNT ON THE TAIL OF A FOIL BOARD

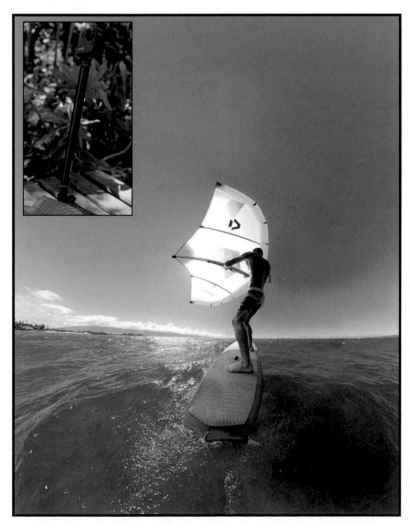

• SETTINGS: Photo taken from video recorded in 360 Video Mode at 5.6k-30. In general, when using this mounting setup, record in 360 Video Mode at 5.6k-30 for high quality video with the invisible floating camera effect. If you are making lower resolution videos for mobile sharing, use 3k-60 since slow motion can help highlight the action with this type of shot. If the surface will be moving a lot, you can alternatively use HERO Video Mode at 1080-60 with Horizon Leveling Turned on, but the view is more limited.

• The Forevercam Tripod Mount was mounted to the 12" SP Gadgets Section Pole. The Section Pole has a GoPro Mount base (also by SP Gadgets), which is used to mount the pole to the Fusion Flat Adhesive Mount. Depending on the surface, a Curved Adhesive Mount might be a better alternative.

HANDHELD POLE

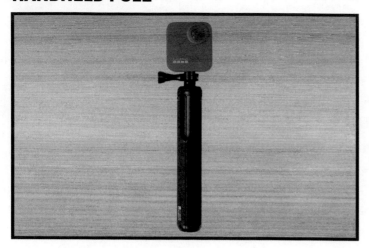

When filming 360 photos and video, hand-held shots give you **the most flexibility for unique angles and creative camera movements**. And since the pole is not visible, all of these movements happen magically, as if someone else is filming.

A handle (typically about 6"-8") or a pole (18"+) provides an easy way to hold your camera and **capture multiple angles with one mount**. A handle or pole (also known as a selfie stick) enables you to capture some of the best angles possible for any activity where you have a free hand. The pole creates distance between you and your camera for ultra wide-angle shots with lots of scenery or for close-up reframed videos. You can **film yourself, follow behind your friends, or hold the pole vertically** to get more height on your shots.

If you want to hold your camera on a pole (but look like you are not), **GoPro's Max Grip** is one of the most obvious choices. With a direct mount end, an extendable pole to 22" and a pole width designed to disappear when used with Max, the Max Grip gives you lots of flexibility with a relatively compact size. Max Grip also has three fold-out legs for an on-the-go monopod. (You do need to be gentle with those legs because they can break rather easily.) When using Max Grip, extend the pole out to its maximum extension for the best stitch lines on your spherical imagery. The **Insta360 Invisible Selfie Stick** is another similar extendable handheld pole, with the option of adding on a tripod base. Because it has a ¼"-20 screw top base, you will need to use a tripod mount adapter to mount Max to the Insta360 pole.

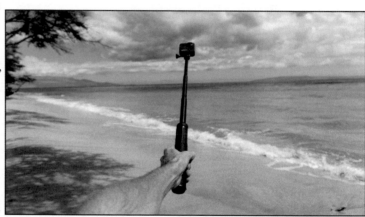

GoPro Max shown on the Max Grip with the pole extended.

For a longer handheld pole, **270Pro** makes a high quality, extendable pole which extends up to 270cm (106 inches). With the wide-angle lens on Max, the super long pole really makes it look like the camera is far from your subject or even flying through the air. Made out of carbon fiber, this pole is light and won't break on you, unlike some of the cheaper plastic options. The **270Pro Backpack Pole** offers five different extension heights, which is much more convenient than the regular pole, which only offers two. Insta360 makes a similar high quality pole, called the **Insta360 Extended Edition Selfie Stick**, which is also made out of carbon fiber and aluminum. If you are into extreme sports, adventure, or just like to hang your camera off of high cliffs for unique shots, you want to have a pole you can trust.

The super long 270Pro Extension pole can be used to create an aerial view.

For a pocket-sized handle, the **GoPro Shorty** has a direct to GoPro mount and provides just enough extension (8.9") to move the camera away from your hand. Plus, it has foldable tripod legs for quick and easy tripod shots on the go.

If you are going in the water with your camera, it's best to find **a pole that floats**. SP Gadgets makes a 12" floating extension that mounts on the end of a floating handle. The pieces connect using a ¼"-20 screw, so there are no mounting pieces to get in the way of your floating camera shots.

More Tips for Using a Handheld Pole:

• See the examples for the **two primary ways to hold your camera** when using a handle or polecam.

• Avoid GoPro's longer pole, called El Grande, because the buckle-style mount at the end of the pole won't disappear out of your 360 shots. Also avoid the GoPro 3-Way because it has to many angles to work well with Max.

• The **Bullet Mount** is another creative handheld pole shot where the camera rotates rapidly around the subject.

• If you find a pole that connects to cameras **using a ¼"-20 screw**, you can use the GoPro Tripod Mount to connect Max to any of these poles.

• **Hold the pole in front of you or behind you** while you ride a bike, walk, travel or surf and it will look like you have a personal film crew following close by.

• When filming with a handheld pole, **move the camera so it follows the action**. This will really help add to that magic floating camera effect.

Mounting Examples:

VERTICAL FILMING

• Use a vertical position **when you want to add more height to your shots**. When using Max with a long pole, a little bit of height goes a long way. The ultra wide-angle lenses make the camera appear much higher than it actually is.

• A vertical position also works well **for vlog style shots to center yourself in the frame**. When you go to reframe your shots, having yourself or your subject closer to the center of the frame will result in less distortion.

HORIZONTAL

• Holding your camera horizontally on a pole is better when you are trying **to create a sense of moving along with yourself or your subject**. This filming position places the camera more at hip or shoulder level for an immersive ride along.

• For anyone with a traditional photography background, it feels wrong to not point the camera lens towards yourself or your subject. However, because you are filming a full spherical image, this is **one of the best techniques for the invisible camera effect**.

• If you are filming **in HERO Video Mode, angle the camera at the end of the pole** so one of the lenses (the one you choose to film with of course) is facing your subject.

MONOPOD

Using a monopod is the **best option when you want to set Max down for a stationary shot.** The long pole leading down to the monopod feet disappears easily out of 360 shots, leaving a minimal amount of touch up work to edit out the tripod feet. A tripod on the other hand will result in a lot more postproduction editing.

A monopod provides the perfect mounting base to set Max down, press the Shutter Button or use the Self-Timer and disappear from the scene (go hide behind a bush, vehicle or sign). For the most versatility, **look for a monopod that raises up to at least eye level.** If you do end up venturing into real estate 360 photography or virtual tours, that eye-level height will produce the most relatable imagery.

When choosing a monopod, also make sure that the adjustments (knobs, etc.) and pole diameter are **less than the width of GoPro Max (about 1-1/4")** so the pole disappears in 360 images. If you have a pole with a ¼"-20 attachment at the base, you can just add a monopod base for an instant monopod. Zeadio makes a simple metal tripod base that attaches with the ¼"-20 screw attachment.

More Tips for Using a Monopod

• Be careful of filming on a monopod in **windy conditions.** A monopod is not as stable as a tripod and can easily get blown over in the wind. Since your lenses are not protected, this could be the end of your camera.

• If you are **filming 360 real estate photography**, a monopod is essential for filming all of your panoramic photos to create virtual tours. We will talk more about using Max for real estate in Step 4.

• Without the appearance of a pole in the shot, a 360 camera is an invaluable tool for someone filming travel, lifestyle, or vlog content. Using **a handheld pole with a combination of a monopod is the perfect combination** for recording a variety of shots without looking like you're filming yourself. You can pull multiple angles out of a single moment in time, allowing you to create fast, high-quality content on the go. When filming in 360, you won't forget to film a thing. In Step 4, you will learn more tips for filming vlog and lifestyle shots using Max.

• A smaller monopod, at least 12" off of the ground, can be useful for mounting Max on a table or desk **for filming at home studio shots and online content.**

• If you are filming in sand, dirt, or grass, **a spike base** works even better so you don't have to edit out the monopod feet later. It's easy to make one of your own for this purpose by gluing together a PVC pipe, a GoPro Mount for the top connection and a plastic solar light spike for the base.

Mounting Example:
MOUNTED ON THE GOPRO MAX GRIP

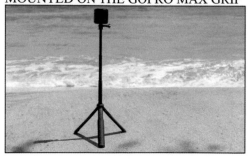

• GoPro Max is shown here mounted on the Max Grip fully extended. Although the pole will disappear in a 360 shot, the monopod feet will need to be edited out for spherical viewing. You will learn how to edit out the tripod feet in Step 5- Editing.

MOUNTED EXTENSION POLE

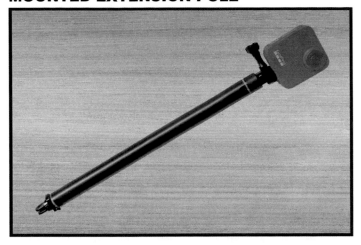

As you briefly learned earlier, an extension pole can be used to **lift your camera up and away from a surface**, creating a floating camera effect. Although the camera remains in a fixed position at the end of the extension pole, you can use 360 editing techniques create the effect that the camera is actually moving.

This simple setup, a mounting base, an extension pole, and GoPro Max, opens up the potential to easily create shots that would have been extremely difficult previously. For example, imagine a shiny new car driving along a scenic cliff. With GoPro Max, mounted off the front of the car, you could easily make a cinematic car commercial with a relatively cheap and easy setup. The possibilities are in your hands!

Several of GoPro's traditional mounts make the best bases for mounting an extension pole:

• Use an **adhesive mount**, like we talked about earlier, for a more permanent mounting position on your equipment. Having an adhesive mount ready to go makes it easy to attach an extension when you're ready to start filming.

• Attach a **Curved Adhesive Mount to the top of a helmet**, add your extension pole so it's facing out in front of you, and capture an amazing angle. This is called the **"Gnarwhal" Mount** (like we showed you before) because it looks like a narwhal's horn. Just be sure to tighten the base of the extension mount well so it doesn't rotate as you ride.

• For a more temporary mount, use **GoPro's Suction Cup Mount**. The Suction Cup Mount can easily be attached and detached from a variety of surfaces, such as a car or window. The Suction Cup is a versatile mount to use as you travel for quick, creative shots. The Suction Cup can be used on smooth, nonflexible, non-porous surfaces. Always test the Suction Cup's suction before you attach your camera. Add the extension pole to the Suction Cup Mount, and now your camera can appear to be magically floating off of any surface.

• GoPro's **Handlebar Seatpost Mount** is another useful option for attaching your camera to a pole. This mount attaches securely around a pole, which serves as a solid mounting base that won't come off.

• For a super strong magnetic mount, the **Bushman Popeye Magnetic Mount** holds up to 99 pounds of pull and is ideal for attaching an extension pole to any metal surface, such as the exterior of a vehicle.

Mounting Example:

EXTENSION MOUNTED TO SUCTION CUP

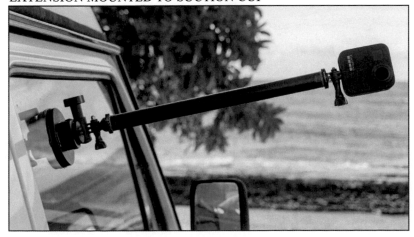

• RECOMMENDED SETTINGS: When using this mounting setup, record in 360 Video Mode at 5.6k-30 for high quality video with the invisible floating camera effect. By zooming out when you edit, you can create the effect that the camera is mounted much further from the vehicle than it actually is.

• The Forevercam Tripod Mount was mounted to the 12" SP Gadgets Section Pole. The Section Pole has a GoPro Mount base (also by SP Gadgets), which is used to mount the pole to the GoPro Suction Cup Mount.

ACTION POV MOUNTS

Point of View (POV) shots **show the action from a first person perspective**, as if the viewer is doing the activity. This style of mounting is filmed by mounting your camera to your body or your equipment. Although many of these mounts don't allow the invisible mount technique, the super wide angle possibilities of Max make the first person view even more dramatic than even the wide angle lens on a normal GoPro camera.

Here are a few of the best first person mounts for filming 360 spherical shots (and of course HERO videos too):

• **Bite Mount.** Popularized by surfers who had few other options for a good POV mounting position, people of all disciplines have found out how useful this mount can be. When using a bite mount, you actually hold the camera in your mouth using a mouthpiece. Some bite mounts have a similar mouthpiece to a snorkel, while others, like GoPro's Bite Mount, is more of a flat plate. A bit mount seems strange at first, but it really creates the most similar perspective to an eye level view. When filming in 360, the forward facing view can be zoomed out for a super wide angle, The result is a super dramatic shot because you can see more of the surrounding scene. If you zoom out too far, the view through the lens facing the subject is horrible because it's so close, but this can be carefully edited to only include the forward-facing view.

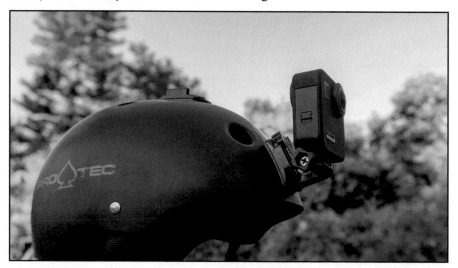

• **Helmet Mount.** Mount Max directly to a helmet for sports where you wear one. Max can be mounted facing forward on the front (just above the rim) for the best forward facing view. Mounting Max directly on top of a helmet allows you to see all the way around-forwards, backwards, and on the sides. If you add an extension pole to either mounting position, you can also capture that invisible mount perspective with a POV view, which is extra intriguing.

• **On your equipment.** As we mentioned in the section on extension poles, you can mount Max directly to your equipment using an extension and an adhesive mount. This perspective can create some amazing follow-along footage and is great for action shots. You can also use some of the other mounts we talked about, such as a Suction Cup or the Handlebar Seatpost Mount, to

mount your camera to your gear, depending on what surface you are mounting to.

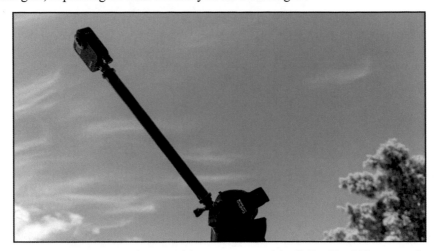

The 12" SP Gadgets extension section is mounted to one of the components of the GoPro Fetch Harness to be worn around the waist.

• **POV Harness or Pole Backpack**. A POV Harness or a backpack with a pole mount allows you to mount GoPro Max out and away from your body so that the camera can follow your action while the mounting set up remains a mystery. There are not a lot of premade mounts available with a waist harness or backpack and a straight pole like you need for 360, so you might have to get creative and make your own. The GoPro Fetch dog harness comes with two mounting plates that give you a good start to creating your own waist harness. The extra trouble is worth it because the shots you can produce with this type of mount can be amazing.

More Tips for Using a POV Mount:

• In HERO Mode, the Horizon Leveling feature is a huge bonus when filming POV shots. As you move and rotate, your camera can keep a steady view of the horizon, resulting in super smooth action shots. This creates amazingly steady videos when mounted to a bike, snowboard, child or pet.

Mounting Examples:

MOUNTED VERTICALLY ON THE SIDE OF A HELMET

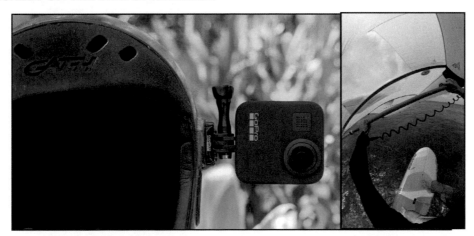

• GoPro Max was mounted to the side of a surfing helmet using the Curved Adhesive Mount and the Mounting Buckle.

• SETTINGS USED: Video recorded at 5.6k-30. The video was then reframed to a 9:16 vertical format in 1080p for mobile sharing and to take advantage of the best perspective using this mounting setup. With 360 spherical footage, you can choose to edit your footage to any aspect ratio, which gives you lots of creative mounting freedom.

Now that you've got your camera mounted, you are ready to move onto Step 4 to learn some vital photography and cinematography knowledge!

STEP FOUR
CAPTURE YOUR ACTION
Learn These "Not-So-Secret" 360 Video and Photo Secrets & Get Results

Now that you understand GoPro Max's settings and have discovered the best mounts to maximize the magic of this camera, it's time to start capturing life's moments. If the setup was the lead in, this is the climax of the story. With the filming tips and tricks in this step, creating a photo or video that holds as much energy as life itself will become natural.

We will break this step down into three sections- filming in 360, working with the 360 Max camera, and specific Max filming tips for vlogging real estate and travel. These techniques will take your filming from standard to extraordinary, so let's begin!

360 FILMING TIPS

Filming or photographing in 360 has its own unique set of skills. Some elements of what's important in traditional photography remain and some are thrown out the window. So, what do you need to think about when composing your shots in 360? **These tips will help you with the most important elements:**

STORYTELLING

When planning shots for your video, remember that you want to tell a story. If you want to make a video that grabs your viewers' attention, **start thinking about your video before you are out there in the action.** The best GoPro videos inspire us and motivate us to go adventure by telling a story, showing the action, and leaving on a high note.

FILM THE PREP

Instead of just recording the main activity, film the preparation. Place your camera close when putting on your gear or prepping your important equipment. On your way out, film a pulled back shot (either on a monopod or a follow shot) leaving for your destination. If filming in 360, as you film, imagine how you will edit these shots later. In HERO Mode, change settings as you film. Use the Linear lens for a more traditional look.

RECORD THE ACTION

This is where you can use your mounting knowledge to record the action. This is where you **show off your skills and most memorable moments** with high action shots or beautiful scenery. Record in hi-res 360 for the most editing freedom when you edit. In HERO Video mode, film at 1080-60 in Max SuperView or Wide for immersive action shots.

MAKE THE ANGLES A MYSTERY

When possible, try to **film multiple angles of the same action without seeing any other cameras** in the scene. This keeps the viewer involved in the action, not in the filming techniques. This is where you can apply your newly acquired mounting knowledge. When filming in 360, can also pull multiple angles from the same shot, facing forward and at you, for example.

CLOSE WITH A BANG

Close your video with some humor or a dramatic point of view shot that leaves your viewer wanting more, or better yet, wanting to go out there and do what you are doing- having fun!

LIGHTING

As with any photography or cinematography, filming in **quality lighting is always going to give you a better starting point** for your imagery.

Of course, you can film anytime of the day, but morning and afternoon lighting produces richer colors. The hours around sunrise and sunset, known as **the Magic Hour or Golden Hour**, are definitely the most dramatic. The long shadows and rich colors during these hours stand out, especially when viewed side-by-side with a mid-day clip. Whenever you can capture photos and videos at these picturesque times, go for it. The resulting footage will make you look like an instant pro.

For the most dramatic lighting, film around sunset or sunrise, known as the Magic Hour in cinematography. Photo taken from a video recorded in 360 Video Mode at 5.6k-30 with Max ISO set to 400.

That being said, a lot of life happens between sunrise and sunset. **Filming in shade**, especially solid shade, also works well for avoiding harsh midday shadows.

Sunny, blue skies or scattered clouds create much more appealing, color rich shots than overcast days. Overcast conditions typically create monochromatic, dull colors and washed out scenes. If you have to film in overcast conditions, try to minimize the amount of sky in your shots by choosing covered locations. Also, editing your footage into black and white can play off of these monochromatic tones and add drama to dull footage.

Another common technique for portraits and fashion is to **film backlit shots of your subjects**. With the sun at your subject's back, typically only soft shadows remain on his or her face. The trick with these shots is that they need to be exposed for the subject, not the overall scene. If you are close enough to your subject, you can use Exposure Lock on your subject to lock the exposure. You can also use Exposure Value Compensation in the Protune settings set at +2. This will make the camera overexpose the shots slightly. You will probably need to fine tune the final exposure when you edit.

TIP: Split Lighting. When recording in 360 with Max, pay attention to how the lighting is different on each side of the camera. Since both lenses are recording, try to avoid bright light on one lens and dim light on the other. With Max, the best way to film in split lighting conditions, such as around sunset, is to **rotate the camera so both lenses share the lighting equally**. Alternatively, when you know you will primarily be using the footage from one of the lenses (say your subject is in front of the sun for example), use hemisphere exposure to set the exposure for one lens. That way you can avoid placing your subject on the side of the frame and possibly near the stitch lines.

TIP: Low Light Situations. Filming in low light situations (early morning, evening, cloudy or shady), will often create blurry photos or videos.

When filming handheld shots in low light, around sunrise or sunset, **raise the ISO to 400** or even to 800 depending how dim the lighting is.

For the best results when you are recording video in low light situations, **use a video frame rate of 24 or 30 frames per second**. A lower frame rate allows your camera to take in more light for each frame, resulting in better quality footage. A higher frame rate (60FPS) is better suited for normal daylight. You can also use Protune to **raise the ISO anywhere from 1600-6400**, but remember that a higher ISO results in video with more noise.

TIP: Speed Blur/Motion Blur. You can **use the low light to your advantage** to create a cool, speed blur background effect. A speed blur usually has an object of focus, surrounded by scenery that appears blurred. In bright daylight, the shutter time will naturally be quick: this creates a shot where everything is in focus and appears frozen. That's perfect for shots when you want that look. This look can, however, take away from the action of the moment and make the scene look stagnant. A slower shutter doesn't freeze the action as much, and as long as you have an object of focus (usually your bike, car, or whatever your camera is mounted to), the speed blur reflects the real movement of the scene.

The easiest way to create motion blur is to **mount your camera to a moving object in low light**. The object will stay in focus because it's moving with the camera while everything passing by will appear to be a bit blurred. If you want to create more blur, lower the ISO to 100. For less motion blur, raise the ISO.

For example, mount your camera to the front of a bike facing back at you so you and your camera move in unison. In low light situations, the camera will not have enough light to keep the passing objects in focus, giving your photos or videos the blurred background effect. This technique works specifically well and looks really eye-catching for TimeWarp sequences but is also noticeable as motion blur in regular speed video shots.

CINEMATIC 360 TIPS

One of the biggest questions new GoPro users want to know is, "How can I make my videos look like a motion picture?" Filming in full spherical 360 is definitely a unique experience, but that doesn't mean that the results of your edited video need to be any less cinematic. With all of the creative editing possibilities, you will find that it's actually easier to create cinematic videos with a 360 camera.

Follow these tips to give your video footage a more cinematic head start. The final cinematic results will happen in the editing room:

• Take advantage of the **highest quality settings** on your camera. Film in 5.6k at 24 or 30 FPS and let this be your go-to. When you reframe to 1080p, this gives you lots of extra resolution for creative editing. Also use a low ISO (100 preferably, 400 max) for bright light shots to get the best quality noise-free video and photos.

• Utilize **slow motion along with movement**. The filming techniques shown in this step, such as panning and tilting, look great with slow motion. Filming in HERO Mode at 60 FPS opens up the possibilities for slow motion. In 360, you can use the ultra-slow motion technique you will learn to create super slow motion from your 5.6k spherical videos. Max

With the right settings and techniques, your GoPro footage can easily mimic cinema quality films.

HyperSmooth Stabilization gives you the creative freedom to film these shots even without a gimbal for smooth footage. If it's bumpy, it won't look cinematic.

• **Put energy into your filming.** Take your filming techniques serious and film as if you are using a bigger cinematic camera. Use a tripod if you need to and treat your camera like it's a cinema camera.

• **Film when the light is right.** Lighting makes the mood and can't be faked even with great editing. Film during the **golden hour** for mood and dramatic shadows. Use **light leaks** to let light filter in and out of your scene. Playing with natural light will make your shots look magical.

• **Film transitions.** As you film, try to remember to film a few of the creative transitions you learned in this step.

• Film in GoPro Color if you want to richest color without much color correction required in editing. When editing, add in **contrast** if needed to deepen the blacks. Adjust **colors** to get your desired look. Flat color will need more color correction to get that cinematic look. Consider exporting your video at 24 frames per second for the most cinematic feel.

• Use **cinematic fonts** to overlay titles in Premiere Pro, DaVinci Resolve or another editing app. Or add a logo to your intro for a professional look. There are tons of fonts available, but a few to get started that can be downloaded for free are Montserrat, Eurostile, Helvetica Neue, Bank Gothic, Couture, Nexa and Bebas Neue.

PERSPECTIVE AND ANGLE

• **Use perspective.** Adjusting the height of your camera in relation to your subject makes a big difference in the perspective of your shots. Some shots look great when your camera is closer to the ground. Shoot from hip-level for a more childlike perspective. Use a pole to place your GoPro really high for an almost aerial-like view. The variety will help to add a sense of wonder and uniqueness to your shots. The height from which you record creates a perspective, and even though you can reframe your shots when you edit, you can't adjust that perspective.

• Especially because of the super wide angle, a 360 shot filmed with your camera set down on the ground is going to look a lot different than a shot recorded high up on an extension pole. **Around head level or slightly above will give you the best perspective for people or vlog shots.**

• **The angle** (on the side, behind, in front) from which you record also has a big impact on your final shot. Following behind your subject is going to produce a far different image than filming from the front. When you edit, you can't magically rotate the camera around your subject unless you actually filmed the shot using that movements.

CAMERA MOVEMENT

Filmmakers use a lot of different movement techniques to make their videos look more cinematic. Some of these movements pertain to filming 360 videos, while others are done when you edit. You will see how easy it is to create some of these movements when you learn to edit in Step 5- Creation.

It's not really necessary for a recreational filmmaker to know the names of the various filming techniques, but an awareness of the various techniques will inspire you to add more flair to your videos. When you watch videos that impress you, pay attention to techniques the filmmaker used to make the video stand out.

In Step 5, you will also learn how to add similar movements to your photos in a snap.

Since most recreational GoPro users don't have expensive filming equipment, it's best to **make do with what you already have** to mimic these techniques in the grassroots do-it-yourself GoPro style everyone loves. The amazing Max HyperSmooth Stabilization on GoPro Max makes all of these shots really smooth, eliminating the need for a tripod or gimbal in most situations.

TILT SHOT

This technique is like **looking up and then down** or vice versa. A tilt shot is filmed by pointing the camera up and then down by rotating it on its horizontal axis. This shot is typically filmed using a tripod.

But with Max, since you have a full sphere to work with when editing a spherical video, you can **mimic a tilt shot when you edit** even if your camera was stationary.

PAN SHOT

A pan shot is similar to a tilt shot, except, instead of moving the camera up and down, a pan shot is **filmed in a side-to-side motion**, rotating the camera on its vertical axis from left to right or vice versa. This technique is like looking left and then right.

Once again, this is one of the cinematic filming techniques that can be replicated when you edit your 360 videos. For eye-catching shots, rotate your camera from an empty scenic shot towards your subject, bringing your subject into the frame. For best results, don't edit the movement in your shots to pan too quickly.

DOLLY

A dolly shot is typically filmed with the camera mounted on a camera dolly, moving **the camera towards or away from the subject.**

In-camera stabilization makes this shot really easy without the use of a dolly. Film your dolly shots by holding Max steady while moving your camera slowly towards or away from your subject. This filming technique looks great with stationary subjects for intros to a video.

To some extent, you can also edit your reframed 360 videos to mimic this filming movement, however, you will be limited to how far you can move in on your subject while maintaining high quality video.

PEDESTAL

A pedestal shot involves **physically moving your camera up or down** in relation to your subject. Since this actually changes the perspective of your subject, this one is better filmed on the spot. Trying to recreate this when you edit looks more like a pan shot than a pedestal.

TRACKING SHOT

In a tracking shot, the camera moves from left to right or vice versa, keeping the camera on the same axis to **move parallel with the subject.**

The Camera Moves Parallel To The Subject

This is one of the cinematic movements you will really want to capture as you film. A great way to mimic this technique with Max is to hold the camera on a pole while riding a bike or skateboarding. The goal is to create smooth movement that moves with yourself or a subject and this happens naturally when holing Max on a pole. When possible, include passing foreground objects between you and the subject for a real sense of movement.

FOLLOW SHOT

In a follow shot, the camera **physically follows the subject at a (more or less) constant distance so you will want to actually film this movement, rather than edit it in later.**

The Camera Follows Behind The Subject

You can capture this angle of yourself by mounting Max on an extension to the back of your equipment, vehicle, etc. With Max HyperSmooth Stabilization, you can also ride behind someone on a skateboard, bike, snowboard or surfboard to follow a friend.

PASS THROUGH

Pass through shots are really fun to add into your clips. To film a pass through shot, utilize the invisible camera effect to physically **move your camera through a space** (such as a tunnel or a tree stump) or between objects (such as stair railings, pier pylons or a window). When you edit the 360 video, you will have lots of fun reframing the journey.

5 IN-CAMERA VIDEO TRANSITIONS

When it comes to editing, most editing apps offer a variety of preset transitions to create move smoothly from one video clip to the next, but you can really set your footage apart by using the Max's stabilization to film in-camera transitions out in the field.

Typically, in-camera transitions are filmed using a gimbal to create smooth movements, however by utilizing the in-camera stabilization in Max, you can really master transitions without the need for a gimbal. If you film with these transitions in mind, when you edit your clips, the hard part is already done. It just comes down to editing two clips together to make the transition happen.

> **TIP:** When editing, use the Cross Dissolve/Crossfade transition in an advanced editing app to transition from one scene to the next (like we will show you in Step 5.)

In-camera transitions are used add more flair to your quality video- kind of like a topping on your ice cream. Pick your favorites and mix them in at the beginning and end of a few of your key shots.

STRAFE BLOCK

This is probably the easiest transition to film and actually remember on the scene. For a strafe block transition, **move your camera sideways using a foreground object close to the camera to blur** the end of one scene and transition to another. By filling your frame with an object (someone's body, a vehicle, a board, etc.), you can then use the same object to transition into the

next clip. The key is having the same object at the next scene.

With the ultra-wide angle lens on Max, you will need to get as close to the object you are filming as possible to completely cover the frame. When you edit, you will have to remember the transition and reframe the shot to create the transition. Alternatively, you can use Linear or a zoomed in field of view in HERO Mode to reduce the wide angle perspective.

PUSH IN/ PULL OUT

Move in on a subject to **completely cover the frame**, and then pull out to reveal a new subject. For example, you could walk towards your subject, filling the frame with your subject's back. Then move locations and start your shot close to your subject. Pull away to reveal a new scene.

The push/pull transition is similar to the strafe block, except that it defines the camera's movement as moving in and out on a subject. Once again, you won't be able to completely fill a 360 sphere, but you can compose this shot in the Touch Screen and edit it to fill the frame when you reframe the video.

THROUGH THE GLASS

Creating the effect that you are **moving from outside of a window through to the inside** is easy using a 360 camera. Just use the Suction Cup to film a view outside of a window or door in 360. Then, film the inside view from the opposite side of the door. When you edit, it's easy to rotate the shot to make it appear that the camera moved right through the window or door.

SKYFALL

Start on a subject. At the end of your shot, **tilt up to the sky**. Start your next shot aimed up at the sky. When you tilt back down, bring the viewers into another clip or scene. This transition is easy to create with Max because you always have sky in your 360 shots.

WHIP-PAN

When filming in low light, **utilize a motion blur** to end one scene and begin another. Create a fast side-to-side motion to end a scene. In the next scene, continue that motion so you can fade in to begin the next clip.

SETTING UP YOUR 360 SHOTS

A lot of the shots you will be filming with Max will probably be used for reframing into a traditional format video or photo, which means you will zoom in or out, add keyframes and flatten the view when you export.

However, if you want to record full spherical 360 with the end goal of sharing a 360 video or photo, there are some special filming tips you should follow for the most mesmerizing 360 videos and photos possible:

Scope The Scene- Take the extra time to look around to find the best vantage point for filming a full spherical view. By centrally placing your camera in a scene, your audience will have more opportunities to look around and explore. Also, take into account the audio because spatial 360 audio adds in another element of wonder. If you get the audio right, it will add a lot to your 360 videos.

Disappear From The Shot- If you are filming a 360 scene, it's best to start recording and then hide out of view. For photos, you can use the Self-Timer to hide from view or the GoPro App/WiFi Remote to press the Shutter remotely. A 360 video or photo is much more mysterious without the filmmaker standing by. Since you won't be by the camera, make sure the camera is in a stable position that won't be blown over by a strong gust of wind and that it's also in a safe spot where no one will take it.

Watch Using the GoPro App- If you are close enough, you can preview the scene and start recording using the GoPro App. You can't watch a live view of 360 videos on the App yet, but you can take 360 photos remotely using the App.

Give It Time- Depending on your goal for the video, you will want to video at least a few minutes. This will give you enough time to reframe the video for different view, or for a viewer to look around the scene.

UNIQUE 360 SHOTS

There are some shots that are totally unique to 360 spherical photography and cinematography that are good to know about when you are out filming. Let's explore how to capture these unique 360-specific shots. You will learn how to edit these in reframing tips in Step 5.

Tiny Planet or Rabbit Hole- A tiny planet shot is where the photo or video is zoomed all the way out, making it appear that the subject is on a tiny planet floating in the sky. The opposite of a Tiny Planet is called a Rabbit Hole shot, where the sky is in the center of the shot and the landscape swirls around it. Both of these shots can basically be reframed from any video or photo filmed in a 360 mode. You can create tiny planet videos, photos, or timelapses, or simply use a tiny planet perspective as one of the views in a reframed video. To film a tiny planet shot, mount your camera on the end of a handheld pole, monopod, or extension pole so there is plenty of distance between your camera and the surface its sitting on (or from the subject). High cloud formations and sunset colors will help add more drama to these shots.

A Rabbit Hole 360 Photo. Edited in the Circular Tiny Planet App.

Running The Planet. (Roll Planet)- A Roll Planet shot is a Tiny Planet or Rabbit Hole shot with a subject running around the sphere in the middle. To appear that you are running around the tiny planet, set the camera on the ground and move in a circular motion around the camera.

Jump Planet- A jump planet is also a type of tiny planet shot, but this one is created by mixing together different scenes to make it appear like you are jumping planets. To film a jump planet shot, jump up when holding the selfie pole in variety of scenes.

ACTION

Once you are ready to start recording some of life's moments, how you film will have a lot of impact on the overall quality of your videos and photos.

Use these tips when filming the action with your GoPro to give your videos and photos an experienced look:

• When filming, remember to **keep your camera steady and let the action create the movement.** With video shots, a steady camera helps create footage that is easy on the eyes- too much erratic movement and it becomes hard to watch.

• Recording in 360 can be confusing to compose when you think about it too much. To start out, you can **film as if you are filming through one lens**, looking at the Touch Screen to compose your shots as you film. You can always reframe that same perspective from the 360 clip, but once you begin to edit, you will see the potential of having the spherical image to work with.

• When taking photos, **a steady camera** helps ensure that your photos will come out "sharp" and in-focus.

• For video shots, it's best to either film **using one of the cinematic filming techniques** shown in this step or **use no movement at all (keep the camera still)**. This will give your videos a more polished, professional look and be much more enticing to watch.

• **Short clips vs long.** For editing purposes, it's easier to **stop recording in between "action" moments**. If it's too hard to reach your camera or your activity doesn't allow it, you can film continuously. It just means you will be dealing with larger files and searching through longer clips of footage later to find those "WOW" moments. You can also **utilize HiLight Tagging** as described below.

HILIGHT **HiLight Tagging**

Finding your magic moments during a video clip can send you on a long search through your files. Taking advantage of a feature called HiLight Tag might just be your solution.

When something memorable happens while you are recording, press the Mode Button on the side of your camera. Pressing this button will add a HiLight Tag. If you are using Voice Control, just say "GoPro HiLight". You can also add HiLight Tags while recording with the GoPro App or the Smart WiFi Remote.

When playing back video on the Touch Screen, Tap the HiLight icon on the Touch Screen to add a HiLight after the fact.

HiLight Tags will help you remember which clips have the goods, which you can make a note of when you go to edit a video. These HiLights also give the GoPro App even more info for creating automatic QuikStories on your phone. Adding a HiLight Tag does not affect your video footage or add anything visible to the video.

WORKING WITH THE 360 MAX CAMERA

The tips in this section will help you **work with the unique qualities of the GoPro Max camera.**

THE WIDE ANGLE LENS(ES)

GoPro Max uses two built-in Fisheye Wide Angle Lenses to record the full sphere required for 360 shots. What does this mean? A fisheye lens is **an ultra-wide-angle lens that allows more of the scene to be included in the frame.** Especially when fully zoomed out, fisheye lenses cause curvature around the edges of the frame.

The Fisheye Wide Angle Lenses are perfect for GoPro Max camera for several reasons:

1. The camera **can be mounted extremely close to you** and still capture you in the image.

2. The lens has a short depth of field, which means **everything from about 3-4 inches away from the camera and beyond will be in focus.** This is great because you don't ever have to focus the camera.

It is important to understand the best techniques for working with these fisheye lenses because wide angle photography is an art in itself.

Here are some vital tips:

1. **GET CLOSE!** The fisheye lenses used on GoPro Max make objects appear much further than they really are. If you aren't close to whatever you are filming, your subject will be very small in the frame. You know how some rear-view mirrors on cars say, "Objects May Be Closer Than They Appear". The same is true with fisheye lenses because they distort the perspective to make things look smaller than they look with the naked eye. Remember this and **get closer to your subject than you think you would need to.** By getting close to your subjects, your capture more engaging photos and videos.

2. When you edit, **placing the subject or horizon in the middle of the frame results in the least amount of distortion.** As you will see when you edit, as you tilt up and down, the horizon will become more curved and distorted. Because of this, when possible, try to place yourself or your subject closer to the center of the frame. It just makes reframing easier.

You can see the difference reframing can make in the appearance of your shots. Both frame grabs are from the same moment, but in the shot on the right, the centered horizon reduces distortion dramatically. Recorded on GoPro Max in 360 Video Mode at 5.6k-30.

If the horizon is towards the top or bottom of the frame, it will have a curved appearance. When you learn to reframe your videos in Step 5, you will see the benefits of straightening the horizon.

In HERO Video Mode, you can use the Linear lens to reduce the fisheye effect.

3. Use the foreground to your advantage.

Taken on GoPro Max in 360 Photo Mode using the Self-Timer. The makeshift stick shelter on the beach provided a great frame for the photo.

With the close focal range of GoPro Max's wide angle lenses, **give your image more depth** by framing an object near the foreground. Try placing the camera near some flowers, trees or your gear to create a sense of perspective. You can even create a cool look by "framing" your image with a foreground object. These foreground objects can add depth to both 360 and traditional photos and videos.

4. Work with the sky.

Taken on GoPro Max in 360 Video Photo Mode at 5.6k-30. The high clouds add to the composition, rather than detracting from it. Sunset colors add more dramatic shadows throughout the scene.

Because wide angle lenses capture so much in the frame, high clouds and sunset colors in the sky add a lot of drama to a scene.

THE STITCH LINES

When filming in 360, GoPro Max is pretty accurate at seamlessly merging the two hemispheres without a noticeable stitch line. However, the stitch line is sometimes partially visible. Making that stitch line unnoticeable is important to the quality of your 360 shots. **These tips will help you avoid seeing the stitch line as much as possible:**

• **Frame your subject away from the edges of either lens when possible.** Since you have to mount Max in line with the pole for the floating camera effect, holding your camera on a pole away from you often places you near the stitch line. When possible, tilt the pole up slightly to place yourself away from the stitch line.

• **The longer the pole, the better the stitch line.** You want to keep your camera at least 10 inches from the mounting base or from your hand if you are holding the pole. If your camera is any closer than that, the stitch lines will not line up properly.

• When filming in 360, as much as you will be tempted, **don't angle the camera on the pole** just to center yourself in the frame. Due to the way the camera stitches the images, you will end up seeing a cutoff pole in your shots.

EXPOSURE

Exposure refers to the amount of light let into your camera during recording. "Correct" exposure is usually a balance between overexposed (where there is a loss of detail in the bright, highlighted areas) and underexposed (where there is a loss of details in the darker, shadowed areas). Getting correct exposure is easiest to capture in front-lit or sometimes cloudy conditions. If you are shooting in other lighting conditions, in most situations, you may want to adjust exposure in editing software after you film.

By default, GoPro Max camera sets exposure automatically. However, there are **three ways you can affect the exposure:**

1) One way is to **use Exposure Control on the Touch Screen for tricky lighting conditions** as discussed in Step 2- Settings. Exposure Control enables you to adjust exposure for one hemisphere or for a specific area of the frame. If your shot is too dark (underexposed), set the Exposure Lock on a dark spot. This will lighten the exposure.

2) The second way to affect exposure is to **use the Exposure Value Compensation** in Protune. You can adjust the exposure by telling the camera to make your video or photos up to two stops brighter (+2) or darker (-2). You can instantly see the effect of your changes on the Touch Screen.

3) The third method is to **use Shutter Speed and ISO lock** to manually set your exposure, as you learned about in the Protune video and photo settings in Step 2. The Live View on the Touch Screen is a great tool to determine the correct exposure.

AUDIO

Audio is an important element for most videos, especially scenic, lifestyle and vlog clips. GoPro Max features six microphones for full 360 "ambisonic" audio with several options to choose from. We cover these options briefly in the settings menu, but let's go into more depth here so you can get the best audio possible from GoPro Max.

The improved audio recording and controls on GoPro Max let you capture amazing high-quality footage with audio to match. The camera's internal audio recorder selects the best audio from six microphones and compiles a spherical 360 audio track and a stereo audio track.

There are several options for recording audio, which were covered in Step 2- Settings, but here is a quick recap:

Wind Reduction (in Protune settings for a video preset) enables you to change settings for high wind or low wind situations, instead of letting the camera's internal recording system decide. Set Wind Reduction to On if you want the camera to always filter out excessive wind noise. Wind Reduction in Max works really well to reduce background noise, making your voice stand out. You may hear a slight buzzing in really high wind conditions where the camera had to reduce a lot of ambient noise.

Most people don't need this, but when you enable **RAW Audio**, which is found in the Protune settings for video presets in HERO Mode only, your camera records a separate .wav audio file, in addition to the video's audio file. You can choose how much internal processing you want for the audio- Low, Medium or High.

More Max Audio Tips

• **Talk to your GoPro's mic before saying your real dialogue** to help calibrate the microphones. This will help maintain even levels throughout your dialogue.

• In windy conditions, **set the Wind Reduction to On**. The new mic does a superb job of reducing wind noise while keeping your voice clear.

• If you plan to share your videos in full spherical 360 for a virtual reality experience, **record in spherical audio mode**. This will give the viewer a more realistic spherical experience as they change the focus of where they look.

• If you have a specific direction of focus **in HERO Mode, use the microphone on the same side of the lens**. This does make a noticeable difference in audio quality, which is especially useful **for interviews, vlogging or any dialogue in general**.

• Alternatively, you can use your phone to **record a separate audio track** to synchronize with your GoPro video footage. You

can hold the phone close to you but out of the video frame while you video. If wind is a problem, use a lav mic (Rode Lavalier Mic is a good one) with your phone or a portable recorder. Use this technique when stereo audio is all you need.

• If you go underwater, the microphone openings tend to hold some water. **Blow them off to remove the water** from the tiny holes to capture the clearest audio possible.

BATTERY LIFE AND EXTERNAL POWER

GoPro Max uses a removable, rechargeable 1600mAh lithium-ion battery that should give you about 1.5 hours of recording time in 5.6k @ 30 frames per second or up to 2.5 hours in HERO Video Mode in 1080p @ 30 frames per second. As you can see, higher resolution and frame rate video settings require more battery life. The actual recording time depends of a few factors. Battery recording times will be less in cold weather.

If you decide to use your phone's charger to charge the battery in-camera, GoPro Max requires a **charger that outputs 5V and 1-2A** so check your charger before you connect it to your GoPro. Max is also compatible with external USB power, so if you want to use an external USB power source, you can run off external power for an extended amount of time. Using the wrong power bank or charger could potentially damage the battery. The side door doesn't have an opening for the USB cable when closed, so you can either open the door or buy the Ulanzi Side Door for Max which has an opening for the USB cable.

In addition to charging the battery in the camera using the USB cable, you can also use the GoPro Max Dual Battery Charger. This charger allows you to charge the batteries out of the camera leaving your camera available for filming. The Dual Battery charger can use USB power or a wall socket and comes with one spare battery, which is very useful to have on hand.

Unlike NiCad batteries, Lithium batteries don't have a memory charge, so recharging your battery even if it is not completely drained will not reduce the battery life. Like all lithium-ion batteries, the battery in Max will eventually lose some capacity over time, so a fresh battery may be your best bet if you notice that your battery stops performing like it used to.

Follow these additional tips to preserve your battery's life:

• **Store your camera at a normal room temperature** when possible. Try to keep your battery out of extreme heat, especially when fully charged. Keeping your camera (with the battery in it) in a hot car will deteriorate your battery's capacity.

• If you need **to store a spare battery for an extended period**, use it until about 40% battery life remains and store the battery in sealed bag in the refrigerator.

There are several things you can do to preserve battery life while actively using GoPro Max:

• If you know you won't be filming for a while, **turn your camera off to save battery.** Your camera will go into standby mode after about five minutes of inactivity. This standby mode greatly reduces the amount of battery being used. But if you know you won't be filming for a while, it's easy to hold down the side Mode button to turn off your camera or say "GoPro Turn Off" so it doesn't use any battery life.

• **QuikCapture Mode reduces standby time** by turning your camera on and recording with one push of the button. There is a delay however while you wait for your camera to turn on, so QuikCapture doesn't work for all filming scenarios.

• **Turn off the WiFi if you are not using it.** The WiFi uses quite a bit of battery power to create the wireless signal. Keeping WiFi on is worth the reduction in battery life as long as you are using the GoPro App or WiFi Remote. But, if you are not using either of those, turn off the WiFi in the Preferences>Connections dialog in the Dashboard on the Touch Screen.

• The Touch Screen also uses up a good chunk of battery. If you are using the Touch Screen often and don't need the full brightness, you can reduce the screen brightness in the Preferences menu. If you are primarily using the Touch Screen to set up your shots, **let the screen go to sleep after you have composed your angle** and tightened your camera in place.

OVERHEATING

GoPro Max, like many GoPro cameras and other high performance video cameras, will overheat if you record long enough. When recording in high resolution, such as 5.6k 360 video, the camera will get very hot. This is normal. Once it gets too hot, the camera will shut off to protect itself. This also happens with many other cameras and has to do with the fact that high resolution videos demand a lot of energy from the camera. If your camera overheats, you just have to wait for it to cool off. Recording in HERO Mode requires less performance and will give you longer recording time before the camera overheats.

Record shorter clips when possible which gives the camera time to cool off in between recording.

VLOGGING, TRAVEL, and REAL ESTATE TIPS

VLOGGING TIPS

Video recording in 360 Video Mode at 5.6k @ 30 FPS. GoPro Max was handheld on the SP Gadgets 12" Section Pole with a monopod base.

With the explosion in popularity of vlogs, the design of GoPro Max really opens up the creative options for vloggers. Max's unique 360 features make it **the ultimate vlogging camera**, especially if you are planning to post your traditional videos reframed to 1080p.

Max is small, portable, and versatile. When using Max, you can create **a wide variety of shots with a single camera** making it the perfect camera to carry with you in your pocket on your adventures.

Vlogging Video Tips

• Both front and back lenses record equal quality video and photos. If you want to see yourself on the Touch Screen while you film, use the back lens to compose your shots. After selecting your settings, make sure to tap the screen to hide the touch screen icons for a clear view of the scene.

• If you are not filming for slow motion in HERO Mode, **filming at 24 or 30 FPS requires less light**. This will produce sharper videos in low light scenes. And with Max HyperSmooth, you will get smooth, stabilized videos straight out of the camera.

• **Don't forget those other modes.** Use Video Mode for the majority of your shots, but TimeWarp videos can be used to add some unique clips into the mix, especially with real time video mixed in (in HERO Mode). For Instagram, film or reframe vertical TimeWarp videos for a truly full-screen mobile experience.

• One of the biggest benefits when filming in 360 is that the invisible pole makes it appear that someone else is filming you. **A**

longer pole/selfie stick such as the 270Pro or Max Grip will give you more flexibility for reframing your shots when you edit. As you film, keep the camera at eye level or slightly higher for a better angle of you. Looking up from below the face widens the chin and can create a double chin look. Try to aim the lens towards you as much as possible.

• If you don't need the floating camera effect, when filming **in HERO mode** for example, **tilt the camera on the pole for an easier angle to center yourself in the frame.** Use the back lens to record and compose your shot on the Touch Screen.

• When recording for Instagram in HERO Mode, **rotate vertical** to maximize screen space on mobile devices. For Instagram Stories, use the Clip timer set to 15 seconds for automatically trimmed clips to upload.

• In HERO Mode, **use a variety of lenses** according to your shots. For scenic shots and mounted action shots, use Wide for the most scenery and beauty. When talking to your camera in a selfie shot, try out Linear for a more traditional look with less fisheye. With 360, you can also reframe your shots to affect the lens using techniques you will learn in Step 5.

• Horizon leveling is another amazing feature to **keep your footage stable** even when you're not paying attention to how you're filming. The stabilization and horizon leveling capabilities make filming yourself almost foolproof.

• **Add some lighting.** Some fill light, such as a panel light or GoPro's light mod, helps to add a more professional look. When using a metal vlog case like the Ulanzi case, you can easily attach a light for better lighting on yourself or your subject. See Step 7 for more information about the best lights to use with GoPro Max.

When you are outdoors, **look for shady areas that are still bright**. This will give you the most even lighting on your face. Indoors, try to avoid artificial lighting. Rather, look for some **nice filtered light from windows** to light you up against a darker background. If you can find a sunlit area against a dark, shadowed background, this also adds some dramatic lighting.

• When recording in 360, since Max can record everything at once, you can pull **multiple angles and clips from the same shot.** Vloggers won't need to rotate the camera to show what they're looking at or talking about. Just recompose the shot when you edit and it's good to go.

• Use **catchy transitions** between views to keep the vlog interesting. For example, if you reframe from the front to rear lens view, use a quick motion and add a swish sound effect.

Audio Tips

Since Vlogs require talking to the camera, high quality audio is vital to a successful vlog. Use the tips in the audio section of this step to record the best audio possible with Max.

MAX BASICS FOR THE TRAVELER

Thanks to its compact size and crystal-clear image quality, GoPro Max makes the **perfect travel companion**. Capture your memories so you can bring them home with you, but remember these helpful GoPro travel tips so you score the footage without getting bogged down.

• Consolidate your gear. Even if you have a full collection of mounts and accessories (because there are lots of options), **only bring what you need**. **Extra batteries** are always useful, along with a **charger that can be used at your destination**. Figure out if a car charger, wall charger, or maybe even a solar charger goes best with your travel plans and go with that. **Pick two or three of your most versatile mounts**- preferably at least one that can record POV angles, and your favorite pole with a monopod base- to film a variety of angles with minimal gear.

• Look at other media for an **idea of an area's highlights**. Local postcards, calendars, and artist's landscape paintings usually show an area's best attractions, so use these as inspiration. Check Instagram to see what other people are photographing in a particular area and then capture your own perspective of the sites that interest you.

• Edit your 360 videos for **a variety of perspectives**. The ability to edit multiple angles from one video means you can film more travel shots in less time than ever and create multiple photos and videos from one video clip. In HERO Mode, **use a**

combination of fields of view to add variety. Use Linear shots for scenery. Zoom in for close-ups of cultural details. Mix in Wide for point of view shots and unusual angles. Mount your camera to a moped, scooter or vehicle. A variety of perspectives in your shots will keep your viewers interested longer.

• TimeWarp Mode is the perfect mode for **travel hyperlapses**. Film a few time lapses or hyper lapses of scenic highlights for extra mood. Film from the top of a tall building, near a bridge, over a river or around city lights for a different overview. When you edit, pan around the shots for an inclusive look around your destination.

• If you have their permission, **film people** because personalities add character to a place. Or film your travel buddies to add a subject in your shots.

• **Record the sounds** of a place, such as city sounds, nature, trains, etc. especially in full 360 spherical audio.

Most of all, have fun, because that will make the best videos!

USING MAX FOR REAL ESTATE

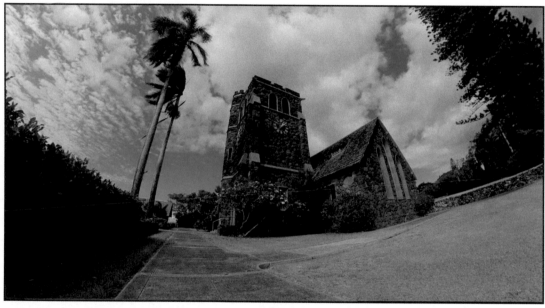

Photo taken on GoPro Max in 360 Photo Mode at 100 ISO for the best quality. The camera was set down on a monopod and the self-timer was used to exit the scene before the camera took the picture.

A 360 camera like Max is **an essential tool for real estate marketing and virtual tours**. With 360 Virtual Tours becoming a standard component to a real estate package, real estate walkthroughs and other virtual tours offer huge potential for making money with your 360 camera.

Whether you are creating real estate walkthroughs or virtual tours of museums, art galleries, hotels, vacation rentals or other attractions, a 360 camera like Max gives you the tools you need to create professional-looking virtual tours.

Lots of companies are offering virtual walkthrough creation platforms, but some of the best to start with are Pano2VR, Kuula, 3D Vista or Panoskin Theasis.

To create the photos you need for these virtual tours, all you need is your 360 camera, a monopod that extends to at least eye-level, and a little bit of knowledge.

Here are some tips to get you started creating your first virtual walkthrough:

• **Mount your camera straight up on a monopod** and extend your camera to around eye-level (5' from the ground) for the most realistic perspective of someone actually walking through a property. Set your camera on the ground when possible, but if you have to set your camera down on a surface, such as a table, still try to maintain that eye-level view. Try to avoid any reflections

that will show your camera to reduce the amount of editing you will need to do later.

• Try to set your monopod **on an easy area to clone** out the monopod feet. For editing, a solid color floor or table is much easier than a complicated tile pattern, for example. We will show you how to clone in Step 5- photo editing.

• **Set the stage.** Before you take any photos, look around to make sure the property is clean, empty of people (so you don't have to sign model releases) and as beautiful as possible. It's not technically your responsibility to stage the property, but your clients will be happier, and you will look more professional if you deliver imagery of a presentable space. No one is going to be happy if there is a towel laying on the ground, for example. Also, turn on all of the interior lights before taking photos.

• **Use 360 Photo Mode** to take the photos needed for the virtual walkthrough. Take photos with the camera facing the same direction when possible. Use a low ISO of 100. With the constant mix of lighting sources, setting a manual white balance setting can be tricky. For the best white balance settings, take a picture first using a gray card. Place this card near an area that you want to make sure the White Balance is accurate, near a wall for example. Then, take the same photo again without you in it. You can match the white balance from the first image to the second image using Photoshop or Lightroom. Set the self-timer to 10 seconds and disappear from the scene. Or use the Smart WiFi Remote or GoPro App (if the distance is not too far).

• **Plan out your walkthrough.** You want to give viewers a smooth flow as they move through a potential purchase property. Place the camera near the center of each room so they can view all of the areas from a relatively equal distance. Also, always plan one shot ahead. Try to take one photo about every 10 feet for apartments and one photo every 20 feet for larger spaces. As you take a photo, you want to make sure you can see the next camera location. That way, when someone is moving through the tour, he or she can see the next point and easily move through the property.

• Once you have a complete tour of high quality images, **use one of the walkthrough apps listed above** to deliver the goods and make your clients happy.

Now that you have the knowledge to capture your footage, get out there and start filming! In Step 5, you will learn how to edit your photos, videos and time lapse clips!

STEP FIVE
CREATION
Now It's Time To Put It All Together

So, now you've got the footage! Editing with Max is one of the most exciting steps of the process. The creative possibilities are unlimited! This is where you are able to take your raw footage and translate it back into an experience both to remember and for others to enjoy!

In this step, we will first show you a variety of editing techniques for editing your GoPro Max videos. Then, we will show you some of the essential techniques for editing GoPro Max photos. Follow the steps below to create your own masterful 360 content!

BEFORE YOU START EDITING

TRANSFERRING FOOTAGE

To begin editing your GoPro footage, you need to transfer your videos and photos from the microSD card in your camera to your computer or phone. After transferring your files, if you sign up for a GoPro Plus account, which is GoPro's subscription cloud service, you can access your full resolution files on any computer or device.

Saving Files To A Phone/Tablet

The GoPro App is the easiest tool to use for transferring your footage to a phone or tablet. **Follow the steps below to transfer your GoPro footage to your phone or tablet:**

Step 1: Open the GoPro app and Tap the Camera Icon at the bottom of the App. Navigate to GoPro Max's connect dialogue. (Make sure the camera's Wi-Fi is turned on.)

Step 2: Select View Media to connect.

Step 3: Tap on the photo or video thumbnail to preview a low-resolution version. The images will appear to be blurry because of the low resolution .LRV file used for the preview.

Step 4: Tap the Download icon for any photos or videos you want to save your device. This saves the high-res file to the GoPro App's media library on your phone or tablet.

> **TIP:** If you want to edit a photo or video outside of the GoPro App, open the file in the media library. Then tap the download icon again to save the file to your phone's photo library (or to share the file).

> **TIP:** If you have already downloaded the footage off of the microSD card onto a computer and still want to edit the files on a mobile device, you can text or email them to yourself from your computer and save them to your device's photo library.

Saving Your Files To a Computer

If you plan on editing your photos or videos on a computer, or just want to back up the files to a computer, **follow the steps below to transfer your GoPro footage to your computer.**

Step 1: Remove the microSD card from your camera. Insert the card into the adapter that came with your microSD card and insert the adapter into the SD Card slot on your computer. **Note:** If your computer does not have a microSD card slot, the easiest option is to use your phone/tablet to save the files. Then use one of the file sharing options in Step 6 to transfer the large files.

Step 2: The microSD card icon will show on your desktop screen. It should be called Untitled or No Name. **Double click** to see the contents. **Double click again** on the DCIM folder. Inside that folder will be one or more folders called 100GOPRO, 101GOPRO, etc., depending on how many files you have stored on your card. Open these folders and drag the files from each folder over to a new folder on your computer. Note: The .LRV (low resolution video) and .THM (thumbnail files) are used with the GoPro App so you don't need to keep them on the computer.

> **TIP:** **Organizing Your Files.** If you don't already have a format for organizing your media, you may want to set up folders by date. Make a year folder with month subfolders. Within those you can add the day if you want. Since the .360 files are hard to preview as a thumbnail, you may also want to add a subject name.

Step 3: View your transferred pictures and videos. The pictures and videos you just transferred are now copied onto your computer.

Step 4: Now you are ready to start editing.

> **TIP:** **Quik for Desktop.** GoPro's legacy desktop App, Quik for Desktop won't import your 360 GoPro Max files.

> **TIP:** **Split Video Files.** Be aware that your camera will automatically split long video files into multiple video files. On Max, files will be split once the file size reaches 4GB, which is after about 8 minutes if you are recording in 5.6k-30. Lower resolution videos will record for a longer period before splitting. There is no interruption during recording and the time counter on your camera shows the total time recorded, regardless of how many files are created.
>
> The reason for these split files is for compatibility with the FAT32 formatting usually used within the camera, which is limited to a 4GB maximum file size.
>
> The split files will be named GS01... and GS02... with the same ending digits. Split videos can be seamlessly merged back together in video editing software and you won't lose any video time.

STORAGE

Your GoPro files are going to require a lot of storage space. You will probably want to **dedicate an external hard drive to your GoPro files** (or at least a big block of memory). How much storage you need really depends on how often you use your camera, but a portable 5TB hard drive is a good starting point. Go bigger if you can. An external hard drive is the easiest way to keep your full resolution files on hand. If you do most of your editing on a device, you can also use GoPro Plus cloud storage for unlimited backup of your photo and video files at the original resolution if you are a GoPro Plus subscriber, but transferring large files to the cloud takes much longer than transferring to an external hard drive or computer. And remember to always back up your files to cloud storage or another external hard drive because you don't want to lose all of your hard-earned memories.

DELETING FILES

To prevent the accidental loss of files, the microSD card is set as Read-Only. When your camera is plugged into the computer with a USB cable, you can copy files from the camera onto your computer's hard drive, but you do not have the ability to delete files from the microSD card. Instead, if you want to format (erase all files) from the microSD card, you can use one of the following options:

On the Camera

Using the Touch Screen:

1. Swipe Up to view your files and select the Grid Icon.

2. Select files to delete one-by-one or select all files by tapping the check mark.

3. Tap the Trash Can Icon again to delete selected files.

To format the microSD card:

1. After you have copied the files from the camera to your computer, swipe down on the Touch Screen to bring up the Preferences Menu.

2. Scroll to the bottom of the Preferences until you see the Reset option. Under Reset, tap Format SD Card.

3. The screen will ask if you want to Delete all files. Tap Delete.

Use the GoPro App

You can also copy and delete files using your smartphone or tablet.

To erase individual files:

1. With your camera connected to the GoPro App, view your Media in the App.

2. When you select a video or photo file, tap the three dots in the top right corner. Select Delete to erase that specific file. You can erase video files, a batch of Time Lapse photos, or individual photos from a Time Lapse sequence.

To format your camera's memory card (which erases all of the photos and videos) using the GoPro App:

1. With your camera connected to the GoPro App, Control your GoPro and select the Settings Icon in the top right corner.

2. In the Settings Menu, under the heading Delete, you can choose to Delete the Last File or Delete All Files from SD Card.

VIDEO EDITING

In the video editing section, you will learn exactly how to edit your GoPro video clips into a short video using FREE apps when possible. Whether you want to post a single clip to Instagram or create a fully-edited video, editing (also known as "post-production" in the video world) is where you **take the results of your creative filming and put together the pieces to share your story.**

Luckily, most of the tools you need for producing professional-level content are available for free: you just need to know where to look and we will show you. There has never been a better time to get started with your 360 video editing!

When editing your 360 videos, there are **two formats for outputting your videos, either as a 360 spherical video, or as a "reframed" standard video,** such as 16:9, 4:3 or square 1:1.

The output you choose has a huge impact on how you edit your videos. Reframed videos offer more editing creativity and are the most popular for standard viewing. 360 spherical videos give your viewers the power to look around the scene to choose their view for a full 360 experience. We will cover both types of editing in this step.

First, we're going to show you how to edit your 360 videos on a mobile device, such as your phone or tablet. We will be using the GoPro App since the 360 editing tools on the app were designed to work with GoPro Max.

Once you learn the basics, editing 360 videos using the GoPro App on a mobile device is quick and relatively easy. Mobile

editing, however, does not produce as high quality videos as computer editing. If you're editing videos for Instagram, mobile editing is fine, but for YouTube or professional level content, you will want to use a computer to edit your videos.

Then, **we will move over to computer editing** to show you the next step in high quality 360 postproduction. Many of the techniques you learn about for mobile editing transfer directly over to desktop editing, so we can begin with the basic concepts using mobile editing.

Editing on a phone or tablet is totally optional. Everything can be done on a computer as well. Even if you plan to edit solely on a computer, **please read the mobile editing section to understand some of the basic concepts that are so vital to editing 360 content.**

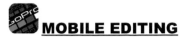

MOBILE EDITING

Use the GoPro App to transfer two 360 video files to the GoPro App Media library on your phone or tablet. **Follow these step-by-step instructions to edit your 360 videos using the GoPro App:**

1- Open Your File

Now that you've transferred the files to your phone/tablet, it's time to start editing. Let's open the file you want to work with.

1.1 In the Media Gallery on the GoPro app, **select a 360 video file to begin with**.

1.2 Tap the 360 icon to open the file.

#2- Preview Your Video / How to Navigate your 360 Videos

The first thing you will want to understand is how to adjust the composition so you can plan a rough vision of what you will edit. On a phone or tablet, there are three ways to adjust the composition, which are all pretty intuitive.

2.1 To **Pan and Tilt** around the scene, you can either physically move your phone around and/or drag your fingers on the screen to move the image.

2.2 To **Zoom** in and out, pinch your fingers together or apart just like you would to zoom in on one of your phone's photos.

2.3 To **Rotate** the horizon, use two fingers to twist the perspective.

#3- Understand The Editing Options

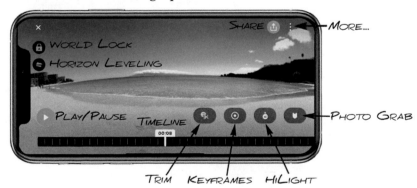

The GoPro app appears to be very simple but actually offers more edit options than meet the eye. Let's take a look at the editing icons to see what is possible when editing using the GoPro app.

3.1 World Lock- When World Lock is enabled, the camera will point in the same cardinal direction throughout the entire clip. As you rotate, the camera will stay fixed on a direction even when you are rotating your camera.

3.2 Horizon-Leveling- This feature locks the horizon and keeps it as level as possible.

3.3 Trim- Use this icon to trim a section out of the full video. This is especially useful to trim off the beginning/end of the clip if you physically pressed the Shutter Button.

To trim your videos, tap the Trim icon. Slide the timeline to scrub to the moment you want your clip to begin. Then tap the trim icon in the timeline.

Slide the timeline to the moment you want to end the clip. Press the trim icon again. Note: you don't you don't need to choose your angle or perspective yet.

Press Save and save it as a new clip. The new trimmed clip will now be in the editing screen.

3.4 HiLight- Add a HiLight to mark the best moments of your video for the GoPro App to use when you edit a Story.

3.5 Photo From Video- Use this icon to extract a still photo from your 360 spherical video. We will cover this in the photo editing section, but this is a super useful tool for pulling high quality still photos from your videos.

TIP: Exporting 360 files from the GoPro app. If you want to export your video as a 360 spherical video, there is not much editing to do be done in the GoPro app. You can trim the video using the trim tool to cut out unwanted parts and turn on World Lock and/or Horizon Leveling if wanted.

Because you're exporting the full 360 sphere, any compositional adjustments you make will not affect the final video. If you export your 360 videos as a spherical video from the GoPro App, you can then edit this file in another editing app. However, exporting a 360 spherical video will result in a slightly smaller video resolution than if you convert your files using a computer app, like you will learn to do next. The video file resolution is 4096x2048 from the GoPro App vs. 5376x2688 on a desktop app.

#4- Reframe Your 360 Video

The Keyframe Icon is the way to really begin reframing your 360 videos to a traditional video. This is where the creativity can start to flow freely.

If you are new to video editing, keyframes are probably a new concept. Keyframes are essential to reframing your 360 content. A keyframe is used to save the composition (zoom, pan/tilt, rotation) at a specific moment in the video. As the video plays from one keyframe to the next, the composition will transition to the next keyframe's settings.

For example, if one keyframe is set to a zoomed in view and the second is set to a tiny planet view, as the video plays, it will slowly transition to the tiny planet view. There are several options for adjusting the transition which we will cover next. **Follow the steps below to begin reframing your video.**

4.1 Keyframes- Tap the keyframe icon and a new set of icons will appear.

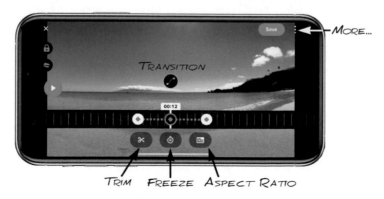

4.2 On the timeline, scrub to the moment you want to add a keyframe.

4.3 Compose your shot and tap the keyframe icon on the timeline to save the keyframe.

4.4 If you make any more adjustments to the composition at that keyframe after saving it, tap the check mark to save those changes or the back arrow to revert to the saved keyframe.

4.5 To add another keyframe, scrub on the timeline to another point in the video. Readjust the composition and tap the new blue and black keyframe icon near the playback time.

4.6 You've just created a transition between one keyframe and another. That is the basis of reframing 360 videos.

A Few More Reframing Tips:

• If you adjust the composition between two keyframes and don't press the keyframe icon to save the keyframe, the keyframe will not be saved.

• To **prevent the shot from transitioning from one keyframe to the next**, add a second keyframe at the end of the section you want to stay the same. Don't make any changes to this keyframe and the framing will remain the same between the two keyframes.

• The framing **before the first keyframe** or **after the last keyframe** will match the closest keyframe.

• To **delete a keyframe**, double tap and select the delete icon.

TIP: Three of the Best 360 Reframes

Ultra Wide-Angle: These are some of the coolest shots you can create with Max because they are beyond what you can do with any single-lens wide angle camera. They are great from action shots with movement and scenic shots. First, zoom out far. Then pan to find your subject. The tilt to place the horizon near the center of the frame. The straight horizon gives the shot the feeling that it's not so distorted, but the amount of scenery and distance you can create between the camera and the subject is amazing!

Tiny Planet: Tiny Planet shots are easy to reframe by zooming all the way out. Then drag up from the bottom to distort the horizon into a tiny planet. Or drag down from the top to create a Rabbit Hole shot.

Traditional Video: Framing your 360 shot into a traditional-looking video works wonderfully for tricking the eyes. With all of the creative transitions and multiple angles you can pull from one clip, viewers will wonder how you did it. Create the appearance of a tradition video by zooming in and keeping the horizon flat and level near the middle of the frame. You don't want to zoom in too far or upscale the video beyond 1080p when using this technique because you will start to see a reduction in quality.

 # 5- Adding / Adjusting Transitions

Now that you have two keyframes, you can adjust the transition style between the two.

5.1 Scroll on the timeline so you are between the two keyframes. The transition icon will show up above the timeline.

5.2 Tap on the icon to change the transition settings. This will affect how the shot transitions from one keyframe to the next. Here are the options:

- Linear: The composition will transition at an even rate, smooth and steady.

- Ease-In: The transition begins slowly at first and speeds up as it approaches the next keyframe.

- Ease-Out: The transition starts out quickly and then eases up before the next keyframe.

- Ease-Both: The transition begins and ends slowly with the quickest motion in the middle.

- Jump Cut: The video will not transition at all as the video plays, but when it reaches the next keyframe, it will suddenly change to that keyframe's settings.

TIP: Creative Transitions. Editing spherical 360 videos offers so many opportunities for catchy transitions. There are limitless ways to mix transitions between shots, but here are a few of the most eye-catching to get you started:

Tiny Planet Out and In: Start your video with a tiny planet shot and quickly transition to a traditional video perspective. Or for even more of a surprise, edit your video to appear as a traditional video and at the very end, zoom out into a tiny planet.

Quick Jump: Use a Jump Cut transition to quickly switch from a selfie shot to a POV shot without any panning. Sometimes too much panning creates a dizzying effect, and this is one great way to swiftly change perspective.

Freeze Transition: The next tool you will learn about, called Freeze Frame, works well to freeze a moment in time right at the peak of action. You can then transition over to a different perspective while the action is frozen, and continue the journey from a different view.

Zoom In or Out: Begin the shot in a super wide angle view and slowly zoom in to a traditional video view as the video progresses. This creates a subtle transition for a more cinematic feel. You can also edit this the opposite way- start with a traditional shot and end with the super wide view.

#6 Freeze Frame

Use the freeze frame icon to freeze a moment of the video. This will not delete any of the video but rather just adds a frozen section to the clip.

6.1 To use freeze frame, tap the freeze frame icon.

6.2 Scrub to the moment you want to freeze.

6.3 Tap the icon on the timeline. The freeze frame will default to three seconds, but you can slide the right side to lengthen or shorten the segment.

6.4 Play the video or scroll on the timeline to preview how the freeze looks. Once you approve, press done to save the change.

- To delete the freeze frame, scrub over the freeze frame area. Press the freeze frame icon and tap the delete icon.

 #7 Aspect Ratio

Select the format for your reframed video. The icons show the shape and proportions. The options are 16:9 Widescreen, 4:3 Standard, 9:16 Widescreen vertical (for phones), and 1:1 Square. When you select one, the aspect ratio will instantly change in the editing window.

#8- Exporting Your Finished Video

When you have finished editing, press the Save button. The Render Video option will create your finished video and save it to the GoPro App's media library. Or press Save Draft if you want to make changes later. You can edit together multiple "reframed" clips using Story in the GoPro App or use another editing app to combine multiple clips.

> **TIP: OverCapture- Another Reframe Method.** Another way to reframe your 360 videos is called OverCapture. OverCapture is less precise than using the keyframe technique we just showed you, but some visual people may prefer it.
>
> After tapping on the keyframe icon, tap the three dots in the upper right corner. Select OverCapture. OverCapture allows you to record your compositional changes live. First, select your aspect ratio, 16:9 or 1:1. Then press the record button. As OverCapture records, rotate your phone or use your fingers to reframe the video. OverCapture will create a new video based on your adjustments.
>
> OverCapture is harder to use, but for certain shots like walking around a tiny planet or following quick action, that may be an easier option for you.

EDITING GOPRO STORIES IN THE GOPRO APP

The Story feature gives you the tools to combine multiple traditional video clips and photos into a video edit. You can also add music and apply color filters.

To begin editing a "Story" video on the App, **Tap "Start a New Story" from the home page of the GoPro App.** You can then add media from the App, your phone's media storage or the Cloud (if you use GoPro Plus).

As of publication, you cannot add spherical 360 videos to your multi-clip stories timeline in the GoPro app. To add your 360 videos to an edit, first export the reframed video. You can then tap on the Stories icon on the home screen of the app. When you select media, only reframed or HERO mode videos and photos will be available. You can then use the following tools for a single clip or multiple clip edit.

The GoPro App will automatically create a short edit with your selected media, utilizing any HiLights you added plus the App's smart technology (such as smile recognition) to find the best moments.

The edit will be based on a theme, which you can change instantly. This pre-edited theme is a great starting point for your video.

Once you've selected a theme you like, you can then go in and fine tune the edit using the five editing icons at the bottom of the GoPro App editing screen:

 TIMELINE

Use this tab to put together your video, including adding and removing more videos, photos and title slides.

Depending on what type of clip you are editing- either a title slide, a video clip or a photo, there are a variety of editing options available.

To edit your media, Tap the pen icon on the media's thumbnail to enter the editing dialogue.

When editing a **Title Slide**, the four editing options are:
• **Text**- Edit the title text or add title slides.
• **Duration**- Adjust the length of the title slide.
Or Tap the four dots in the right corner of the image to:
• **Delete**- Delete a title slide.
• **Duplicate**- Duplicate the selected title slide.

When editing a **Video Clip**, the following tools are available:
• **Trim**- Trim the beginning or end of the clip to select the area you want included.
• **Frame**- Trim, Rotate, or Flip videos and adjust the Horizon (when available).
• **Filter**- Add filters to an individual clip for an artsy look. This is an easy way to color correct your reframed videos after you've edited them. There are 22 filters to choose from:

> 5 Beach Filters- Cine, Keel, Waimea, Vibe and Soleil
>
> 4 Indoor Filters- Nola, Grotto, Vegas and Asana
>
> 3 Snow Filters- Bluebird, Aspen and Luge
>
> 3 Urban Filters- Rooftop, Graffiti, and Grind
>
> 4 Vegetation Filters- Zipline, Sequoia, Vail and NaPali
>
> 2 Water Filters- Gili and Ibiza
>
> 1 Black and White Filter- Duke

• **Speed**- Adjust the playback speed of your clip (depending on the frame rate).
• **Volume**- Adjust the video's audio volume.
• **Text**- Add a text overlay on your video.
• **HiLight**- Hilight your favorite parts of a video for the GoPro App's auto editing.
• **Adjust**- Make visual adjustments to the look of your clip using, Exposure, Contrast, Vibrance, Temperature (White Balance), Shadows, and Highlights.
Or Tap the dots in the right corner of the image to:
• **Delete**- Delete the selected clip.
• **Duplicate**- Duplicate the selected video clip.

For **Photo Editing**, some of the above options are available, plus there is one additional option:
• **Duration**- Set the video duration of the photo to Long, Regular or Short.

 THEMES

Choose a video style based on GoPro's pre-designed themes. The style can be changed instantly on your edit simply by selecting a different style.

 MUSIC

Add music to your video. Choose from GoPro's library or add music from your phone's library.

 STORY LENGTH (DURATION)

Select a desired clip time to coordinate with the selected theme's music and pace.

 FORMAT

Choose from 16:9 Widescreen, 1:1 Square, 9:16 Vertical, or 4:3 Standard.

Once you have finished editing in the GoPro App, Tap Save to save your video. You can then save it to your photo library or

share it through Social Media outlets.

Check out these tips to make your mobile videos more fun to watch:

• **Combine GoPro clips with other videos** taken on your phone or other camera. Any videos or photos in your Camera Roll can be used in the video.

• **Add titles.** Give your videos some character with titles or subtitles.

• With mobile videos, **longer is not always better.** You can often make the point in a short 60 second clip, which is the maximum length of an Instagram video.

• Choose the **music for the mood**. If you don't like the selections available, you can also add your own music, but make sure to avoid using copyrighted music without permission.

DESKTOP VIDEO EDITING

Now that you've learned how to edit your 360 video using the GoPro App on a phone/tablet, let's show you how to edit Max videos using a computer.

Depending on the computer's operating system (Mac or Windows), the workflow for editing your 360 videos will vary.

There are lots of options when it comes to video editing. The goal of this section is to help you understand the various techniques used to edit video footage filmed on your GoPro Max.

We will break down the video editing into three steps, Pre-Editing, Reframing, and Exporting 360 Spherical Video.

For the following video-editing tutorials, select two clips you would like to work with. You can use the same two clips for all three tutorials so you can see the difference in editing techniques.

Here are some tips to consider when you first start to think about how you are going to edit a video:

• **Have a vision** for your finished product. If you plan to put together a longer video, create a storyboard or timeline to plan ahead and look for the pieces you need.

• **Bookmark** your edit worthy moments. When organizing clips to use for a video, write down the time marker of your highlights for the clips you decide to use to make it easy to find these moments later. This is particularly useful when you start to edit longer videos.

• **Erase files as you go.** If you look through a video clip and see that there is nothing usable, erase it as you go. You will have lots of files to sort through, so the more you can thin out your library, the easier it will be to find your usable clips. Staying organized will make your task easier when you go to edit a video.

PRE-EDITING ON GOPRO PLAYER (MAC) AND GOPRO MAX EXPORTER (WINDOWS)

Straight out of the camera, the 360 videos files from GoPro Max are **not compatible with other video editing apps**. Before you import your GoPro Max files into a video editor, you need to convert your .360 video files into an equirectangular format that is compatible with a video editor.

On Windows, use Max Exporter to convert the videos. On a MAC, use GoPro Player. GoPro Player (MAC) and Max Exporter (Windows) can be downloaded for free from GoPro's website on the Apps page. So, go download the appropriate app for your computer's operating system.

NOTE: GoPro Player for Windows. GoPro is developing the GoPro Player for Windows also. Check their site to see if it is available. Until it is, you can use the GoPro Player Beta version instead of Max Exporter if you choose. Use this link to join the Facebook group where the Beta is available: https://bit.ly/PlayerBeta

Go Deeper
GoPro Max creates files using an EAC format to create files that are small enough to process inside GoPro Max. However, these files are not directly editable in other editing apps, hence the need for conversion.

Import and Convert Your Files

To edit or convert your 360 files to an equirectangular format, follow the steps below:

1. Open either GoPro Player (MAC) or Max Exporter (PC).

2. **Import the Video File.** Open the two video files you will be working with. You can batch process multiple 360 files by opening multiple files at once (Cmd+Click on Mac/Ctrl+Click on PC). Then, you can queue them up to export, so you don't have to export one file at a time.

3. **Choose from these export options.** Some of the editing features you learned about in the Mobile Editing section are also available in both Apps. These include:

• **Horizon-Leveling**- Locks the horizon to keep it as level as possible.

• **World Lock**- When World Lock is enabled, the camera will point in the same cardinal direction throughout the entire clip. So as you rotate, the camera will not stay fixed on you but rather on a direction.

• **360 Audio**- If you recorded the video in 360 Audio, you can export the full spherical audio with the file. If you don't select this, the video will export stereo audio. 360 Audio is not available when World Lock or Horizon Leveling are selected.

4. Before you export, read on for more tips for your specific App.

 Using Max Exporter (PC)

For Windows users, editing or reframing your 360 videos is a two-step process. First, the 360 files need to be converted to a file that is compatible with other editing apps. To do this, you will use GoPro's Max Exporter to convert the videos to an equirectangular format, which can then be edited in a more advanced video editor. GoPro plans to release a version of GoPro Player for Windows in the near future (GoPro Player Beta is available in the link given before), which will allow Windows users to reframe 360 content directly in the GoPro Player. For now, you will have to use other third party apps. Max Exporter lacks any other editing tools and is used for converting your files to a compatible format for editing in another app.

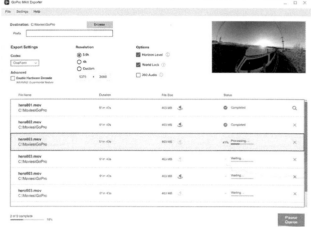

• **For the highest quality export settings,** export your spherical videos using the Cineform codec at 5.6k resolution with Horizon-Leveling, World Lock or 360 Audio if desired.

• Save the two clips to a folder to use for the other video tutorials.

 GoPro Player (MAC)

For Mac users, you can either choose to use GoPro Player as your final reframing tool or use the app to convert files to an equirectangular file for another editing app.

GoPro Player gives you the tools to reframe your 360 content and to export 360 videos almost exactly like you learned using the GoPro App, except on a computer. You can also use the GoPro Player simply to export 360 videos as equirectangular 360 spherical files for further editing in another editing app. You will need to use a video editor to combine multiple clips and add text, music, etc., but once the videos are reframed, your 360 videos can be edited just like any traditional video.

The GoPro Player Export Screen

• **Exporting 360 Spherical Video Files.** Before you export on GoPro Player, trim your files for any unwanted parts. This will reduce the rendering time.

• For the highest quality export settings, export your spherical videos using the Prores codec at 5.6k resolution with Horizon-Leveling, World Lock or 360 Audio if desired.

• Save the two clips to a folder to use for the other video tutorials.

• **Reframing in the GoPro Player.** The editing features on the GoPro Player are almost identical to the GoPro App, so now that you learned how to edit using the GoPro App, the GoPro Player will be easy.

The following screenshot shows the 360 Player Editing screen.

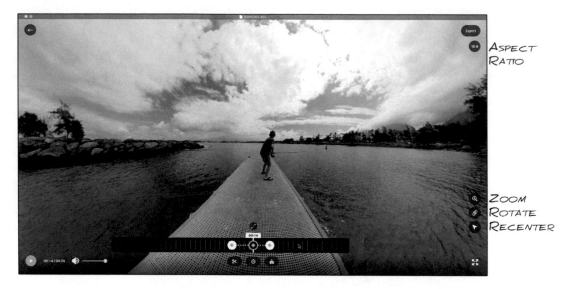

The GoPro Player Editing Screen for Reframing Your 360 Videos

Since the editing techniques in GoPro Player mimic the GoPro App, you can apply the mobile editing techniques you previously learned to the GoPro Player for reframing your 360 videos. Only a few of the icons differ from the editing dialog in the GoPro App. These icons are located on the right side of the screen and relate to reframing your image since most computers don't have touch screens.

• Zoom (or hold the Option Key) - Use Zoom to zoom in and out.

• Rotate (or Hold Control Key)- Rotate the horizon.

• Recenter- Recenter is kind of like a reset button, which will bring you back to the original view you saw when you opened the file.

• After you make adjustments to your video, an Export icon will be available on the top right side of the screen. Select your format 16:9, 9:16, 4:3, 3:4, or 1:1 and export your video. If you want to discard your reframing and export your video as a 360 Spherical video, use the back button in the top left corner.

HOW TO REFRAME 360 VIDEO

GoPro FX Reframe in Adobe Premiere Pro® (MAC and Windows)

For reframed videos in a professional editing app, due to a lack of reframing tools for free video-editing apps, such as DaVinci Resolve, we will show you how to use GoPro FX Reframe in Adobe Premiere Pro. GoPro designed the GoPro FX Reframe Plugin (which is free) for Adobe Premiere Pro® and Adobe After Effects®. This plugin is a powerful tool for reframing your Max videos. Even though Adobe's apps are not free, we will still offer step-by-step tips for using GoPro FX Reframe since it is specifically designed for GoPro Max and will show you the potential of what you can do as your editing skills improve.

Hopefully, GoPro will release a reframing plug-in for Davinci Resolve in the future since it is a free app with similar tools, but until then, these are the resources we have to work with.

GoPro FX Reframe can be downloaded from GoPro's website at https://bit.ly/GoProFX. If you have Premiere Pro installed on your computer, it will automatically be added as a plug-in.

Follow these step-by-step instructions to create a reframed GoPro video:

#1- Set Up Your Video Editing Timeline and Add Media

For this lesson, we will create a 1080p video since every computer should be able to handle this resolution and 5.6k spherical video is reframed to 1080p without losing quality. When reframing 5.6k 360 video, you can upscale the reframed video to 4k, but you may see some reduction in quality in the final video, especially on zoomed in shots. This tutorial focuses on reframing your 360 video, rather than all of the traditional editing techniques you can use to edit videos.

1.1 Open Adobe Premiere Pro.

1.2 Start A New Project. Click New Project and give your project a name. Let's call it "GoPro Reframe Tutorial". Click OK.

1.3 Import Media. Drag the two video exported video clips from the folder you created into the Timeline to create a sequence. The Timeline is where we will reframe your videos and assemble our edit.

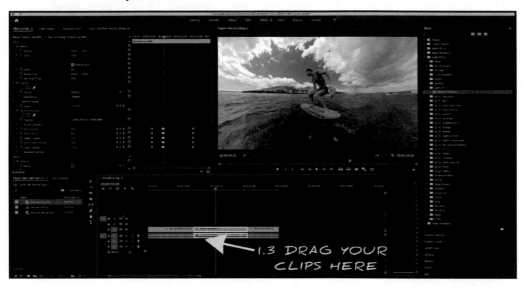

Import your video clips into Premiere Pro

1.4 Set Up the Project Settings. Let's set up the Sequence Settings for our reframed GoPro video. In the Premiere menu at the top bar, select Sequence>Sequence Settings. There are a lot of setting options that can be changed here, but let's just change the basics to output a 1080p video. Under Sequence Settings, use these settings:

- Timebase: 30.00 frames per second
- Video-Frame Size: 1920 x 1080 (For a 4k Video, enter 3840 x 2160. If you filmed in 3k, try not to go over 1080p)
- Pixel Aspect Ratio: Square
- Display format: 30 fps Timecode
- Video Previews: Apple ProRes422 (Mac) or GoPro Cineform (PC)
- Under VR Properties, make sure Projection is set to Equirectangular and Layout is Monoscopic.
- Click OK.

#2- Edit Individual Clips

2.1 Now, let's add GoPro FX Reframe to the clips one by one. In the Effects Panel on the top right side of the editing window, Open Effects > Video Effects > GoPro FX and drag GoPro FX Reframe onto the first video clip in the timeline. This effect allows your video to be viewed as a full 360 video, rather than a flat equirectangular video.

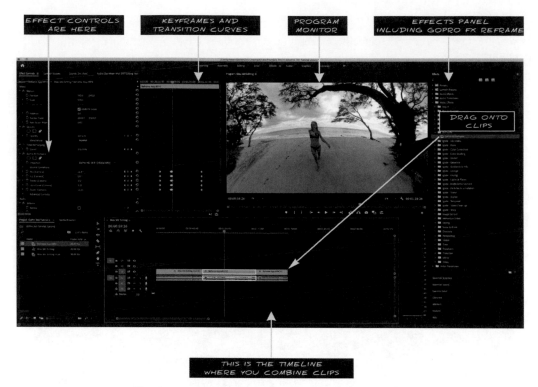

Use this as a quick guide to the Premiere Editing window.

2.2 Set the Projection. In the Effects Control panel on the left side of the screen, find the GoPro FX Reframe effect controls. Match the Projection to your Timeline settings- GoPro HD 16:9 (1920x1080) for a 1080p timeline.

> **TIP: Exporting Multiple Versions of One Edit.** If you change the Projection, you can export multiple aspect ratios from a single edit depending on where you plan to upload it. The reframing and keyframes will remain the same. This is really useful if you want to upload the same clip to YouTube and Instagram but in different aspect ratios.

2.3 Trim the clips. Using the selection tool (the arrow), drag the edge of your clip to the desired in and out point. We won't go into the different trimming tools here because there are a few, but the easiest one to use the Ripple Edit tool. Hold down Ctrl on Windows or Command on Mac (you will see a yellow Trim Tool.) while dragging the end of the clip to close any gaps left by trimming.

2.4 Adjust the Playback Speed. If you filmed in 3k at 60 FPS and want to play back the video in slow motion, right click and change the Speed to 50%.

> **TIP: Variable Speed Playback.** For a really tech effect that adds excitement to your clips, you can also edit your clip to play back in super slow motion. Since GoPro Max doesn't offer any super slow motion settings, we will do this using a cool little trick. We will show you how in the Super Slow Motion section (coming up soon).

2.5 Use Keyframes to change the view. Now, we are going to use keyframes to create transitions from one view to the next, just like you learned how to do in the GoPro App. Click on the Keyframe Icon for Pan, Tilt, Rotate, Lens Curve, and Zoom to turn on Keyframes for those controls. These are the basic controls needed to reframe your 360 videos. Lens Curve is the only control you may not be familiar with. Lens Curve can be used to reduce the fisheye effect for a more Linear look in your videos. A positive value decreases the fisheye "bubble" in the middle of the frame.

> **TIP: Advanced Controls.** Under Advanced Controls, make sure Sync Keyframes is checked so all of your keyframes stay synced. Keep Motion Blur checked for a more realistic look as the shots pan and tilt.

2.6 Slide the playhead to the moment in the video where you want to **add your first keyframe**. You can reframe the shot by manually adjusting the Pan, Tilt, Rotate, Lens Curve and Zoom values in the Effects Control dialog. Or to make visual adjustments using a mouse, click on the GoPro FX Reframe text in the Effects Control Panel. This adds a grid to the media preview screen (called Program Monitor) providing the tools you need to dynamically reframe your video directly in the Program Monitor. The five basic adjustments are available using these dynamic controls. This diagram shows how to use each control:

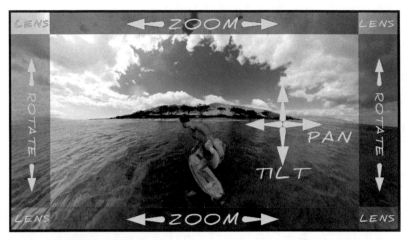

The Dynamic Reframe Controls in the Premiere Program Monitor

> **TIP: Lens Adjustment.** The Lens Adjustment tool in GoPro FX Reframe is a useful tool for editing the look of the lens in Premiere Pro. This tool is not available in the GoPro App. When you are zoomed in on a shot, increasing the Lens value (sliding it to the right in the Dynamic Controls) reduces the fisheye effect, giving your videos a more Linear appearance.

2.7 Make your reframing adjustments at the next point. Press the spacebar to play the video or drag the playhead to the next keyframe point. The keyframes will automatically be saved at whatever point you make adjustments.

2.8 Adjust the transitions. After you have finished reframing your video, you will want to adjust the transitions create smoother transitions from keyframe to keyframe. GoPro FX Reframe doesn't have the same transition settings as in the GoPro App or the GoPro Player. Let's start by changing all of the transitions to Continuous Bezier. Drag your mouse to highlight all of the keyframe icons in the timeline next to the Effect Controls. Right click (Cntrl+Click on a MAC) and select Continuous Bezier. If you want to change a synced batch of keyframes, click and drag the mouse select to just that set of keyframes. Then, change the transition to one of the other transition styles. Any time you make changes to the reframing, this will affect the transition setting. Always reset the keyframe setting back to Continuous Bezier after making framing adjustments.

> **TIP: Transition Curves.** If you want to adjust the curve of the transition, expend each of the 5 reframe adjustments in the Effect Control Panel. (To do this, click the small ">" next to the adjustment name. You will then see the curve of each transition which can be adjusted by moving the handles. This takes some practice to get right.

2.9 Color Grade the Clip. After making your adjustments, use Lumetri Color, LUT's (which are preset color correction values), or presets to adjust the color of the clip.

2.10 Repeat Steps 2.1 to 2.9 for the other clip you imported. You will want to follow the steps to reframe every 360 video you import into the timeline.

> **TIP: Second Camera View.** GoPro FX Reframe also allows you to enable a second camera view from the same 360 footage. Under Advanced Controls, enable the second camera to add another view (currently framed in a circle) overlaid onto your video. Use the framing controls as before to adjust the second camera angle.

2.11 Add Final Touches. In the Effects Panel under Effect>Video Transitions, add transitions such as Cross Dissolve or Fade to Black between clips to create a smoother video. Drag some of your favorite music (we gave you suggestions for YouTube "safe" music in the mobile editing section) into the clip if you want to add an audio soundtrack. Use the Text tool to add titles by selecting the Text tool and typing on the video in the Program Monitor. Text styles can be edited using the Essential Graphics dialog on the right Effects Panel.

> **TIP: Creating an Edit.** You can also add standard 16:9, 4:3, HERO Mode or other GoPro videos to the timeline to mix with your reframed 360 video clips for a full video edit in one timeline using Premiere Pro.

#3- Export Your Video

3.1 Preview your edited movie by dragging the Playhead to the beginning of the Timeline. Press the Spacebar to play.

3.2 Select your export settings. When you are happy with your edited video, click File>Export Media. This will bring up the export screen.

Premiere offers lots of export options, including presets for YouTube and Vimeo.
• For this tutorial, let's use the YouTube preset. In Presets, select YouTube1080p HD since we set this tutorial up for a 1080p video. For higher quality export, under the Video settings, change the Bitrate to CBR (longer export time) or VBR 2 Pass (longest export time). Change the Bitrate to around 16Mbps for 1080p. In VR Video, uncheck Video is VR since we are exporting a flat video and don't want to add metadata saying it's a VR video.
• In the future, if you set up your timeline for 4k and want to export 4k video, select YouTube 2160p. Make the same export setting changes as you did for 1080p, but the Bitrate should be set to around 50 Mbps.

3.3 Export the video. In Output name, give your video a name, "GoPro Reframe Tutorial" for example and specify where you would like to save your video. Click Export. Your video will be ready to share after it renders!!!

> **TIP: Preparing Files For YouTube.** When producing videos for YouTube, you can upload either 1080p or 4k (called 2160p on YouTube) resolution videos. The YouTube uploader will automatically detect your video resolution and give viewers resolution options to suit their device.

You now know how to edit a reframed 360 GoPro® video clip edited BY YOU in a professional video editing app! Congrats!

HOW TO EDIT AND OUTPUT 360 SPHERICAL VIDEO

Most of the time, you will probably reframe your 360 videos to export as standard 1080p or 4k videos for people to watch. If you want to edit your video as a 360 spherical video, here is how you do it.

Davinci Resolve

We will show you how to edit 360 videos for 360 spherical output using DaVinci Resolve since this is a FREE, powerful editing app which compares to Premiere Pro. (Unfortunately, there is not a reliable 360 reframing plugin for DaVinci Resolve yet.)

DaVinci Resolve is a FREE video editor with most of the features of the industry standard editing apps, such as Adobe Premiere Pro and Final Cut. This lesson was specifically designed to teach you how to export 360 spherical videos and aren't complete DaVinci Resolve tutorials. However, if you want to take it further (even to a professional level) BlackMagic offers free training modules to master this powerful app.

> **TIP:** If you still want to learn more about DaVinci Resolve after learning the tips in this step, visit the Training section from the DaVinci Resolve Download page. It's full of helpful, free resources to master DaVinci Resolve, including a free downloadable book in PDF format.

DaVinci Resolve 16 (or higher if available) can be downloaded for Windows or Mac for free from www.blackmagicdesign.com/products/davinciresolve at the bottom of the page. The program is free, but you do need to register. Blackmagic also offers a pro version called Studio for around $300 but you don't need this version now (and maybe never, depending on how far you take your video production). With the free version, you can edit high resolution 4k 360 videos and HERO Mode videos without a watermark

If you are using Premiere Pro CC or Final Cut Pro, similar editing techniques can be used and some tips for these programs will be offered throughout the editing section.

Follow these step-by-step instructions to create a GoPro Max 360 spherical video:

#1- Set Up Your Video Editing Timeline and Add Media

For this lesson, we will create a 4k 360 spherical video since the maximum video size using the free version of DaVinci Resolve is 4k. Max is capable is producing 5.6k spherical video.

1.1 Open Davinci Resolve.

1.2 Start A New Project. Double Click New Project and give your project a name. Let's call it "GoPro 360 Tutorial."

1.3 Set Up the Project Settings. First, let's set up the Timeline Settings for our GoPro video. The Timeline is where we will assemble the video. In the Davinci Resolve menu at the top bar, select File>Project Settings. There are a lot of setting options that can be changed here, but let's just change the basics to output a 4k 360 video. Under Master Settings>Timeline Format, use these settings:

• Timeline resolution: Custom- 3840 x 1920 (360 videos use a 2:1 aspect ratio)
• Timeline frame rate: 30
• Playback frame rate: 30
• If you are using Premiere Pro or the paid version of Davinci, the full 360 file size of 360 video recorded at 5.6k is 5376 x 2688.
• For 360 content filmed in 3k, you can upscale the video slightly to 4k without losing much quality but don't zoom in too far.

1.4 Import Media. Drag the two converted video clips from the folder you created into the "Media Pool" area on the left side of the DaVinci screen. If you see the dialog box saying, "The Clips have a different frame rate than the current project settings," select "Don't Change." (We already set up our project's settings for 360 output.)

The Media Pool is in the top left corner of DaVinci.

#2- Edit Individual Clips
(All of these edits are done in the Edit tab at the bottom of the screen.)

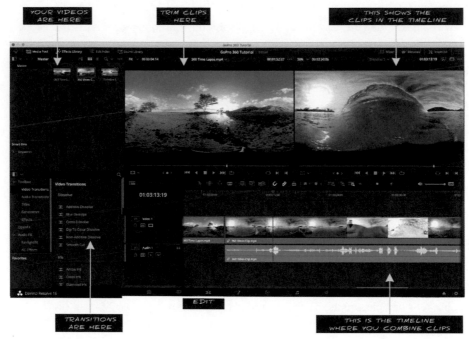

Use this as a quick guide to the DaVinci Editing screen. The Source Viewer is the screen on the left, where you trim your clips.

2.1 Select a Video Clip. In the Media Pool, double click on the first video clip. This will bring a full frame view of the clip into the 'Source Viewer," which is the screen on the left at the top of the Davinci Editing screen. The view will show an equirectangular video. This is what you will use to edit and export the video.

2.2 Adjust the Frame Rate for Slow Motion. If you want the clip to play at normal speed, you don't have to change anything. If you want the clip to play in slow motion, this is where the slow motion frame rates (60 FPS) come into play. By converting the high frame rate to play back at a slower frame rate than recorded (30 FPS), the footage will play back smoothly in slow motion.

To change the frame rate for slow motion, right click (Ctrl+Click on MAC) over the clip in the Media Pool. Select "Clip Attributes" and change the Video Frame Rate to 30. Clips, or portions of the clip, can still be sped back up in the Timeline to play at regular speed.

You don't need to change the frame rate for clips that will be played back at regular speed.

For videos recorded in a Slow Motion frame rate (60FPS), change the video frame rate in the clip attributes to 30 (or 23.976 if you prefer). The clip will play in slow motion when it's added to the timeline in Step 3.4.

> **TIP:** If you drag a clip into the Timeline without adjusting it for slow motion and then reduce the Clip Speed in the Timeline, the clip will play back choppy.

2.3 Trim the clips. Select the In and Out Points, the points where your clip will start and stop, by dragging the Slider located directly below the viewer. Drag the slider to the moment where you want your clip to begin, and press I on your keyboard to set the "In" Point. This will leave off anything before that point.

Drag the slider to the point where you want your clip to end and press O to set the "Out" point. This will leave off anything after that point.

You can also use the left and right arrows on your keyboard to scroll frame by frame. These "In" and "Out" points can also be adjusted when the clip is in the timeline.

2.4 Add the clip to the Timeline. Place your cursor over the video in the Source Viewer and drag the clip to the Timeline below.

> **TIP:** Isolate Video or Audio. You can grab only the video by hovering over the preview in the Source viewer and dragging the filmstrip icon to the timeline.

2.5 Repeat steps 2.1-2.4 for the other clip.

> **TIP:** After the first clip is added to the Timeline, you can drag the next clip either down to the Timeline or to the Timeline Viewer Screen on the right. When you drag it to the right, you will see some of the most common input commands to choose from.

> **TIP: Color Grading.** Color Grading in Davinci is complicated for a beginner. It's much easier in Premiere Pro. To keep it simple, we will cover adjusting the look of your clips (called Color Grading) in the next section.

#3- Add Transitions, Music and Export Your Video

3.1 Add transitions in between the clips for a more professional look. On the top left of DaVinci next to the Media Pool, click on the Effects Library. In the Toolbox, under Video Transitions, select Cross Dissolve and drop it between two clips on the timeline. You can then click on the Transition to adjust the speed of the transition. There are lots of fun transitions to play with, so have fun with this.

3.2 Add a title to the beginning. In the Effects Library toolbox, select Text from Titles and drag it to the empty space (called a track) above your first video clip. You can customize the wording and appearance in the dialogue box on the right. For 360 videos, keep your text relatively small and centered in the frame to avoid distortion when the clip is viewed in 360.

3.3 Add music to create the mood. Drag a song file (usually .mp3) from your computer into the Media Pool. Then drag the song onto the Audio 2 bar of the timeline below the video's audio. You can adjust the length of the song to sync with the video by dragging the end to match the end of your video clips. If you don't want the original audio from the video clips in the background along with the music, you can click the "M" (mute) box in the Timeline to mute the audio on Audio Track 1.

3.4 Preview your edited movie by dragging the Playhead to the beginning of the Timeline. Press the Spacebar to play.

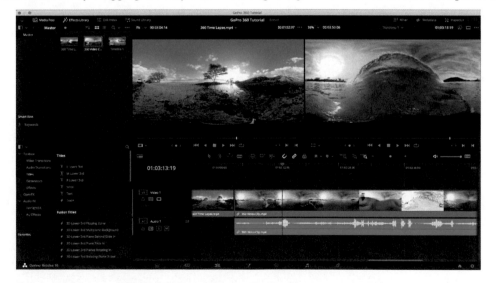

Preview your edited clip in the viewer on the top right.

3.5 Select your export settings. When you are happy with your edited video, click Deliver on the bottom bar of Davinci Resolve (the last icon on the right). This will bring up the export screen.

Davinci Resolve offers lots of export options, including presets for YouTube and Vimeo.

• To export a 360 spherical video, use the Custom tab and under resolution, fill in the resolution (for example 3840p x 1920 for 4k 360 video). Export at 5376x2688 for the full resolution video if you are using Premiere Pro or the paid version of Davinci.

In Filename, give your video a name, "GoPro 360 Tutorial" for example.

3.6 Export the video. Click the "Add to Render Queue" button and then the "Render" button on the right side of the screen. This will export your edited equirectangular video.

3.7 Reinsert Metadata. You may need to reinsert the metadata so your video is recognized as a 360/VR Video. If you edit in Premiere Pro, check "Video is VR" in the export settings to add the metadata. For videos exported from Davinci Resolve, use the Spatial Metadata Injector Tool, which is a free desktop app, to reinsert metadata. You may have to allow permissions, but the app is safe to use. (On a MAC, right click over the app in the Applications icon in the Finder window and select Open from the drop down menu.)

You now have your first edited 360 GoPro® video clip!

> **TIP: .360 File Type For GoPro Player.** If you want to reframe the video in the GoPro Player after editing it in Davinci Resolve, reinsert the metadata and then manually change the file type back to a .360 file by clicking on the file name. Once your file ends in .360, you will be able to add keyframes and reframe the clip in GoPro Player.

> **TIP:** Uploading 360 Videos to YouTube. When uploading 360 spherical videos to YouTube, it's best to upload the highest resolution videos that your camera will produce, which is 5.6k on GoPro Max. The YouTube uploader will automatically detect your video resolution and give viewers resolution options to suit their device. The video will take a while to process as a 360 video, so post it as "Unlisted" and go public once you have verified that it's showing in 360. Google recommends adding something like this to the description for your uploaded 360 videos:
>
> *"This is a 360 video, so pop on your Google Cardboard or VR Headset to be totally immersed in my world! No headset? No problem. Move your mobile phone around and catch the total 360 experience."*

Go Deeper

MORE EDITING TECHNIQUES. Once you have some editing practice and are comfortable with the basics of video editing, check out the options below for some extra effects.

COLOR GRADING

Color Grading is the video editing term for adjusting your video's overall look. Color grading can get pretty in depth, but let's just start with a few of the basic adjustments you can make to improve your video's appearance. DaVinci Resolve is a powerful color grading tool used for many major movies. The Color Grade tab at the bottom of the screen brings up a very overwhelming looking screen. However, we will just touch on a few of the basics and you should be fine. Blackmagic offers a 2-hour training video just on adjusting colors for those of you who are interested in learning more at a later time.

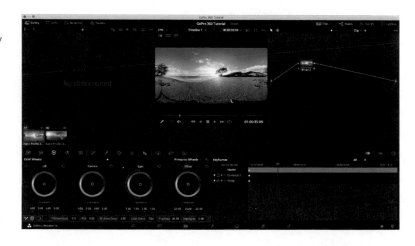

Three of the most useful color grading tools are the Lift (dark tones and shadows), Gain (highlights), and Gamma (midtones) wheels, but these are way too advanced to start with. For now, you can make some more basic adjustments to your video's

appearance by following these steps.

1. Select the "Color" icon on the bottom of DaVinci Resolve to go to the Color page.

2. Click on the thumbnail of the clip you want to edit.

3. In the middle left of the screen, make sure the Color Wheels are shown. If not, select the circle icon below the thumbnails on the left.

Just use the adjustments on the bottom bar of this Color Wheel box.

4. On the bottom bar, you will see a dropper icon, the letter "A" in a box and the numbers 1 and 2. Press the "A" to view an automatic color adjustment. You can use this as a starting point, or you can select Edit>Undo to return to the original settings.

5. To the right of the "A", the 1 and 2 buttons access some of the more traditional adjustment tools such as Temperature, Color Boost, Shadows, Highlights, Contrast and Saturation. If you hover the mouse over them, you can slide either way to adjust the values and preview how it affects your video image. Be careful not to get too carried away because overediting can make your image look doctored, especially when using the Saturation slider. Contrast, Color Boost, Highlights and Shadows are the most useful to start with. These changes shouldn't affect your stitch lines, but make sure to check when you preview your video in 360.

> **TIP:** As you become more experienced, you will develop a style and settings that appeal to you. You may also want to download some LUT's, which are color grading presets you can use to achieve a uniform look throughout your videos, but that is something to remember for the future. Powergrades are another DaVinci Resolve color editing preset tool to look into as you become more experienced.

ULTRA SLOW MOTION

Changing the playback speed of your videos is one of the best ways to create exciting, captivating videos. Since GoPro Max doesn't offer super high frame rate settings for ultra-slow motion, we will have to use some tricks to digitally create slow motion.

You can edit ultra-slow motion segments to reframed traditional video or to spherical 360 videos.

To create Ultra Slow Motion, DaVinci Resolve has a great tool called Optical Flow you can use to play back your videos far slower than the actual frame rates would allow.

As you learned previously, to achieve true slow motion, you are limited to the frames that were actually recorded in the original video. For example, when you play back a video recorded at 60 FPS at 30 FPS, you can only slow down the video 2x to maintain smooth video footage. That is only 50% of the original speed.

One of the great benefits of using DaVinci Resolve to edit GoPro videos is you can utilize an effect called Optical Flow to edit portions of your clips into Ultra Slow Motion. This effect was named Flux in GoPro Studio (which is no longer supported by GoPro), but it's more commonly called Optical Flow. Optical Flow can also be applied in Premiere Pro or Final Cut using a similar technique, but DaVinci generally produces better results.

With Optical Flow, you can slow your footage down to 3%-10% to achieve super ultra-slow motion far slower than the original frame rate would allow. This creates an almost paused effect which is perfect for accentuating those really beautiful, extreme or funny moments.

This is also a huge benefit when editing Max videos because of the lack of super slow motion settings.

However, not all is perfect with Optical Flow. To achieve super slow motion, the program makes up frames that don't exist by analyzing the frame before and the frame after and then fills in the space with digitally-created frames. For most scenes, this works really well, but for some scenes, the results are less than perfect.

Consider the following tips when you want to edit your clips into ultra-slow motion:

• When possible in HERO Mode, record at 60 frames per second so the program doesn't have to create so many frames. The fewer frames the program has to digitally create, the better your chances for an effective result. However, Optical Flow can be used with footage recorded at any frame rate.

• Choose the right scenes to apply Optical Flow to. Clean backgrounds and simple scenes work better because they are more predictable. Busy scenes with lots of background elements, such as bushes or water, make it harder for the program to imagine what the missing frames should have looked like. You can try Optical Flow with any clips, but if the results come out strange, the background could be the problem.

• Optical Flow can be applied to any video that has been slowed down beyond 24 frames per second to prevent choppy video.

You've come a long way since we first met because this is definitely getting into some more complicated editing. But we will walk you through step by step to add Ultra Slow Motion to your clips:

1. In the Edit Tab, drag the clip into the Timeline. Make sure the Clip Attributes are adjusted to play back in slow motion to start with the slowest motion possible.

2. Right click (Ctrl+Click Mac) over the clip in the Timeline and select "Retime Controls." You will see 100% and a small arrow show up on the bar below the clip in the Timeline.

3. Add Speed Points to a Short Section of the Clip. Drag the Playhead to the beginning point where you want to change speeds. Click the small arrow next to 100% and select "Add Speed Point."

4. Drag the Playhead to the next point where you want to change speeds. Click the small arrow next to 100% and select "Add Speed Point."

5. Adjust the speed of the clip by clicking the arrow in between the points you just marked. For Ultra Slow Motion using Optical Flow, reduce the Speed to 10%.

6. To fine tune the speed and smooth out the transitions between speeds, use the Retime Curve. Place your cursor over the clip, Right Click (Ctrl+Click Mac) and select Retime Curve. A new bar will show up below the clip. Click the small arrow next to the words "Retime Frame" and select "Retime Speed". You can fine tune the speed by moving the level up and down.

7. Important Step for Optical Flow. To add the Optical Flow, Open the Inspector Tab at the top right. Double click Retime and Scaling and then select:

Retime Process: Optical Flow

Motion Estimation: Standard Better (This setting depends on the speed of your computer and desired quality. As you move down the menu, the quality increases, but so does the render time.) The last option, Speed Warp, is only available on the Paid Version of Davinci Studio, but the other settings produce great results.

NOTE: Depending on your computer, exporting with Optical Flow applied takes longer because Davinci Resolve has to analyze and create new frames, so make sure you only apply Optical Flow to the clips that need the extra frames.

• If you want to reframe your 360 video after adding super slow motion, bring the video into Premiere Pro and use GoPro FX Reframe. Or after reinserting the metadata, change the file extension to .360 and reframe using the GoPro Player.

GPS TELEMETRY

If you were connected to GPS when you recorded your videos in 360 or HERO Mode, your video files contain the GPS data. However, actually extracting the data and overlaying it onto your video is not so simple.

For HERO videos and TimeWarp videos recorded with GPS, the simplest technique to overlay data is to use stickers in the GoPro App.

The ability to easily overlay GPS data on your 360 videos and reframed videos is not available directly through GoPro's apps. To overlay data on 360 videos or reframed videos, you will need to use several steps. Doing this using free tools is quite complicated. The free version of the GoProTelemetryExtractor can extract the data, but you will then have to find another app that can overlay the data onto your 360 videos. There are a few paid desktop apps available also, RaceRender (MAC) and Dashware (PC), but these are also not specifically designed for 360 content.

OTHER QUICK FIXES

Sometimes footage doesn't come out like we hope for. Fortunately, some things can be corrected after the fact. Here are a few common filming mistakes you can fix when editing

• **Underexposed shots.** If you filmed in low light, or with a max ISO that was too low for the lighting conditions, your footage may be darker than desired. You can brighten the exposure in any editing app to lighten the shots, but make sure you don't go too far because it may bring out noise in your shots. In Davinci Resolve, the easiest way to adjust the exposure is to adjust the Shadows and Highlights in the bottom bar that you were using for color grading. It can get much more involved, but this is a good place to make simple adjustments. In Premiere, use the Exposure slider in the Lumetri color panel.

• **Audio.** The easiest option of course is to use GoPro Max's in camera audio options to record the best possible audio on the spot. That may mean using Raw Audio in HERO Mode. If you already recorded the footage and the audio is less than par, you can first try to correct it using audio adjustments in DaVinci Resolve or another editing app. The last option may be to mute the track's original audio and record a voiceover, use a separate sound effect audio track, or use that clip with music as the audio.

EDITING A 360 TIME LAPSE VIDEO

Time lapses are fun, creative additions to any video, and they can give your viewers a great understanding of the overall scene. Both time lapse modes (360 and HERO) have an automatic time lapse video output which is the easiest way to create a time lapse video. If you used a photo output in Time Lapse Mode, combining your photos into a video just requires a few easy steps.

The goal here is to condense all of the time lapse photos from a scene into a video so that each photo becomes a frame in the movie. You can play a time lapse at a faster or slower frame rate depending on the scene you recorded. (Note: Time Lapse Video and TimeWarp Videos automatically play at 30 frames per second)

> **TIP:** **Time Lapse From Regular Video.** You can also simulate a time lapse look from a regular video clip using DaVinci Resolve or Premiere Pro by speeding up your videos. Just remember that frames are much further spaced out in a time lapse. A video recorded at 30 FPS needs to be sped up 1500% to equal a .5 second interval. This will eliminate the frames in between to create a time lapse effect.

How to compile your Time Lapses:

☐ **Use the Theta+ App**

The easiest way to edit a 360 time lapse video from photos is to use the Theta+ Video app on your phone or tablet. Use the GoPro App to save the photos from the time lapse to your photo library. Then, Open the Theta+ App and select the Photo Import option. Select Range and then select the first photo of the batch and then the last. The App will give you the option to combine them into a 360 TimeLapse. The maximum frame rate available on the Theta+ App is 15 frames per second, but this still creates awesome 360 time lapses. Even though the app will reduce the resolution, you can then open the saved 360 file in GoPro Player (or GoPro FX Reframe in Premiere Pro) to reframe it to a traditional video.

 Use Davinci Resolve or Premiere Pro

The most reliable and customizable way of merging your photos into a time lapse video is to put all of the photos from the time lapse into one folder on your computer. (Your GoPro camera will create multiple folders for a time lapse after 1000 pictures).

In Davinci Resolve, add the folder to your Media Pool and it will automatically recognize the batch as a time lapse and merge them into a video format. Just make sure you don't erase any files before importing because the file names need to be in numerical order to play as a single clip. This will create a 360 time lapse which can be exported in 360 and posted as is or imported into Premiere for reframing.

In Premiere Pro, simply import the batch of photos. Select the images and use the Automate Sequence icon at the bottom of the project panel to merge the photos into a video. In the Automate Sequence setting options, set the still clip duration to 1 frame per still. The benefit of using Premiere Pro is that the time lapse can then be reframed using the GoPro FX Reframe plugin.

> **TIP: Batch Editing Time Lapse Photos.** If you want to batch edit your photos first in a desktop editor such as Lightroom, make your edits, then export the files so the names are still in numerical sequence. You can then import them into DaVinci Resolve or Premiere Pro and play them as a time lapse.

Editing Tips:

• If you used a photo output and something unwanted showed up in a frame, you **can remove the photo from the batch** before you import them into DaVinci Resolve or Premiere Pro. Because the filenames won't be in sequence, the files will be split where the photo is missing. You can easily place them back together in the timeline. Alternatively, you can import the entire time lapse and cut the unwanted frame out of the video clip.

• Work with the speed. **Try adjusting the speed** to get the look or length you are going for. Speed changes add a lot of drama to time lapse videos.

• **Use keyframes to add extra movement,** such as panning or zooming, to your time lapse. 360 content really gives you a lot of flexibility to move around the scene.

• Depending on your computer's speed, your time lapse may not play back smoothly until you export it. The preview doesn't show all of the frames, so it will look choppier than the final exported video. **Export your video to view the full effect of your time lapse.**

PULLING FRAME GRABS

A frame grab is **a still image (photo) taken from a video clip.** With the high video image quality on GoPro Max, a still image taken from 5.6k video is about the same quality as an image taken in 360 photo mode, so you can really utilize your video clips to extract amazing still images. Frame grabs pulled from video have the same resolution as the video file, so a higher resolution video produces a larger still image. Here two easy step-by-step methods for pulling a frame grab:

Use the GoPro App

Photo From Video- Use this icon to extract a still photo from your 360 spherical video.

For a Video Still on Your Camera's microSD Card

1. Play the video from your camera using the GoPro App. Tap the Image icon at the bottom of the screen.
2. Then scroll to the frame you want to grab and tap Save Frame. This will save a 360 photo to the GoPro App Media Library.

For a Video in the GoPro App's Media Gallery

1. Tap the video icon to open the video. Tap the Photo Icon.
2. Select the 360 Icon for a 360 Spherical Photo. Or select an aspect ratio (16:9, 4:3, 9:16, 3:4, or 1:1) to save a flat photo.

3. Scroll to the exact frame you want in your timeline. For a 360 photo, you don't need to reframe the shot. For a flat photo, reframe the shot exactly how you want it to look before you save the frame.

4. Tap Save Frame to save the photo. This will save the photo to the format you selected.

Use the GoPro Player (MAC)

1. Open the video in GoPro Player.

2. To export a 360 Spherical photo, tap the "Photo Grab" icon.

3. To export a flat, reframed image, click on the Keyframe icon, reframe your photo, select the export aspect ratio on the top right, and click Export.

> **TIP:** **Metadata.** After exporting a frame grab, you can reframe the photo in the GoPro App and then adjust its appearance in a photo-editing app like you will learn about next. Frame grabs pulled from a 360 video will lack the metadata that tells an app to treat the photo as a 360 spherical image when editing. The metadata can be reinserted easily as shown in the next step on editing your photos.

PHOTO EDITING

When it comes to 360 photography, there are lots of things you can do with GoPro Max! There are tons of ways to edit photos and you will eventually find your own style. This section will teach you how to make corrections to your photos as well as use editing techniques to **give your GoPro Max photos or frame grabs the extra pizazz they need** after coming straight from the camera. This section is written to help you process photos to make them look their best!

As with video, you can output your photos to be viewed in either a 360 spherical format or as a "reframed" flat photo. We will first teach you specific steps for editing 360 photos for a spherical output since they require their own workflow. We will then show you some of the best and easiest editing techniques for flat "traditional" photos, such as HERO Mode photos or reframed photos.

360 PHOTO EDITING WORKFLOW

For virtual tours and scenic 360 photos, you will need to edit and output 360 photos for spherical viewing. Because they are being viewed seamlessly as a spherical image, 360 photos need their own special techniques to maintain a seamless image. Even though 360 photos are often presentable out of the camera, they do need common editing adjustments such as color correction, erasing unwanted objects, and fine tuning the quality. Follow the steps below for an easy workflow and to learn about the best apps for editing your 360 photos.

EXPORTING 360 PHOTOS

360 photo editing is available for any photo taken using 360 Photo Mode or any frame grab pulled from a video recorded in a 360 Video or Time Lapse Mode. We taught you how to pull a frame grab from 360 video in the previous section.

To export a 360 photo or frame grab, export the photo without reframing from the GoPro App to your phone's photo library. On the GoPro App, you will see an icon of a camera and sphere indicating a 360 photo. Once you save the photo, you can then edit the photo on your phone or share it to your computer. Or, you can directly download the files from the microSD card to your computer. 360 photos are saved in a .jpeg format at a 2:1 aspect ratio, so when you look through your files, you will notice their unique thumbnail shape.

METADATA

After you edit using the recommended apps, the photos should be saved with the photo's metadata telling the host that the photo is a 360 Spherical Photo. **If the metadata is missing, the photo will not display properly in 360.** If you pulled a still 360 spherical photo from a video, that file will also lack the metadata needed for 360 editing. **On a phone or tablet,** you can reinject the metadata using Meta360, which is a paid mobile app for reinjecting metadata. All you have to do it import the photo, inject the metadata and export the photo. It's quick and simple. **On a computer,** use Exif Fixer (by panoramaphotographer), which is a free desktop app.

The free Exif Fixer App for reinjecting photo metadata

BASIC EDITING AND COLOR CORRECTION

It's important to use the right editing apps for your photos that will maintain a seamless photo when viewed spherically. When you edit a 360 Spherical photo, it will be viewed as an equirectangular photo. This can be odd to work with at first, but as you edit, remember that when viewed in 360, the edges will be viewed seamlessly.

Use the following apps when editing your 360 photos for seamless 360-aware editing:

🖥️ Google Photos (free)

Google Photos is a **free desktop editing tool for editing your 360 photos**. Google Photos can also be accessed on mobile devices, but the mobile app doesn't offer the same editing tools as the desktop app. Edits on a mobile device will have to be performed in Snapseed (which is Google's mobile photo editing app) or another mobile editing app such as Lightroom Mobile.

Google Photos automatically recognizes a GoPro Max spherical photo (as long as it

has the metadata) so you can view it as a 360 image. When you make edits, the app is aware of the edges so your stitch lines will remain unseen. The editing tools are limited in Google Photos, but it's a great free resource to use for basic color correction.

To Use Google Photos:

1. Open your 360 spherical photo in Google Photos. The photo will show up as a 360 spherical photo.

2. Tap on the Slider edit icon and the photo will open in the editing window as an equirectangular photo.

3. Add a color filter or use the adjustment tool to manually adjust Light, Color and Pop. Avoid using the crop tool because this will ruin the seamless edges of your photo.

• Unfortunately, Google Photos does not offer a Cloning tool yet, so you will have to turn to another editing app such as Photoshop or a mobile app for cloning.

• If you want to edit your 360 photos on a mobile device using Lightroom Mobile or Snapseed, we will cover the steps for that too.

🖥 Photoshop (not free)

Photoshop has **the best tools for complete editing of your spherical 360 photos**. Using a combination of Camera Raw for overall image adjustments and 3D editing for edits to a specific area of the photo, you can edit your images from start to finish using Photoshop.

The following steps provide you with a basic workflow for editing 360 photos in Photoshop:

1. Open the spherical .JPEG image in Photoshop.

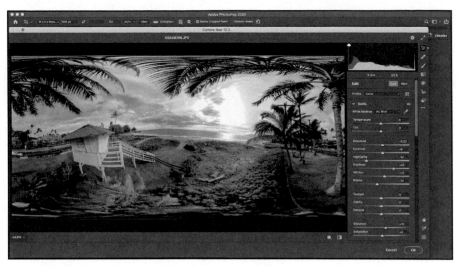

2. Convert the photo to a Smart Object by Right Clicking and select Convert to Smart Object. This has to be don't so we can use edit the image using Camera Raw.

3. First, make universal adjustments, such as brightness, contrast, vibrance, etc. using Camera Raw. Select Filter>Camera Raw Filter to open the image in Camera Raw. Camera Raw uses Edge Aware Editing to maintain a seamless spherical image.

4. The most useful adjustments are found in the Basic adjustment panel, including Temperature, Exposure, Contrast, Clarity and Vibrance.

5. Once you have made your adjustments in Camera Raw, select Ok to finalize your edits in Camera Raw.

6. Flatten your image by right clicking over the layer in the Payers panel on the right side and selecting Flatten Image.

7. Now, edit your image as a Spherical Panorama. Render the photo to a 360 layer in 3D>Spherical Panorama>Import Spherical Panorama From Selected Layer(s).

8. Choose your workspace. You can switch between workspaces in View>Workspaces.

9. Under properties, adjust the FOV to zoom in or out on the image.

Navigate around the panorama using the tools to make local adjustments (adjustments to specific areas), such as cloning out unwanted objects, and dodging (lighten) and burning (darken) to lighten or darken specific areas of the photo. When viewed in 3D, objects such as monopod feet are easy to clone out of the image.

10. When finished, export the 360 photo. To export the 3d photo, go to 3D>Spherical Panorama>Export Panorama. This will save your edited photo with 360 metadata.

> **TIP:** If you use Lightroom to import your images, Right Click over the Image and Select Edit in> Open as Smart Object in Photoshop. Then follow the steps above.

📱 Lightroom Mobile and Snapseed

Lightroom Mobile and Snapseed are two of the best mobile apps for editing your 360 photos. **Lightroom Mobile offers a wider variety of editing tools** for editing your photos but dramatic adjustments may cause the seam to become visible when viewed in 360. Adjusting Exposure and Brightness globally affects the photos and should not affect the stitch lines, but using filters and other adjustments that analyze individual pixels can make the stitch lines become obvious. You can use some of the color correction editing techniques shown in the next section on flat/reframed photos for editing your images in Lightroom Mobile, but be aware of how the seam is affected by your edits. **Snapseed is another useful photo editing app** made by Google with similar editing tools to Lightroom Mobile.

CLONING

Removing unwanted objects is much easier in a photo than in a video. In 360 spherical photos, **cloning is especially useful to remove the tripod/monopod feet** if your camera was mounted on a monopod. If you are trying to clone out the monopod feet when the photo is begin displayed as an equirectangular image, the tripod feet will appear spread out along the bottom of the screen making this a hard area to clone. This point directly below the camera is called the nadir. The nadir is typically the area that needs cloning.

There are several techniques to use for cloning objects out of your 360 photos.

The Clone tool in the 3D View of Photoshop is one of the best ways to remove unwanted elements in a photo because you can edit in 360, rather than equirectangular. The monopod base and shadow were removed in the image on the right as an example of what can be done quickly and easily.

In Photoshop on a computer, use the clone tool when you are in 3D view. This brings the tripod feet together how you would see them in real life, making them easy to clone out.

The online 360 editor Kuula also has an easy-to-use tool for removing the tripod from your shots.

Most of the mobile apps, including Snapseed or Photoshop Express let you clone out unwanted areas using the Healing Brush on your touch screen. However, it can be tricky to fine-tune cloning on your device especially with an equirectangular 360 photo. The tripod feet end up being spread out along the base of the equirectangular photo.

The best paid app for removing a tripod is Edit360. This app allows you to rotate the horizon so you bring the tripod feet back together in an equirectangular view, allowing you to clone out the tripod all together. You can then rotate the horizon back to level and export the finished photo.

ANIMATING YOUR 360 PHOTOS

Animating the reframing adjustments on a 360 photo really brings the image to life. If you want **to animate a 360 photo** (like you did using keyframes for a 360 video on the GoPro App), import the edited 360 photo into the free Theta+ App (iOS/Android). Tap on Edit and you will see a variety of animated presets to bring your 360 photos to life as a short video file. You can then share this photo with animation on Instagram or host it on your website/blog. (In Step 6, we will show you how to host 360 photos to a site.)

MORE 360 PHOTO APPS

Circular Tiny Planet Editor. This is a paid app, but the tiny planet effects are definitely worth it if you want to have some fun creating them. You can add multiple layers of special effects, such as starry skies, clouds or birds. It's a great app for getting creative with your tiny planet photos.

EDITING REFRAMED PHOTOS AND HERO MODE PHOTOS

Reframed and HERO mode photos are flat photos that don't require the same specialized workflow as 360 spherical photos. These are edited like any other photos from your phone or another camera. However, editing these photos to improve their look is equally important. We will use Lightroom Mobile for editing these photos on your phone or tablet since quality photo editing can be done using your mobile device. Similar techniques can be used if you are using Photoshop or Gimp (a free desktop photo editing app) on a computer.

Editing flat, "reframed" photos requires a similar process to editing your 360 photos except for a few of the steps. Now let's cover a few tips specifically for editing your traditional photos.

REFRAMING YOUR PHOTOS

The first step to editing a reframed photo is to reframe and export the photo using the GoPro App. This will create the flat photo file for you to work with in the other apps we recommend. Using the GoPro App is the best way to prepare your photos for further editing.

In the GoPro app media library, open the 360 spherical photo or video you want to use.

1. Tap on the media thumbnail to open it.

2. Tap on the "Photo Grab" icon at the bottom of the screen to pull a flat photo from the 360 file. To export your photo as a flat reframed photo, reframe your photo like you learned how to do for videos.

3. Tap the "Save Frame" icon to export the photo file in your desired aspect ratio. This creates a new photo file in the GoPro App Media Library.

4. The flat reframed photo is now in your phone/tablet's Photo library and is ready to edit in a photo editing app.

You can also use the Share options to copy the image to Snapseed or another editing app on your phone.

A similar technique can be used to reframe photos using GoPro Player (MAC) on a computer.

1. Open the photo in GoPro Player.

2. To export a flat, reframed image, the best option for now is to make the image as large as possible on your computer and take a screenshot (Cmd+Shift+4 on a Mac/ Win + Shift + S on a PC). Unfortunately, there is no Photo Grab icon available yet for pulling reframed photos from 360 photos, unlike you can for video. Note: You will then need to save the photo as a .jpg to use with most mobile apps.

BASIC EDITING (TRADITIONAL/REFRAMED PHOTOS)

Let's start with the basic editing that should be done for any photo. These little adjustments make a big impact. **We are going to use Lightroom Mobile for this tutorial** since it's free and it offers a bit more control over your images than Snapseed. Although we are using Lightroom Mobile for this tutorial, similar adjustments can be made on most photo-editing programs, both desktop and mobile.

Import your photos

After you have transferred photos onto your phone, open Lightroom Mobile and select a photo to work with.

Applying Presets/Filters

Under the Presets option, scroll through the presets to see how they affect the appearance of your photos. This is like adding filters in other mobile editing apps. With experience, you will know your favorite go-to's. Or you may decide that you prefer to manually adjust the appearance of your photos.

Priime is another free mobile app with some amazing filters for your photos.

Color Correction

Straight out of your camera, your photos may look a bit dull. It's easy to correct the appearance of your photos in a few simple steps to add more color and life. These adjustments are made using the Light and Color tools in Lightroom Mobile, but every decent photo-editing app has similar features. In Snapseed, they are found in Tune for JPEGs.

1. Use the Light tool to adjust Exposure, Contrast, Whites and Blacks. Exposure and Contrast are typically the most impactful adjustments to fine tune the tone of your photo.

2. Using the Color tool, the Vibrance and Saturation adjustments will add more impact to your images. When adjusting Vibrance and Saturation, add color until it looks oversaturated and then back it down a bit so the image doesn't look over edited. You will rarely go beyond +25 for Saturation, depending on the photo. If you took the photo using a manual White Balance setting, you may need to adjust White Balance or Temperature. If you used Auto White Balance, these most likely won't need to be adjusted.

TIP: Local Adjustments. If you choose to use local adjustments (for a specific area of the frame) for a 360 photo, avoid editing the areas around the edge because these adjustments could make the stitch lines visible.

3. Lastly, after other adjustments are made, use the Clarity slider in the Effects tool if the image needs more contrast and punch. The Clarity slider boosts the midtones of a photo.

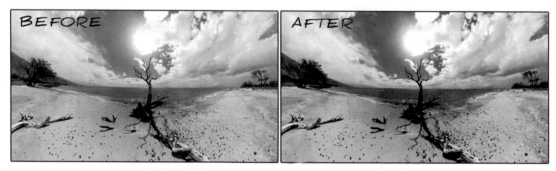

The Original photo is on the left. The image on the right was adjusted using the basic editing adjustments shown above. Here are the adjustments made: Exposure -.16, Contrast +9, Whites +38, Highlights +12, Shadows -12, Whites +21, Blacks -22, Vibrance +29, Saturation +9, Clarity +29.

These same adjustments can also be made using the Develop Module in Lightroom.

REMOVING FISHEYE

There is an easy way to correct lens distortion in your photos if they need a more linear perspective.

Using a lens correction adjustment will cause some loss of the content around the edges of your photos, so make sure you don't lose anything you feel is important to the composition. Also, keep an eye on objects around the edge of the photo to make sure they don't become too stretched out in appearance.

The best way to remove the fisheye effect on a mobile app is to use SKRWT, which is a paid app (about $1.99US), but it's one of the best available:

Lens corrections were made to the image on the right to remove the fisheye effect.

1. Import your photo into SKRWT and select the curved edges icon on the bottom right.

2. Select the GoPro tab on the right. Slide the bottom bar to the positive numbers until you are happy with the results. Between 10-15 is typically a good range to remove fisheye from a photo taken in Wide FOV.

3. Save your image to your phone and make any additional edits using Lightroom Mobile or Snapseed.

🖥 If you make the Lens Correction adjustment using Lightroom on your computer, you can also fine tune the amount of distortion removed using the Distortion slider. You can also make this correction in Photoshop using Filter>Lens Correction. Under the Custom tab, adjust the Geometric Distortion slider to remove the fisheye effect.

CROPPING

Cropping can be used to either change the aspect ratio of a photo or to adjust the composition. Since the GoPro App offers several aspect ratios to choose from when you export your photos, you probably already cropped your image. You also may want to crop your reframed photos into a panoramic aspect ratio, which looks impressive at a 3:1 ratio. If you want to crop further or change the aspect ratio, cropping is easy using Lightroom Mobile or Snapseed.

> **TIP:** Cropping your photo is another technique you can use to remove the wide angle look of your photo. By cropping the edges of the frame and keeping the center of the image, you can remove the areas with the most distortion.

HERO Mode photos are only 5 MP, so depending on how you plan to use the photo, don't overdo it. Cropping reduces the number of pixels in a photo, so the more you crop, the more original image pixels you lose. Reframed photos from 360 spherical video are about 15 MP. The higher resolution of these photos gives you more pixels to work with when cropping. If you are using the photo for Instagram or other mobile media, you don't need much resolution so feel free to be bold.

FINISH IT OFF

Once you have finished editing your traditional photos, you can finish them off by adding a few final touches.

The photo was cropped to a 1:1 (square) aspect ratio and a Vintage Instant filter was added using Lightroom Mobile. A frame was added in Snapseed. These types of filters and effects can easily be added to your photos to make them more fun and stylish!

A vignette adds a dark area around the edges of the frame, or you can choose a stylish edge, such as a film emulsion. Lightroom Mobile has vignette controls. Snapseed and Photoshop Express both have some good edge and frame options.

You can also add some fun lighting effects. Lens Distortions and Pixlr are free apps with lens flares and other effects that are easy to preview and add to your photos.

SPLIT A PANORAMA FOR INSTAGRAM

Want to add a swipeable, multi-panel photo to your Instagram? If you used PowerPano or cropped one of your images to a panoramic aspect ratio, there are a few available apps to easily split the panorama into three (or more) equal squares. When you upload this file to Instagram, viewers can swipe to view the panorama in a series of seamless photos. For more attention on the Instagram search page, post the full panoramic photo first, followed by the sliced pano.

The best apps for creating a swipeable pano are Swipeable (iOS), Unsquared (iOS/Android), Panoragram (iOS), and InSwipe (Android).

CREATE A PLOTAGRAPH (REFRAMED 360 OR HERO MODE PHOTOS)

A plotagraph is a **fusion between a photo and a video**. In a plotagraph, most of the scene appears stationary as you would see when viewing a photo. The magic of a plotagraph is that a selected part of the image shows movement. In a plotagraph, an area of the photo (the sky, for example) is animated by digitally adding looping movement. Plotagraphs are very popular on Instagram and websites because they are easier to create than a cinemagraph, which is a similar technique using a video. The easiest way to create a plotagraph using your GoPro photos is to use a free app on your device called Enlight Pixaloop or Plotaverse.

Cinemagraphs

A cinemagraph is similar to a plotagraph, but it starts with a video. This opens up the possibilities from more animation, but these are also more complicated to create. Imagine a beautiful sunset photo, with all of its colors to appreciate, but in this scene just the ocean and one palm tree are moving in the breeze. These kinds of imaginative scenes can be created using a cinemagraph technique. You can create cinemagraphs on Photoshop, but the process is pretty complicated. Cinemagraph Pro is the best app for creating these, but it's expensive if you want to remove the watermark. Plotagraphs are much more easily created for free.

Now that you've edited your photos and videos like a pro, you are ready to move on to Step 6 and show them to people!

STEP SIX
SHARE IT
Get Your Vision Out There For People To See

Now that you've filmed and created your media, it's time to share the love. With so many options for your final pieces, you may wonder how to view and share your edited photos and videos.

As you film more and more, you will likely run into the scenario where you filmed somebody doing something awesome, beautiful, creative, or entrepreneurial that you want to share.

Read on to discover the many ways to get your media out there for friends, family and maybe the world to see.

SHARING FILES

SHARING THROUGH THE GOPRO APP

The GoPro App enables you to share photos and videos directly from the App. You can share files that are currently on your camera's microSD card or files you have downloaded to your device.

Now that the GoPro App has built-in editing, it's super easy to edit and share quick video edits and photos using the GoPro App. You can share your edits directly from the GoPro App to social media (such as Facebook, Instagram, etc.) or share with your friends via text messages, email or a link from GoPro's site. Open the media, tap the download share icon, and select share. Select how you want to share and it's easy as that.

If you want to share 360 files with other people who are familiar with 360 editing like you are now, send them the original 360 file to create their own edits. It's amazing how different people will edit footage in such unique ways. For smaller files, you can share the 360 files directly from the GoPro App. For larger file sharing on mobile devices, after downloading the 360 files to your phone, use WeTransfer to send a download link to the file. Or if you are both on iOS and near to each other AirDrop is the easiest. Use Nearby Sharing for sharing on two Android devices.

If the files are already on your computer and you still want to share them to a phone or tablet, on a Mac, right click (Ctrl+Click) and select Share to select how you want to send the file (Messages, email, etc.) On a PC, select the file in its folder and use the Share Button on the Share tab to share the file. This works for smaller files. Next, we will give you options for large files.

SENDING LARGE FILES

If you were out filming and captured some shareworthy video footage of your friend or even a stranger who was out there shredding, you might be struggling to figure out how to share the large video files. Even a short video file is too big for most email accounts, so you need to find a better way to share files. Dragging the file over to a USB flash drive and loading it onto your friend's computer is one rather old-school, but effective, way of sharing files.

If you don't have the convenience of physically sharing the file, there are a few free ways to send large files. (These are the current size limits at the time of publication.)

WeTransfer is the best free option because it lets you share files up to 2GB as often as you like without signing up for any plans. All you need to do is to enter your email and the recipient's email address and link the file. The transfer can be completed from a desktop or mobile device.

Hightail (formerly YouSendIt) offers a free plan that lets you send files up to 100MB, which isn't much if you are sharing 5.6k 360 files, but it could be sufficient for short clips depending on the resolution. You can send much larger files with the paid plans.

POSTING VIDEOS AND PHOTOS

If you want to provide a way for people to view your edited photos and videos online, there are lots of options available. We will cover the best for both 360 and standard photos.

360 PHOTO-SHARING

Facebook

Facebook allows easy 360 photo sharing. After uploading a 360 photo to Facebook, the sphere icon in the corner indicates that Facebook automatically recognized your file as spherical content. If your 360 files are not showing up in 360, the metadata probably just needs to be reinjected.

Instagram

Instagram doesn't yet support immersive 360 photos, but there are still a few creative ways you can show off your 360 content.

• First, you can edit your photo and save it as a flat image, such as a tiny planet, or a standard wide angle image pulled from a 360 photo.

• Second, edit a short 360 video animating one of your 360 photos using the Theta+ Video app. The user won't be able to navigate your image, but you can still share the magic of 360.

• Third, use Instagram's carousel album feature to share a swipeable horizontal panorama. There are several apps available to easily slice your panoramas into multiple photos to use with the carousel. On iOS, use Swipeable, or Panoragram. For Android, use PanoramaCrop. If you want to pano to stand out, upload the full panorama first, followed by the sliced images.

Google Photos

Google automatically recognizes 360 photos. Upload your photos to Google Photos, click on Share and get a link to share your photos.

After uploading your 360 photos to Google Photos, you can also choose to upload your 360 photos to Google Street View on Google Maps. After uploading fifty 360 photos (listed privately), you can get listed as Trusted Street View Photographer, which can be a fun travel hobby with a few perks.

Upload to a 360 Photo Sharing Site

You can also choose to upload your 360 photos to a photo sharing site, such as Kuula.co, Orbix360 or RoundMe. Some of these sites allow you to share the link or embed the photo on your site.

• Kuula.co offers a wide variety of 360 hosting services, including adding filters, simulated flare, 360 graphics and illustrations to your photos. Some plans charge a fee, but you can get started with the Free plan to start sharing photos.

• Orbix360 is another free 360 sharing site which allows you to create virtual reality experiences, including uploading 360 photos.

• RoundMe is a fee-based sharing platform for creating Virtual Tours around the world. You can see what other people have created and get started with their free account if you want to contribute.

360 VIDEO SHARING

If you want to share your videos as a 360 spherical video, you have a few great free sharing options for hosting your videos with the ability to view them in 360. All of these, except for Veer can also be used for hosting your wonderfully edited HD videos as well.

You Tube - *Most popular. Host 360 and HERO Videos.*

Create a channel and upload your videos for private or public viewing. The GoPro App provides access for uploading your edited videos directly from the GoPro App. Or you can upload your videos from a computer or device library.

YouTube allows you to upload 360 video content or standard HD video content for free with a wide range of sharing options. You already learned how to format your 360 videos for YouTube upload in Step 5- Creation.

YouTube is by far the most popular video sharing website so far, and with Google's backing, will continue to be. With a basic account, you can upload videos smaller than 128GB and less than 15 minutes in length. You can upload as many videos as you like. Once your channel gets a following of 1000 subscribers and 4000 hours watched in the last 12 months, you can even earn some extra cash from your videos by monetizing your channel, especially if one of the videos goes viral. YouTube also has a password-protected private setting if you just want to share videos with your closest friends.

Facebook - *Social Media Video Sharing*
Facebook doesn't need much introduction, but Facebook also allows you to upload 360 videos to your account. The maximum video size is 10 GB and less than 240 minutes, so you can upload rather large files. Facebook obviously also allows standard HD video upload as well for your HERO Mode videos. You can also post directly from the GoPro App to Facebook.

Vimeo - *Creative/Non-commercial Videos*

With a free basic account, you can upload 500MB of video per week up to 5GB total storage. The content must be original and non-commercial. You also have the option of making your videos private with password protection, which is convenient if you want to share selected videos with a limited crew.

Veer – *360 Video Sharing for Experienced Creators if Accepted*

Veer.tv used to offer hosting their online hosting services to anyone but has shifted over to hosting content from experienced creators only. As your knowledge grows and 360 video content improves, consider creating a portfolio and applying. They offer a variety of features and perks once you become an accepted creator.

VR HEADSET VIEWING

If you own a VR headset or want to create an experience for VR headset users, there are several ways to host your content to be compatible with a headset. 360 videos hosted on Facebook can be viewed using Oculus headsets, which include Oculus, Rift, Gear VR and Oculus Go.

VR headset viewing through YouTube is only compatible with Daydream, or PlayStation (VR). The playback quality through YouTube is higher than Facebook. You can also view Youtube videos in VR using Google Cardboard, which splits the playback screen into two smaller screens using your phone and a cardboard viewer. Google Cardboard is a cheap and easy way to experience VR viewing with your phone.

Veer.tv offers VR photo and video content for all headsets.

WEBSITE EMBEDDING

If you run your own website or blog, you can use a 360 hosting site to embed 360 photos and videos on your site.

The following sites are four free options for embedding 360 content on your site using an embed code: YouTube, Facebook, Orbix360 and Kuula. After uploading your videos or photos, use the Share feature to copy an embed code, which can be added to your site.

VIRTUAL TOURS

Virtual tours are one of the most useful ways to share your 360 experience with other people. We already covered some of the best tools for creating virtual tours in the Real Estate tips in Step 4.

PHOTO PRINTING

As you have learned, GoPro Max takes high-resolution photos that allow for a wide variety of printing options. Printing flattened 360 imagery is definitely the easiest way to showcase your newfound photographic skills, but there is also an interesting option available for printing spherical photos, which is shown at the end of this list.

With the plethora of creative photo printing options available, here are a few of the best for printing flat photos:

Acrylic Face Mounts

The printed photograph is mounted behind a thin layer of acrylic and usually comes with a hanger mounted to the back, so it is ready to hang. Acrylic Face Mounting creates a modern look for wall art.

It's a tricky process, but Bumblejax, Costco, and BayPhoto are a few labs that can produce these eye-popping prints for you.

Metal Prints

This printing process actually prints your photo directly onto aluminum, creating a unique modern display, with lots of shine and realism.

Google "Metal Prints" or check out BayPhoto, Costco or Bumblejax.

Wood Prints

Photos printed on wood have a very organic feel and create an instant art piece. If you print without a white under layer, the wood grain shows through your image, giving it a unique texture that is perfect for adding a personal touch to your photography.

Check out Woodsnap.com or BayPhoto, or Google "Wood Photo Prints" to find a printer who can print your photos on wood.

Gallery Wraps/Giclees

Make your photo look like a traditional wrapped piece of art by printing it on a gallery wrap. Choose Metallic Photo Paper for extra vibrancy in your photo.

Google "Gallery Wraps" or check out BayPhoto and Costco for printing options.

Spherical Photo Printing

For a different kind of art piece, you can print your 360 photos onto a sphere. Scandysphere or Snapspheres will do it for you, but their printed spheres are very expensive. For a DIY printed sphere, several free apps are also available to create the file for printing and mounting the photos yourself. Photoball (android) and Print-Sphere offer DIY apps for spherical printing.

Congratulations, you now have the knowledge and power to create and share your experiences with the world! In Step 7, you will learn more tricks to take your GoPro footage to the next level.

BEYOND THE BASICS

Take It Further

Once you have mastered the basics of using your MAX camera and see how much fun this camera can be, you will probably want to add more flair and style to your videos and photos. When you are ready to add some extra features to your camera setup, these additional tips and accessories will help you get even better shots.

The list of accessories and extras that are available for your GoPro Max goes on and on, but in this step, we will break it down to the accessories that will make the biggest impact on your footage and on your filming experience.

These accessories will instantly improve the quality of your videos and photos:

MAX UNDERWATER

Even though Max is not really an underwater camera yet, there is an option to film underwater shots. A company in the UK came up with the concept of putting your 360 camera inside of an acrylic "bubble." This pushes water away from the camera's lenses, **allowing the stitch lines to remain accurate and the lens to capture sharp imagery.** The 360Bubble is rather expensive, and you could possibly make one yourself using a clear acrylic lamp globe, but buying a premade bubble would be the best option. If you use Max underwater in a bubble, you will need to use the GoPro App or Smart WiFi Remote to start recording before you go under water. Once you submerge the camera, the WiFi signal won't work.

MAX IN THE AIR

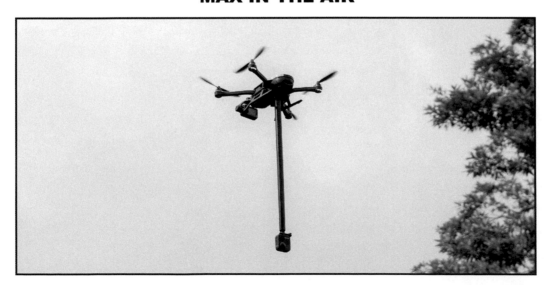

The view from GoPro Max mounted beneath a drone as shown in the first picture. The view it creates is surreal. Photo pulled from video recorded in 5.6k-30 in 360 Video Mode. Max was mounted to an extension pole, which was secured to the drone using a flat adhesive mount.

Just because Max is not directly compatible with a drone, it doesn't mean Max can't fly. By mounting Max to a drone and sending it up into the air, you can capture some truly unique aerial imagery. If you have a drone that can handle the extra weight, mount Max on an extension pole extended out from the drone for the clearest view possible without the parts of the drone interrupting the shot. An adhesive mount can be used to secure the extension pole. You can also let Max extend down below the drone for a full panning view without the drone in sight. Just plan your takeoff and landing carefully since the drones weren't designed to carry Max like this.

PORTABLE LIGHTING

Most of your daytime lighting will come from the sun, but using an external light can extend your filming time or even just fill in light when the sunlight is not bright enough.

Mounting an external light directly to GoPro Max is tricky, especially for filming in 360. The **size of the light needs to match the depth or be narrower than the Max camera** so it doesn't show up in your videos or photos. Ulanzi makes the **GoPro Max Metal Vlog case**, which holds the Max camera and has a hotshoe mount on top for mounting a light to the top of the camera.

There are a variety of external lights that can be mounted directly to your GoPro or placed in a scene for spot lighting. Due the compact size which matches the depth of Max, **GoPro's Light Mod** is the best choice for an external portable light.

LumeCube also makes some useful lighting options for vlogging. Traditional LumeCubes are too bulky to mount onto GoPro Max, but the **LumeCube Panel Light and Panel Mini** are thin enough to mount on top of Max. These lights offer white balance settings and provide more light than GoPro's Light Mod, but they are not waterproof.

When using lights when filming 360, **use Hemisphere Exposure** to set the exposure for the lens where the light is pointing since this will be your main focal point.

FOR NIGHT VIDEO

Mount a light to your GoPro for night filming. Night video filmed without artificial lighting requires using a high ISO setting resulting in lots of "noise". The use of a light allows you to bring your ISO back down a few stops, improve the view of the scene and continue GoPro'ing into the night.

AS A FILL LIGHT

In low light settings, such as under a canopy of trees or on a cloudy day, external lights can be used to fill in shadowed areas.

Place the light up against a subject or one of the key landscape areas for highlighting. Or place the light behind a translucent object for backlighting.

Now that you know which accessories will improve the look of your footage, check out these tools to enhance your filming experience.

REMOTE CONTROL

The Smart WiFi Remote can be used with GoPro Max to control your camera from a distance. Taking control beyond your phone's App, this waterproof remote really opens up the possibilities for different shots.

The Smart WiFi Remote is waterproof up to 33' (10m) deep and can control your camera from up to 600'/180m away in the right conditions away which makes it much easier to disappear from your 360 shots.

The WiFi signal does not work underwater and will lose the connection within a few inches from the surface. The camera should automatically reconnect to the remote once you bring your camera back to the surface of the water.

Try out these uses for a Remote:

SCENIC SHOTS AND REAL ESTATE PHOTOGRAPHY

Set up your camera and compose your shot. Then you can walk away and press the Shutter Button when you are out of the camera's view. The extra distance allows you to film a wider range of scenes without appearing in your shots.

ACTION PHOTOS

When shooting self-portrait action photos, the Smart WiFi Remote is especially useful. With video, you can record continuously during the action, but with self-portrait action photos, you need to push the Shutter Button at the exact right moment even when the camera is mounted at the end of a long pole. The remote can also be used to continuously take photos in HERO Photo Mode for as long as you hold down the Shutter Button.

INACCESSIBLE ANGLES

If your camera is mounted somewhere inaccessible, like on the wing of an airplane, inside the 360Bubble or the side of your truck while you are off-roading to some remote camping spot, use the remote to start and stop the video during the exciting parts of the ride. Depending on the distance between you and your GoPro, you may also be to use the GoPro App on your phone for this type of remote access.

UNDERCOVER ANGLES

If you are trying to record footage without anyone noticing, set your camera in the right spot and start recording or taking photos as soon as the action starts. This works great for nature shots because animals are more likely to approach your camera when no one is around.

GOPRO MAX LIVE STREAMING

GoPro Max along with the improved GoPro App now offers Live Streaming in 1080p from your camera direct to YouTube and Facebook Live as well as other platforms using an RTMP URL. (Note: YouTube only allows LiveStreams for channels with 1000 subscribers or more.) Mount your camera and deliver the feed straight to your friends and followers.

Follow these tips for the best success with Live Streaming through your GoPro Max:

• Live Streaming is **only available in HERO Mode**, not in 360 Video Mode. With your camera connected to the GoPro App, switch over to HERO Mode for the Live icon to become available.

• Live streaming **requires an external WiFi connection** (other than your camera's). You can use a HotSpot through your phone, but for the most consistent feed, use a connection through a router. Connect your camera to the GoPro App first and the GoPro

App will do the rest.

• In your video settings, **select a widescreen resolution (1080p) in HERO Mode** before switching over to a Live Stream since the Live Stream automatically plays in Widescreen. This will help you compose your shots beforehand. Live streams play in widescreen. Also, your other settings will still affect the quality of your video, so preview your shot and adjust settings such as ISO, etc. beforehand.

• Depending on your WiFi signal, there **could be an 8-10 second delay** between what you see in your camera and the live stream.

• You **may need to reconnect to your camera's WiFi** to continue using the GoPro App after streaming live. This will probably be corrected in a future GoPro App update, but for the mean time, it's one of the quirks of using Live Stream through the GoPro App.

• **To use Live Stream,** connect your GoPro to the GoPro App. In the Modes, Swipe over to Live. From there, you can follow the prompts to connect your camera to YouTube, Facebook , Twitch (iOS) or set up an RTMP URL and begin streaming.

• If you want a high quality copy of the stream for yourself, don't forget to **select the option to record a high quality version to your camera's microSD card** in the setup dialog.

OFF THE GRID MAX SETUP

GoPro camera enthusiasts live outside of the box. With these accessories, you can step away from a wall socket and your computer for days or weeks and still be able to record your adventures:

PORTABLE BATTERY CHARGER

Out of the box, the only way to charge Max is to plug it into your computer or wall charger and wait for the batteries to refill. The GoPro Dual Battery Charger (for GoPro Max) lets you recharge with a USB port or wall socket giving you the freedom to get out there and disconnect. A portable power bank, like one by Ravpower or Iniu, is a great source of power for the dual battery charger. You can also connect any portable USB charger or USB phone charger directly to your camera as long as it outputs 5V and 1-2 Amps.

For real freedom from the grid for long trips through rural areas, a portable USB solar charger like the HiGoing 14000mAh Solar Power Bank (5V/2A) will be your ticket to ride.

PORTABLE DATA STORAGE

If you know you are going to be capturing lots of footage without being able to offload onto a computer, the best option is to bring a few high capacity (128 or 256GB) microSD cards. When you fill one up, swap it out for a new one and keep it in a safe spot. Another option is to use a portable memory card backup device to store your photos and videos if you want to travel light. The Gnarbox Portable Backup & Editing System pretty much eliminates the need to travel with a laptop, giving you storage and editing capabilities in one portable device for the content creator who really wants to roam free. This will give you plenty of storage to empty your memory card, get some editing done in your down time and keep filming as you wander on.

Now get out there and have fun!

TROUBLESHOOTING

These are some of the most common problems GoPro users have run into with previous camera models. If you encounter any of these problems, try these solutions first. You can always contact GoPro's customer support via telephone, and they will troubleshoot any problems with you right away. See GoPro's website for their customer service contact info for your country.

CAMERA MALFUNCTIONS

If you experience any of the following problems: **first, try the solution offered.** If the problem happens repeatedly, **reinstall your camera's firmware** by performing a manual update through GoPro's website or update any outdated firmware through the GoPro App. It's possible that the firmware did not install properly during the initial installation. If the problem persists, contact GoPro's customer support.

Problem: The camera heats up when recording.
Solution: This is normal, especially when filming at high resolutions or frame rates. If you continue to experience overheating, turn off the WiFi or temporarily turn off your camera to let it cool down. Also, recording in short stints will reduce the strain on your camera.

Problem: The camera freezes up and stops responding.
Solution: This is not normal and could indicate a problem with the installation of the firmware or communication with the microSD card. To unfreeze your camera, remove and reinsert the battery. Make sure to use a compatible microSD card with a large storage capacity to prevent using a maxed-out card. If it continues to happen, try manually reinstalling the firmware through the Support page on GoPro's website.

PLAYBACK ISSUES

Problem: Your computer does not recognize the memory card when your camera is connected to your computer.
Solution: Make sure your computer is running the current operating system.

For Mac Users: Some programs may interfere with the communication between your camera and computer. If the computer is not automatically recognizing your memory card, you can also import the footage using Image Capture, which is located in your Applications.

Problem: There is only audio and no picture.
Solution: Reinstall your camera's firmware by performing an update through GoPro's website, through the GoPro App. If the problem continues, contact GoPro's customer support. You may need to get a replacement camera.

Problem: Choppy video playback. Some users experience choppy video playback. This is mainly due to the highly-compressed video files that require a lot of work from your computer. GoPro Max uses two very complex compression codecs called HEVC and H.264 (depending on the video resolution and your settings) to store a lot of video footage in a relatively small amount of memory. Your computer will most likely have the most trouble playing high resolution or high frame rate files. The good news is that your files are recorded properly. The not-so-good news is that your computer may not be able to handle the large video files.
Solution: First make sure you transfer your files to a folder on your computer before attempting to view them.

Next, if you are converting your videos in the GoPro Player, trim the videos first to reduce the size of the video files.

If you are still experiencing choppy playback, check to make sure your computer meets the minimum system requirements as shown in the User Manual. If your computer does not meet these requirements, you may need to update your computer.

If you are experiencing any other issues with your GoPro Max or any of GoPro's other products, contact their Support team.

Made in the USA
Middletown, DE
30 October 2020